PRIMITIVE
ART IN
CIVILIZED
PLACES

SALLY PRICE

PRiMitiVE ART

IN CIVILIZED PLACES

SECOND EDITION WITH A NEW AFTERWORD

THE UNIVERSITY OF CHICAGO PRESS
CHICAGO & LONDON

The University of Chicago Press, Chicago 60637
The University of Chicago Press, Ltd., London
© 1989 by The University of Chicago
Second Edition 2001
Afterword © 2001 by The University of Chicago
All rights reserved. Published 1989
Printed in the United States of America

10 09 08 07 06 05 04 03 02 01 1 2 3 4 5 6

Library of Congress Cataloging-in-Publication Data

Price, Sally.
 Primitive art in civilized places / Sally Price.—2nd ed.
 p. cm.
 Includes bibliographical references.
 ISBN 0-226-68067-3 (pbk. : alk. paper)
 1. Art, Primitive. 2. Art and anthropology.
3. Aesthetics—Moral and ethical aspects.
4. Ethnocentrism. I. Title.
N5311.P75 2001
709'.01'1—dc21 2001042815

Dedicated to those artists whose works are in our museums
but whose names are not

CONTENTS

ACKNOWLEDGMENTS

For such a short book, this one has depended on the expertise and coopera-tion of an unusually large number of people. I wish here to thank them all—from librarians and mycologists to students and *knipseldienst*-ers— even though space does not permit me to mention each one by name.

For the past five years, Richard Price has offered a combination of intellectual and moral support without which this book never would have been completed. At each stage, he made numerous suggestions about resources, approaches, and writing that have significantly enhanced the coherence and accessibility of my ideas. At the same time, he kept me smiling and encouraged me to combat the discouragement of hard mo-ments by the joy of hard work.

I am also indebted to Sir Edmund Leach, who had the audacity to suggest that "the distinction between savage and civilised upon which the whole edifice of traditional anthropology was constructed deserves to be consigned to the trash can," and to Edmund Carpenter, whose insights on "civilized" uses of "primitive" peoples have been a special inspiration to me. Both Edmunds provided help for this project through their published work, personal letters, and generous gifts of books that were not readily available to me during two years of research in Paris.

William C. Sturtevant fed useful ideas, references, and contacts into this project at many points; I am most grateful to him for unflagging personal support of the proposals that provided opportunities for its funding.

My debt to colleagues in the Johns Hopkins Anthropology Depart-ment is perhaps best expressed by recycling Sidney Mintz's acuminous assessment of the ten-year period (1974–84) during which I enjoyed their friendship and intellectual stimulation: "Their encouragement and sup-

port during our first decade together have given new meaning to the word *collegiality*" (1985: x, emphasis his).

Back in 1984, Irene Winter, in her role as co-organizer of a panel at the 1985 College Art Association meeting, responded positively to a one-paragraph abstract entitled "Primitive Arts in Civilized Places." For the intellectual stimulation and personal support she has offered since then, and for her critical reading of an early draft of the manuscript, I am most grateful. Hal Foster offered me an opportunity to present my preliminary view of the subject in an *Art in America* article, parts of which have survived intact in the following pages. Jim Clifford and Dan Rose also encouraged and enriched my thinking about transcultural views of art, Leslie Rowland added helpful insights, and Chris Steiner shared his own work with me in ways that made mine better. Gary Schwartz contributed an immensely helpful critical reading when the book was in its final stages. Once the manuscript was finished, Marlie Wasserman provided unselfish support and encouragement toward its publication.

The kindness of Michel Izard, Michel Leiris, Claude Lévi-Strauss, Philippe Peltier, and especially Georges Rodriques greatly facilitated my incursion into the world of primitive art dealers in Paris. And the willingness of these latter to grant interviews to an American ethnographer attempting to probe their world is deeply appreciated; I wish particularly to thank Pierre Amrouche, Asher Eskenazy, André Fourquet, Hubert Goldet, Rita and Anthony Meyer, and Alain Schoffel, as well as several dealers who were generous with their time but asked that their names not be cited. Throughout, I have attempted to respect each of their wishes in terms of the attribution of specific comments.

Leah Price's incisive criticisms encouraged this project at many crucial points while it was unfolding by fits and starts into an awkward first draft. Both she and Niko Price contributed substantially to the personal contentment that made its completion possible. So, too, did Harry and Ligia Hoetink, Patrick and Maryvonne Menget, and Emilien and Merlande Larcher, among others.

Aimé Césaire's generosity when Richard Price and I moved our base of operations from Paris to Martinique, halfway through the writing of this book, made the transition to our little home by the sea even more pleasant than it would otherwise have been.

The Wenner Gren Foundation for Anthropological Research funded the initial year of my research with a grant-in-aid and then followed it with a second year's support. The American Council of Learned Societies underwrote my work during 1985–86. The Laboratoire d'anthropologie sociale,

under the direction of Françoise Héritier-Augé, provided academic hospitality in Paris via a research associateship during 1985–87. And the Institute of International Studies at the University of Minnesota, under the direction of Brian Job, did the same in Minneapolis during 1987–88. To all four of these organizations, many thanks.

INTRODUCTION

What do we mean when we talk about "primitive art"? I am not aware of any other term in anthropology or art history that has come under such disgruntled attack by people who feel that they should dissociate themselves from it but still on some level wish to believe in its legitimacy. The result has been a large number of definitions encumbered by extended disclaimers. C. A. Burland, for example, aware of arguments that had been made in the post–World War II years against the label "primitive," stuck by it nonetheless, proclaiming that it "is wooly and inaccurate, but by constant usage it has come to mean something which is widely understood" (Hooper and Burland 1953: 19). One scholarly discussion of the term opened with the remark, "We all feel qualms, I suppose, when we read or hear about 'primitive art'" (Claerhout et al. 1965: 432), and a substantial number of commentators seem to share the feeling of disappointment expressed by René Huyghe of the Académie française, who noted that the term, although "partly justified . . . is no longer fashionable" (1973: 67). Even in the late 1980s, many writers simply cannot get themselves to abandon either the term itself or the evolutionist connotations that permeate it. H. W. Janson's widely used *History of Art,* newly revised in 1986, is typical:

> "Primitive" is a somewhat unfortunate word. . . . Still, no other single term will serve us better. Let us continue, then, to use primitive as a convenient label for a way of life that has passed through the Neolithic Revolution but shows no signs of evolving in the direction of "historic" civilizations. [1986: 35][1]

I begin by presenting two sets of definitions of "primitive art." The first represents formulations with authenticated provenances; the second is a

1

more maverick assortment, intended to signal the undertones of the term as it is actually used and to introduce some of the concerns of this book.

I

"We are dealing with the arts of people whose mechanical knowledge is scanty—the People Without Wheels" (Hooper and Burland 1953: 20).

"Primitive art is produced by people who have not developed any form of writing" (Christensen 1955: 7).

"Properly, it is the art of those people who have remained until recent times at an early technological level, who have been oriented toward the use of tools but not machines" (Douglas Newton, cited in Kramer 1982: 18).

"Now the term . . . has simply come, for lack of a better term, to refer to art of classless societies" (Moberg 1984/85: 23).

II

Any tradition of visual art produced by mentally balanced adult humans that is regularly analyzed in the comparative context of drawings by apes, children, and the insane.

Any art capable of evoking in Western viewers images of pagan rituals—particularly cannibalism, spirit possession, fertility rites, and forms of divination based on superstition.

Any art made by persons who, in Westerners' metaphorical imagery of the Family of Man, are regarded with affection as baby brothers, genetically related and genealogically equal but not yet trained to repress their natural urges in conformance with the rules of civilized behavior.

Objects crafted before World War I within artistic traditions not represented in world art museums until after World War I. (Or its corollary: Objects crafted before World War I within artistic traditions not represented in books on the history of art until after World War I.)

Any artistic tradition postdating the Middle Ages for which museum labels do not identify the artists of exhibited pieces. (Or its corollary: Any artistic tradition postdating the Middle Ages for which museum labels give the dates of displayed objects in centuries rather than years.)

The art of peoples whose in-home languages are not normally taught for credit in universities.

Any artistic tradition for which the market value of an object automatically inflates by a factor of ten or more upon export out of its original cultural setting.

Over the course of the following pages, an attempt will be made to stimulate critical reexamination of certain concepts that are part of the most basic ideological currency of our society. Some of them are so familiar that they seem like matters of simple common sense; others are metaphors that constitute a kind of standard shorthand for referring to the unity and diversity of human beings. When I refer to these concepts as specific artifacts of our Western cultural heritage, I represent them by capitalized words: "the Great Civilizations," "Primitive Art," "the Family of Man," and so on. Within this convention, "Western" signals an association with European-derived cultural assumptions, whether in the thinking of someone from New York, Tokyo, or Lagos.[2]

This book is based largely on material from France and the United States—partly because those countries were my home during the period of research and writing, but also because each represents a major locus for the meeting of Western viewers and non-Western artifacts and hence provides great riches—both popular and scholarly—for the issues I set out to explore. It incorporates no attempt to provide a systematic survey or comparison of the status of Primitive Art in different parts of the Western world. Nor does it deal in detail with the economics of the Primitive Art market. The dealers, collectors, and curators who spoke with me about their world taught me certain things about the key role of tax laws in France and the United States (and ways in which they are circumvented), the varied entrepreneurial practices of "runners" and other middlemen, the practical implications of a sliding scale between "restoration" and "forgery" of art objects, the rivalries over acquisitions between dealers and museum personnel, the behind-the-scenes intrigues of auctions, and many other aspects of the trade that contribute to its financial structure; nonetheless, I know that what I have been shown of this particular iceberg is no more than its tip.

Furthermore, the following pages do not scrutinize, classify, or judge the distinctive disciplinary and ideological niches from which one or another authority's views have sprung. Like the relevant bookshelf in many art-conscious households, I have lined up next to each other, pressed to-

gether and unclassified, such diverse views of Primitive Art as those espoused by Nelson Rockefeller, Franz Boas, Ladislas Segy, Frank Willett, William Rubin, Raymond Firth, and John Povey. For my experience suggests that whether such a shelf is in the living room of a psychiatrist or a dentist, a business executive or a lawyer, an anthropologist or an art historian, a wealthy collector or a nonbuying museum enthusiast, it tends to be employed as a kind of <u>generalized cultural resource</u>—that is, without an insistence on differentiating the specific credentials of its various authors. My discussions of the ideas of particular individuals are thus not intended as general criticisms of those persons' profession, academic discipline, class, political ideology, or nationality. Reflections on the perspectives of French versus American commentators, of anthropologists versus art historians, and of museum curators versus art dealers have been expressly kept to a minimum. I have also resisted the temptation to follow up on a colleague's suggestion to characterize the published views that I cite from U.S. sources as being the products of a "pre- or post-1960s mindset." This general decision is sure to cause some distress to readers who would like to have a basis for dissociating themselves from those tenets they find uninformed, outdated, or ideologically objectionable. Friends and acquaintances whose identity in some sense resides in such categories as "art critic," "anthropologist," "museum curator," "intellectual" or "liberal" have occasionally protested to me that a particular view I criticize is that of some *other* group, not theirs, and that I cannot justifiably neglect to pinpoint the source of the biases under discussion. I am convinced, however, that an analysis of the differences in perspective among these categories would prove to be far more complex than many people imagine, with subtle cross-influences blurring the stereotypic character of each one, and with individuals' life experiences leading them to transcend and contradict in idiosyncratic ways the received wisdom into which their formal training has initiated them. The implications of these sorts of distinctions would clearly constitute a legitimate and enlightening area for inquiry, but they would also be tangential to my primary aim.

Ultimately, the goal of this book is to elucidate the everyday understandings of educated and enthusiastic, but nonspecialized, Westerners. Rather than analyzing primary scholarship on Primitive Art, it explores the development of a second-generation view of the subject—one that emerges from the knowledge and views of academics, curators, and professional dealers, but that reframes and repositions their cultural and social connotations in the context of movies, talk shows, newspaper reviews, popular magazines, and dinner-party conversations. It deals, in short, with

some of our most basic and unquestioned cultural assumptions—our "received wisdom"—about the boundaries between "us" and "them."

In part, this book is about the plight of objects from around the world that—in some ways like the Africans who were captured and transported to unknown lands during the slave trade—have been discovered, seized, commoditized, stripped of their social ties, redefined in new settings, and reconceptualized to fit into the economic, cultural, political, and ideological needs of people from distant societies. Although the devastation wrought by this twentieth-century brand of cultural imperialism is of an entirely different order from that of its slave trade precedent, it, too, diminishes the communities that are its suppliers. To understand this phenomenon, we must begin by focusing our attention, not on the art objects themselves, nor on the people who made them, but rather on those who have defined, developed, and defended the internationalization of Primitive Art, and on their racial, cultural, political, and economic visions. From this perspective, our central problem, to adapt a phrase from Ortega y Gasset (1925), becomes the *dehumanization* of Primitive Art and its makers. The following chapters are intended to illustrate the multiple mechanisms—from collecting strategies to interpretive frameworks—that have served to effect and validate this process.

Written by a card-carrying academic for art lovers of whatever background, this book makes frequent stops for shifts between scholarly and popular discussions of its subject. After the text was written, a reader suggested that the way in which it juxtaposes its evidence from diverse sources (news clippings, magazine ads, scholarly pronouncements, museum labels, film scenarios, touristic encounters, and so on) displays affinities with a little-recognized art form that has been dubbed *femmage*[3]— a kind of sister concept to Modern Art's *collage/assemblage*. This notion pays *hommage* to the artistry of countless women throughout history who have devoted aesthetic energy to scrapbooks, appliqué, photo albums, and patchwork quilts (inventing valentines in the process) well in advance of Picasso's or Braque's interest in that particular approach to artistic expression. On the other hand, the same composite quality of my presentation could as easily be linked to postmodernist experimentation in ethnographic writing, which involves "not a scrambling but a deliberate juxtaposition of contexts, pastiche perhaps but not jumble" (Strathern 1987: 265–66). In fact, however, the structure of the following chapters represents a very personal choice based on the nature of the book's subject matter and my own perspective toward it. For I propose no tidy answer to the many complex and subtle problems inherent in Western understandings about non-

5

Western arts, but wish only to raise some doubts about the comfortable assumptions that often dictate the place of "exotic" art in our society, and in the process to expose a cultural-political agenda that is, in Pierre Bourdieu's words (1979: 60), less innocent than it might seem to be.

In the final scene of Raul Ruiz's provocative, linguistically nomadic film *Het Dak van de Walvis* [The roof of the whale], the only two Yagan Indians still left in the world in the year 2000 are talking together on a pampa in Tierra del Fuego.[4] While serving as informants to the anthropologist documenting their language for Science, they have also been taken under the wing of his well-meaning and industrious wife, who has initiated them into tea drinking and other Civilized pleasures formerly unavailable to them. Sitting erectly on straight chairs, impeccably attired in suits and ties, they are discussing (one in highly cultivated German, the other in equally erudite English) the relative merits of Beethoven and Mozart, making well-informed allusions to musical structure and the details of Mozart's final trip to Prague. By the time the debate draws to a close, they have arrived at a sober and mutually satisfying conclusion that Mozart is the greater of the two. The deciding factor—the relative appeal of their respective record jacket designs—represents a gentle reminder that transcultural understanding is often a rather tricky business.

With the ongoing homogenization of the world's ways of life, it is becoming increasingly popular for the members of dominant nations simply to hold on tightly to their own, even as they experience greater opportunities (through the media and travel) for exposure to those of others. The following pages address one small aspect of this very broad and daunting dilemma.

1

THE MYSTIQUE OF CONNOISSEURSHIP

It is an inherent characteristic of common-sense thought . . . to affirm
that its tenets are immediate deliverances of experience, not deliber-
ated reflections upon it.—Clifford Geertz [1]

The idea of connoisseurship evokes the image of an impeccable gentle-
man—well bred, well schooled, and well dressed, discreet in behavior,
self-confident and measured in judgment, and, above all, a man of su-
premely good taste. A connoisseur is also a person whose opinions carry
special authority for others; we trust the perceptions of connoisseurs be-
cause, as the dictionary now opened on my desk proclaims, they are "espe-
cially competent to pass critical judgments in an art, esp. one of the fine
arts, or in matters of taste." One could legitimately argue that some of the
attributes just cited are not properly included in a bare definition of con-
noisseurs, but few would disagree that they make their appearance with
dogged regularity among those who lay a general claim to that status
according to stricter definitions. A sloppily dressed art connoisseur would
be theoretically possible, but the image strains the tolerance of our imagi-
nation, and in fact there are relatively few people who consider themselves
bona fide "connoisseurs" ("esp.," as the dictionary puts it, "of the fine arts")
but do not wear custom-tailored suits or travel first class. [2]

The antithesis of the prototypical Connoisseur is surely the pro-
totypical Savage. The difference is, as it were, black and white. The latter is
not very well dressed (or often, not very dressed at all), is not properly
schooled, tends to indulge in noisy and sometimes lascivious behavior,
confuses mythical tales with true history, abandons artwork to the termites
instead of conserving it in museums, savors palmnut grubs and human
stews rather than escargots and calves' brains, and shares nothing of the
Connoisseur's competence in matters of taste and the fine arts. These two
distant members of the human race occasionally come into contact through
the market in Primitive Art, which one produces and the other assesses.
With several refreshing exceptions, their wives and sisters wisely stand
aside, cognizant of their respective societies' belief that these encounters

have economic consequences that are best isolated from the whimsy of women.

I begin my exploration of their relationship, and of the complex realities behind these frontal caricatures, with a consideration of the first of the two gentlemen—the Connoisseur.

Starting at the very heart of connoisseurship, the "matter of taste," let's listen to what one of the foremost connoisseurs of our century, the art historian Lord Kenneth Clark, has to say about this essential ingredient.

> What is good taste? . . . taste isn't artistic talent, and it isn't sensitive appreciation. And while I'm saying all the things it isn't, I might add that it has nothing to do with fashion. There's good and bad taste at practically every epoch and in practically every civilisation. . . . Which brings me to the last thing which taste isn't. It hasn't much to do with, what shall I say, social eminence, education, aristocratic upbringing and all that, any more than manners have.

Clark then points out that "smart" people can have bad manners and bad taste, while humble, modest people sometimes have good manners and good taste. Taste is like manners; it means not showing off too much, not being ostentatious.

> Taste depends on a balance of ends and means. . . . Tact, that's the word. Of course, it's really the same word as taste. It means what you can feel with your hands without being altogether conscious of it. Tact must be unconscious. Contrived tact is almost always disastrous. . . . Good taste cannot arise from indifference. On the contrary, taste involves an appetite. . . .
>
> That, I think, gives us one of our basic meanings of taste. It's something that you like the taste of, something that you like without knowing why. . . . [It involves, he goes on, both discrimination and restraint.] Discrimination derives from sensibility to various flavours, which allows us to discriminate between them. Restraint derives from sensibility to the feelings of others, which restrains the ever-bubbling, boisterous ego within us which otherwise would upset the harmony upon which all good society depends. So taste is important because it demonstrates the eternal truth that man is one, that his physical sensations and his conduct can't be separated. [Clark, n.d.]

As befits a statement by such a distinguished connoisseur, this discussion was spoken with the directness and clarity that a comfortable sense of

authority allows. It is also rich in ideas, for, in addition to enjoying the kind of sensibility that plays such an essential role in his concept of taste, Clark was clearly endowed with the "ever-bubbling, boisterous ego" which that sensibility serves to restrain.

Clark's definition begins on a rather extended negative note, raising possible ingredients in the concept only to dismiss them without further discussion. It would be an error, asserts Clark, to think of taste as a matter of "fashion" (that is, as confined to a particular historical period or "civilisation"). Nor is it limited to members of a particular segment of the society as defined by aristocratic roots, by educational background, or (to interpret Clark's euphemistic "and all that" in the context of his later references to "humble" folk) by wealth. Nor must we imagine that taste is the product of the conscious mind, for that brings us into the realm of the contrived, and contrived taste, he shivers, is "disastrous"; rather, taste is something people possess "without knowing why." Furthermore, taste is not "ostentatious"; in its true incarnation, it provides a very personal sense of pleasure that has no need to be paraded in front of others. And, finally, it cannot "arise from indifference," for indifference is the negation of discrimination, and discrimination is the seed from which true taste flowers.

At this point, Clark's negative definitions of taste feed into his recognition of some of its more positive attributes. "Discrimination" allows us to distinguish flavors of variable merit; "restraint" adds a consideration for the feelings of others; and together they constitute a contribution to "the harmony upon which all good society depends." Finally, and as a kind of corollary to the rest, taste confirms the "eternal truth" that body and soul are one, that physical sensitivity and moral behavior form a coherent whole; in other words, if I may be permitted to interpret the thrust of the passage, the Aesthetic Order upon which our Culture reposes is solid and legitimate, and in harmony with the ideals of a moral Social and Political Order.

The conviction that taste is independent of "fashion" is an essential element of the definition; without this independence, taste could be viewed as arbitrary and ultimately trivial. The same holds true for its isolation from factors of social eminence, education, and aristocratic upbringing, not to mention the conscious awareness that could reduce it to "contrivance." Like principles of faith, the argument goes, matters of taste float high above the reaches of human manipulation and cultural contamination. At the most, individuals can sense, grasp, feel, or imbibe the distinction between things of good and bad taste; they cannot, however, redefine the terms of the distinction itself, for those are classic and eternal and universal. Just as religious belief cannot exist in the presence of the possibility that Man

mythical, inherent hierarchy.

creates God in his own image, so a devotion to good taste would fall apart if its canons were thought to reflect no <u>higher authority</u> than that of its practitioners. It follows that good taste cannot be taught or bought, and that it never becomes obsolete.

This particular view of taste crops up repeatedly in the writings of art connoisseurs. The dealer Henri Kamer, writing about African art, refers to the importance, among his colleagues, of

> that rare faculty of having an instinct for quality.
> To feel the quality of an object is to have a sixth sense. . . .
> It is possible to learn to recognize the styles . . . through books which have been published on the subject, or better yet, to study them in the field. But taste and a feeling of quality are never acquired. This is innate. [1974: 38]

Employing the same despairing image of "disaster" that Clark used to condemn bad taste, and grouping, like Clark, the dangers of relying on learning and on money, Kamer contrasts, on the one hand, successful collectors who have no "knowledge" but are endowed with innate sensitivity with, on the other, "specialists who hold a number of impressive degrees and have enormous funds at their disposal, [but who] have been responsible for disastrous acquisitions."

The assertion that true connoisseurship is both <u>innate and uncon-</u> *gifted?* <u>scious</u> is frequently supported by anecdotal evidence from memories of *to entitled.* childhood. Lord Clark explains his own gift in this realm through reflections upon his (unconscious) sensibilities, at the age of seven, to a set of Japanese prints which many years later produced an aesthetic reawakening of the original experience that might be described, I believe, as something like that of Proust's madeleine.[3] This impressively precocious sensitivity and its long dormancy in his conscious mind are interpreted by Clark as testimony for the existence of the "pure aesthetic sensation."

> That concept, once received in the highest intellectual society, would now dare scarcely to show its head in a provincial discussion group. And yet without some such hypothesis the whole experience is very hard to explain. I am not so vain as to compare it to an infant musician's immediate understanding of a fugue, or to a youthful mathematician's joy when he first encounters Euclid's proof of the Infinity of Prime Numbers. Their gifts are, of course, incomparably more impressive. Nevertheless I think it must be reckoned a freak aptitude of the same kind. [1974: 44]

In the same vein, the art dealer Germain Seligman suggests the power of his own childhood aesthetic responses when he confesses that

> I am puzzled occasionally by the strange familiarity of objects which to my knowledge I have never seen before. When I first visited the Metropolitan Museum in 1914 and saw four tiny and altogether delightful white enamel and gold angels in the Morgan Collection, I sensed at once that I knew them. My father claimed I could not possibly have remembered, as I was much too young when he had sold them. [1961: 9]

And Thomas Hoving, though a bit slower to undergo the pivotal experience (in a college lecture hall), describes it in equally mystical terms: "Something within me, something I had no idea was there, simply ignited. Later on, years later, I came to realize that what had occurred was akin to religious experience" (1982: 4).[4]

The reliance on a spontaneous, untutored "feel" for things aesthetic, rather than the more dreary practice of systematic study, often represents a matter of principle, an almost defiant assertion of a liberated spirit. Paul Valéry once wrote:

> In questions of art learning is a sort of defeat: it illuminates what is by no means the most subtle, and penetrates to what is by no means the most significant. It substitutes theories for feelings and replaces a sense of marvel with a prodigious memory. It amounts to an endless library annexed to a vast museum: Venus transformed into a document. [Valéry, translated in Baekeland 1984: 27]

Dominique de Menil, before stating her own position that "There is a place for speech in the approach to a work [and] reflection is not opposed to emotion," acknowledged the extent to which many artists and critics have discredited the contribution of intellectualized and articulable thoughts to art appreciation:

> Matisse's "Those who want give themselves to painting should begin by cutting out their tongues" and Braque's remark that "in art, there's only one thing that matters: that which cannot be explained" are brutal reminders that, as Malraux said it, "the only language of paint-

ing is painting." And even Baudelaire spoke of "the dreadful use-lessness of explaining no matter what to no matter who." [Anon. 1984: 11]

Pierre Bourdieu cites a culinary aesthetician who draws an analogy between food and art to make the same argument, proposing that "gastronomy" is to taste itself what grammar is to literary sensitivity. While the gourmet is a delicate connoisseur, the gastronomist is a pedant, analyzing taste only because of an inaptitude for the sensation itself, which is a matter of instinct. There is more than an implicit hierarchy in this system:

> [gastronomists] belong to the lower, modest order, and it is up to them to improve this somewhat subordinate order through tact, moderation, and elegant lightness. . . . Bad taste does exist . . . and refined people sense this instinctively. For those who do not sense it, rules are indeed necessary. [P. de Pressac, quoted in Bourdieu 1979: 73–74.]

The ability to discriminate (or, more to the point, to *be discriminating*) is incontestably the most essential skill of connoisseurship. A serious wine connoisseur would not easily admit to mistaking a St. Emilion for a Pomerol; a connoisseur of mushrooms would be embarrassed to confuse an Agaricus campestris and an Agaricus bisporus; a proper art connoisseur presented with two fifteenth-century paintings of the vision of Saint Augustine would not hesitate before identifying the one by Sandro Botticelli. In terms of their powers of discrimination, acknowledged connoisseurs represent a limiting case within a much more general cultural phenomenon, for everyone in our society aspires to mastery of this faculty in some (selected) areas of life; a true coffee lover would be horrified to learn that she had unknowingly gulped down a cup of Nescafé. No one can go through life without exercising discrimination on a daily basis, and the presence of advertising constantly taunts us about areas in which we might otherwise tend to be lax. TV commercials shame the housewife who really doesn't see (or care too much about) the difference between the whiteness of clothes washed in detergent A and detergent X; deodorant ads carry the same message to those who might entertain an indifference to (or tolerance of) the natural aroma of the human body; and ad writers for British Caledonian Airways put their faith in the French to interpret in a correctly discriminating manner their comparison of a flight attendant who is a "charmer" from another who is genuinely "charming."

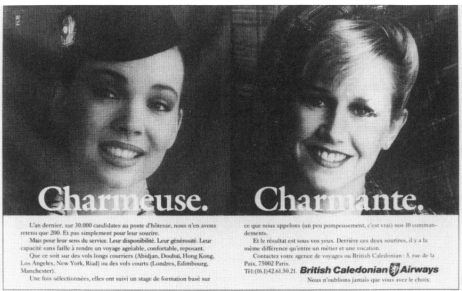

Charmeuse. Charmante.

L'an dernier, sur 30.000 candidates au poste d'hôtesse, nous n'en avons retenu que 200. Et pas simplement pour leur sourire.
Mais pour leur sens du service. Leur disponibilité. Leur générosité. Leur capacité sans faille à rendre un voyage agréable, confortable, reposant.
Que ce soit sur des vols longs courriers (Abidjan, Doubaï, Hong Kong, Los Angeles, New York, Riad) ou des vols courts (Londres, Edimbourg, Manchester).
Une fois sélectionnées, elles ont suivi un stage de formation basé sur

ce que nous appelons (un peu pompeusement, c'est vrai) nos 10 commandements.
Et le résultat est sous vos yeux. Derrière ces deux sourires, il y a la même différence qu'entre un métier et une vocation.
Contactez votre agence de voyages ou British Caledonian : 5, rue de la Paix, 75002 Paris.
Tél:(16.1)42.61.50.21. **British Caledonian 🛡 Airways**
Nous n'oublions jamais que vous avez le choix.

LIBÉRATION ● MERCREDI 30 AVRIL ET JEUDI 1ER MAI 1986 11

Like the emperor's subjects who were encouraged to recognize and applaud the quality of their monarch's new clothes, we generally deal with the task of discrimination according to a complex set of cues, in pursuit of the impression of being just a bit more (correctly) discriminating than our raw perceptual faculties allow us to be. Thus, academics attending seminars have impeccably subtle ways of assessing selected colleagues' opinions before deciding whether to respond to the presentation of a visiting speaker with praise, contempt, or silence; the substitution of a Calvin Klein label on a K-Mart (discount house) windbreaker has proven itself capable of eliciting approving compliments from persons who pride themselves in sartorial discrimination; the difference between seeing a given engraving in a junk shop or on a wall of the Louvre may condition our evaluation of its aesthetic worth; and so on. Judging the sophistication and knowledge of the person to whom one is talking introduces another variable; for example, the college professor who tells his class with absolute authority that the Martiniquan city of Fort-de-France was destroyed by a volcano in 1902 adopts a less certain tone when repeating the misinformation to a colleague who has some acquaintance with the history of the Caribbean. Most people

have a good sense (privately) of their individual limits, and <u>bluff only gently</u> <u>at the edges of their actual competence.</u> But how far to extend oneself in this domain, and how brashly to defend one's stances, are obviously matters of personal temperament, and some are bolder than others. *I thought it was*

As a person <u>moves up in the ranks of connoisseurship,</u> those who pose *inherent?* a threat to claims of discriminatory competence become at once fewer and *(lol)* more watchful, and those who accept it admiringly become more numerous and more trusting. While the authority of connoisseurs is in general not open to question, the weight of the responsibility and the potential precariousness of its foundation are sometimes recognized. Toward the end of his career, with a solid reputation as one of the world's foremost art connoisseurs comfortably under his belt, Kenneth Clark had the self-confidence to poke some fun at the rules of the game he had been playing all his life:

> I never doubted the infallibility of my judgements. At the age of nine or ten I said with perfect confidence "This is a good picture, that is a bad one." When I was moved by a work of art it never occurred to me that someone else, with <u>more mature judgement,</u> might feel differently. This almost insane self-confidence lasted till a few years ago, and the odd thing is how many people have accepted my judgements. My whole life might be described as one long, harmless confidence trick. [1974: 45]

Art appreciation in our society represents a dilemmic clash of principles. On the one hand, true art lovers feel they should, on some level, experience "pure" aesthetic reactions to form—reactions that in no essential way depend on "clinical" knowledge, aristocratic upbringing, or access to estimated prices in an auction catalog. On the other hand, the entire edifice of art connoisseurship is <u>a well-defined and defended hierarchy of</u> <u>authority,</u> in which some among us are assigned responsibility for recognizing the intrinsic beauty of masterpieces and others among us are expected to nod our heads in assent.

The situation is analogous to that recently encountered by a young student of my acquaintance in a French *lycée*. Her biology class was given cross-sections of a leek to observe under their microscopes and sketch in their lab books; the result, the teacher explained, would resemble the diagram that she had drawn in red, white, and blue chalk on the blackboard. Our young friend peered into the microscope, saw shapes rather different from those on the board, and consulted her lab partner, who told

her that she was right but that she should just copy the drawing on the board if she wanted a decent grade. Having recently arrived from a progressive American school that preached methods over results, she rashly bucked the system by depicting what she (and her partner) saw, and was reprimanded by the teacher for having "failed to see correctly." In schoolwork as in art appreciation, the rhetoric of respect for each person's perceptual and judgmental integrity can run into awkward moments when its principles are tested in the context of an established hierarchy of authority.

There is also potentially unsettling evidence against the notion that true good taste is free from the vagaries of "fashion." Anthropologists and art historians dealing with Primitive Art have long tried to insist on this point of view; Roy Sieber summed up their position when he wrote:

> It is not my intention to dismiss connoisseurship or the right of each age to its ethnocentric aesthetic, but to note that the history of taste is a story of constantly shifting attitudes which are not cumulative, and which are neither inevitable nor infallible beyond the moment they are in favor. [1971: 128]

The evidence is mounting in more traditional areas of art historical scholarship as well. In a detailed analysis of the changing artistic tastes of the English and French over a period of several centuries, Francis Haskell (1976) suggests a cautious attitude toward the received wisdom that good taste is ageless, presenting a persuasive argument that even in the finest of the fine arts, judgments of aesthetic quality are a product of their specific time and place to a greater degree than is often realized.[5] Treading gently in a sensitive area, Haskell stops short of dismissing aesthetic pronouncements of the traditional sort. But he concludes his book by suggesting that "It is surely the case that history itself can—at certain moments—only be understood at the price of a certain abdication of those value judgements which art lovers (rightly) esteem so highly" (1976: 117). An interesting sidelight in this ambitious study, which is confined to small comments in the introductory and concluding pages of the book, is his recognition of the discomfort his findings produce. Admitting that "variations in artistic taste constitute not only a problem, but a disquieting one," Haskell goes on to acknowledge

> the distress which (as I found from many people's reactions to the following lectures) can be aroused by our enforced acknowledgement that what is self-evidently of supreme importance to us can once have

seemed insignificant, or even actively repugnant, to men whom we know from manifold evidence to have been fully as cultivated, often far more so, than ourselves. [1976: 4]

And he reiterates at the end that "I must confess to a considerable degree of unease at the implications of the problems I have been discussing" (1976: 116).

As one who has occasionally proposed the "relativity of taste" (as Haskell phrases it [1976: 5]) to members of the Western art world, I can attest that the "distress," "repugnance," and "unease" which he encountered were not unique to his own experience. There is something unsettling indeed about the possibility that our judgments and those of our cultural heroes are in any sense the product of the particular setting into which we and they happen to have been born; and it is sometimes the case that the more professionally people devote themselves to an interest in art, the more threatening the specter becomes.

Few students of Western society have examined the social parameters of taste with as abundant a compilation of data as the French sociologist Pierre Bourdieu. His study of visitors to European art museums (co-authored with Alain Darbel [1969]) presents data of particular relevance to the present discussion; his more ambitious *La distinction* (1979) probes more widely into the ideology and practice of taste through an exploration of people's preferences in music, movies, furniture, eating habits, home entertaining, vacations, and many other aspects of life within different segments of the French population as defined by social, economic, occupational, and educational factors. His data constitute a massive mosaic of disparate bits and pieces of French life, based on systematically administered interviews and multiple-choice questionnaires. Standing back from the details, however, what emerges is a forceful image composed of two contrastive elements: an *ideology* of "natural taste" and a *pattern* of behavioral choice based on tastes acquired through "education."

It is as if Bourdieu has stood on its head the title of a 1936 painting by Yves Tanguy—*Hérédité des caractères acquis*—to depict the dilemma of "the acquisition of inherited characteristics."

Bourdieu is acutely aware of the critique that Valéry might have made of his undertaking and, like Haskell, he recognizes the abrasive potential of his findings.

> There are sure to be people who will be surprised that I have gone to such lengths to state such obvious truths, and who will at the same

17

time protest that these truisms completely misread the clear yet in-expressible flavor of their own response to works of art. What does it matter, they will say, to know where and when Van Gogh was born? What do the vicissitudes of his life or the periods of his work matter? What really counts for true art lovers is the pleasure they feel before a painting by Van Gogh. And isn't this what sociology obstinately refuses to see, through a kind of reductive, deflationary agnosticism? Sociologists are in fact always suspected . . . of contesting the authen-ticity and sincerity of aesthetic pleasure simply because they describe the conditions of its existence. This is because, like any other kind of love, a love of art recoils from tracing its origins and prefers on the whole [to see itself as the result of], not common conditions and experiences, but rather the chance happenings that can always be interpreted as predestination. [1969: 161]

Bourdieu describes a subtle process of education, taking place within the family at least as much as in the classroom, which "has the gradual effect of masking, through the inculcation of things arbitrary, the arbitrariness of things inculcated," with the final result that "culture . . . becomes na-ture"; in other words, "culture is realized only by denying itself as such, that is as something that is both artificial and artificially acquired" (1969: 162–63). Homing in on his concern with understanding the ideology of class distinctions, Bourdieu argues that the "privileged classes of bourgeois society are seeing what is in fact a difference between two cultures . . . as a fundamental difference between two natures—one nature that is naturally cultivated and another nature that is naturally natural" (1969: 165). And finally, taking up the metaphor of institutionalized religion which so fre-quently serves to express his view of cultural distinctions, he asserts that art museums are the sacred places whose "true function" is to reinforce the barrier between "those who have received Grace and those to whom it has been denied" (1969: 165). Everything about them serves to show, he argues, that

the world of art stands in opposition to the world of daily life, like the sacred to the profane: the untouchability of the objects, the religious silence imposed on visitors, the puritanical asceticism of the furnish-ings, which are always rare and uncomfortable, the nearly systematic rejection of anything didactic, the grandiose solemnity of the decor and the decorum, with the colonnades, the vast galleries, the painted ceilings, and the monumental staircases all seeming as if they were

designed to reflect a passage from the profane world to the sacred world. [1969: 165–66]

The introduction to *La distinction* reiterates the conclusion of *L'Amour de l'art* and paves the way for its role in a more generalized view of cultural preferences and habits. Anticipating Marshall Sahlins's similar generalization that "there is no such thing as an immaculate perception" (1985: 147), Bourdieu argues that

> The eye is a product of history, reproduced by education. . . . there is no "love at first sight" in the encounter with a work of art. . . . This typically intellectualist theory of artistic perception contradicts very directly the experience of art lovers who conform most closely to the accepted definition; the acquisition of legitimate culture through unnoticed familiarization within the bosom of the family tends in effect to favor an enchanted experiencing of culture which requires forgetting the act of acquiring and ignoring the instruments of appropriation. [1979: iii]

If the ruling class of aesthetic judgment sees itself as beneficiaries of a mystical, innate gift, suggests Bourdieu, they are playing with a sort of trompe-l'oeil, for "their struggle to gain a monopoly of artistic legitimacy is less innocent than it might appear; there is no struggle concerned with art that is not also concerned with the imposition of an art of living" (1979: 60). Here, the battle lines between Bourdieu's understanding of connoisseurship and that espoused by Kenneth Clark begin to become clear. Clark, who was a tireless "popularizer" of art history through his television series and his accessibly written books, liked to believe that "anyone" could participate in the joys of art appreciation as he understood it; taste does not depend on "social eminence, education, aristocratic upbringing and all that."[6]

If we look to the writing of men who are Clark's generational and cultural peers, however, we find disquieting indications that his view may be overly optimistic. Lewis Mumford, who like Clark combined impeccable cultural credentials with an easy, popular style of writing, described a visit to an exhibition of New York realists at the Whitney Museum in 1937. Being careful to specify that "it was not the critics' preview," Mumford tells us that he

> became suddenly conscious of the other visitors. They were the sort of people you might expect to find at a fire, but never at an art gallery.

There were groups of crisp, black-haired men, with cheeks like West-
phalian hams, whom you might see dining at Cavanagh's or at Joe's in
Brooklyn; there were shrewd horsey-faced fellows you'd more likely
meet in the paddocks or the prize ring, judging limbs and shoulders,
than in the midst of a collection of paintings. Politicians, real-estate
brokers, contractors, lawyers—what were they doing here? [1979:
229]

In the half-century since this scene was witnessed, it is certainly true
that attendance at art museums has become more "democratic"; the pres-
ence of politicians and lawyers which was shocking in 1937 would not be so
in 1987. But if we redraw the line only slightly the point still holds: there
are some kinds of people we expect to rub elbows with at art exhibits and
others we don't. One has only to stroll through New York's Museum of
Modern Art, brushing past luxurious furs and breathing in the costly
perfumes, to be persuaded that, as Bourdieu showed in a European context,
the openness of art museums to the public at large is only one small factor in
the set of social and cultural conditions that determine the accessibility of
art in our society.

Putting Bourdieu's findings together with observations like Mum-
ford's, it becomes increasingly difficult to locate the heart of artistic appre-
ciation in the "pure aesthetic response" that Kenneth Clark and others have
championed. Partly because of the increased documentation on non-Western
arts and partly because of the historically variable image emerging from the
work of scholars such as Francis Haskell, those who have been studying the
phenomenon of aesthetic response in the 1980s are beginning to consider
more seriously the cultural factors that influence it and therefore the rela-
tivity of the judgments themselves. As a result, avenues for the investiga-
tion of aesthetics in a comprehensively comparative sense are, even if not yet
very well traveled, as least open for traffic.

Joseph Alsop's monumental work on Western connoisseurship ex-
emplifies this transitional state between the culture-bound and culture-
encompassing study of the aesthetic experience. Basing his entire enterprise
on the distinction between "the small number of cultures having art his-
tory" (the ancient world, China, Japan, the civilization of Islam, and
Western societies from the Italian Renaissance on) and all others (1986: 30;
see also 1981), Alsop manages to raise questions whose relevance to those
"others" is somewhat greater than he imagines.[7] In a fascinating discussion
of the history of great fakes, and the effect that their discovery has on

viewers, he distinguishes two levels of response to a visual work of art. The first, based on "what pleases the human eye," is the "pure aesthetic response," which "all cultures have" but which at the same time "is in some degree dependent on cultural formation." The second response is based on knowledge that viewers have acquired about the place of the object in the context of a documented art history; this "historical response" is proposed as the special property of a small number of civilizations, ours included.

In cases when an admired and universally "authenticated" work of art is discovered to be a "fake" (most often through laboratory analysis or archival documents having nothing to do with the object's external appearance), "the historical response goes to war, as it were, with the aesthetic response; and . . . [usually] the historical response then entirely overcomes the aesthetic response" (1986: 30). For people closely concerned with these unveiled forgeries (such as those who have purchased them at high prices in the belief that they were "authentic"), the actual visual perception of the object is affected by the discovery of its "contaminated" origins.

Alsop places in a footnote his explanation for how a visual perception can be altered when the object itself remains unchanged, but I believe it is a crucial element in the issues he is raising, and it is certainly of central importance to the subject of this book. Citing a scientist's study of sensory perception to elucidate his art historical argument, Alsop is also trespassing on the ground floor of cultural anthropology when he remarks (quoting Israel Rosenfield's report on research by Gerald M. Edelman) that our vision is very much dependent on "our ability to organize the world around us into categories" (1986: 30). When we look at a given painting, what we recognize is (for example) the *category* "Picasso" or "fake," as much as a specific item. A central preoccupation of cultural anthropologists is the discovery of which categories (such as "fakes" and "Picassos") a given group of people chooses to delineate and call upon in their day-to-day living; Alsop is certainly correct in highlighting its importance in art connoisseurship as well. The change in a viewer's "recognition" of an object as it is redefined from masterpiece to fake helps elucidate the contribution that contextualization makes to *every* experience of viewing. "Contextualization" enters the experience in a wide range of ways, many of them so subtle that viewers hardly notice their presence. In addition to explicit didactic messages in catalogs or museum labels, hints about how to "read" an object are lurking all around it—its ornate gilt frame, its location in a flea market, the presence of crowds pressing eagerly for a view of it, its resemblance to something once owned by the viewer, the knowledge that it was made by a

"tribal" artist, a tag telling its price, or perhaps soft gasps of admiration or disapproval from other viewers. Given Alsop's concession that "what pleases the human eye in works of art is in some degree dependent on cultural formation," it might be prudent to draw a less definitive line than he does between "the pure aesthetic response" and "the historical response." For the distinction between a viewer's reaction to an authentic work and a fake, which he locates in "the historical response," is just one of countless examples of how we see works of art in terms of preformed categories. In addition to recognizing objects as authentic or fake, we recognize them as masterful or ordinary, classic or avant-garde, elitist or popular, rococo or minimalist, and a host of other contrastive possibilities that are not always possible to pigeonhole as belonging to "historical" or "aesthetic" consciousness.

As John Berger (1973) has argued, "what we see and what we know" are not really possible to disentangle. Berger's understanding of this conceptual interference with the visual experience lays stress on the power relations that are tied into it; in his view, "the esoteric approach of a few specialized experts who are the clerks of the nostalgia of a ruling class in decline" (1973: 32) dictates and confines the aesthetic sensitivities of those who might otherwise relate art to their own lives along rather different lines.

But whether we see recognized connoisseurs as gifted leaders or despotic dictators in matters of taste, it seems clear that *both* they and their followers are participating in an experience that is far more complex, in terms of culturally learned cues, than a simple response to visual stimuli. As Franz Boas might have put it, the seeing eye is an organ of tradition.[8]

2

THE UNIVERSALITY PRINCIPLE

It's a human family, and of course there are different colors and differ-
ent ways of dressing and slightly different speech, but you find the
same thing (everywhere), and that is what is so extraordinary. . . . It's
the same thing, dear. . . . There's no difference at all. And that's
what's so comforting. —Millicent Fenwick, former congresswoman,
U.S. ambassador to the UNFAO, and alleged model for Lacey Daven-
port in the Doonesbury cartoons[1]

We begin our foray into ideas about non-Western art by noting an obvious
and striking feature of the late twentieth-century world—the accessibility
of its diverse cultures to those who enjoy membership in Western society.
The speed, availability, and low cost of air travel (whether commercial
charters, private jets, helicopters, or Cessnas) have made the remotest
corners of human civilization available even to casual travelers, and the
distances trekked over the course of many months by pioneering expedi-
tions are now traversed in a few hours of cushioned sitting. Even for those
who don't leave home, the exotic images of world diversity, which had long
been disseminated through the printed page to readers' imaginations, have
come alive with both action and color in movies and television. Thanks to
satellite communication, news of a mudslide in the mountains of Colombia
reaches New Yorkers at about the same time as people in Bogotá are
beginning to hear about it. And the world market system assures us that,
given financial resources, anyone can own anything from anywhere: in
Paris, I can buy fresh mangoes and tropical root crops any day of the week
in local grocery stores; in rural Martinique the biweekly vegetable truck
markets European apples and onions; and for North Americans, deciding
where to eat out has become a matter of choosing among the world's
cuisines.[2]

. . . The world is ours.

From a Western point of view, this planetwide closeness is permeated
with the flavor of Unity, Equality, and Brotherly Love. One of its most

23

successful depictions has been engineered in television commercials for Coca-Cola (a many-shaded sea of faces, all smiling, and united by their human warmth and shared appreciation of the good things in life, including Coke). The musical prize might well be awarded to the 1985 hit, "We Are the World," in which the singers' brotherly smiles, phenotypic diversity, and altruistic record contracts were never allowed to stray very far from the minds of those who were humming along with the melody; indeed, this song of triumph over famine (or at least determined optimism toward this goal) captures much of the essence of the Family of Man ideology, whose Brotherhood represents an idyllic regression to childhood ("We are the world; we are the children . . ."), and much of whose attraction lies in the satisfaction engendered by philanthropic goodwill. If the U.S. version of this ideology has been epitomized in a capitalist promotion of soda pop and the British version in the promotion of good deeds by rock stars, the French version that captured it best was perhaps a charity ad which blanketed Parisian billboards during the spring of 1986, showing a little blond girl planting a benevolent kiss on the head of a little black boy, while his mother, dressed in African robes, stared blankly and passively into space.[3]

The enlistment of the Brotherhood ideology for commercial purposes has been carried on most recently in "The United Colors of Benetton," a

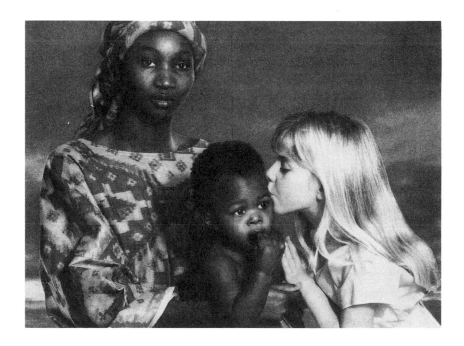

visually enhanced pun between the many-colored Italian clothes being promoted and the many-colored people featured in the ad; here again the fact that the models were children (though the bulk of Benetton clothes seem to be made for adults) is not a random choice. In all of these versions, whether they are aimed at raising money for the starving or for the well-fed, there is a definite suggestion of philanthropy. For, from the privileged perspective of white Europeans and Americans, the mingling of races strongly implies an act of tolerance, kindness, and charity. The "equality" accorded to non-Westerners (and their art), the implication goes, is not a natural reflection of human equivalence, but rather the result of Western benevolence.[4]

This consideration goes far toward making sense of Leonard Bernstein's otherwise rather curious introduction of André Watts to the concert world in 1963. Watts's racial identity, clearly an important factor in Bernstein's proud sense of personal discovery, was never directly mentioned, but once cleansed, elevated, and transformed into a kind of fairy-tale status, it did come through, in a euphemistic comparison of Watts's appearance to that of "a young Persian prince." Converting the potentially offensive notion of a "mixed marriage" into a more neutral comment on Watts's "mixed-up name," Bernstein went on to extol the joys of international brotherhood:

> He is named André Watts, and that mixed-up name comes from having an American father named Watts and a Hungarian mother who met each other in Nuremberg, Germany, where André's father was stationed with the United States Army. I love that kind of story. I like to believe that international marriages produce highly distinguished human beings.

Bernstein's intent was to express support and admiration, but he was playing the role of a white patron for a black performer, and the patronizing undercurrent lasted into the final words of his introduction: "With warmth and *pride*, André Watts."

The debut of Primitive Art in an elite Western cultural institution (whether the Metropolitan Museum of Art, the Museum of Modern Art, or the Musée du Louvre) is customarily heralded with similar expressions of warmth and pride. Here, too, the pride (a sentiment more rarely proposed in discussions of Perugino or Matisse than of Primitive Man) emerges from the same unstated premise that such events come about through an enormously commendable broadmindedness and largesse on the part of the host

culture. Virtually by definition, the European/Euro-American heritage is uniquely equipped, the logic goes, to allow for such enlightened appreciation of cultural diversity. Westerners thus become the ones responsible for issuing invitations to partake of the Brotherhood of Man.

The classic statement of this joyous human unity is Carl Sandburg's prologue to the Museum of Modern Art's 1955 photographic exhibition, *The Family of Man*.

> The first cry of a newborn baby in Chicago or Zamboango, in Amsterdam or Rangoon, has the same pitch and key, each saying, "I am! I have come through! I belong! I am a member of the Family."
>
> . . . People! flung wide and far, born into toil, struggle, blood and dreams, among lovers, eaters, drinkers, workers, loafers, fighters, players, gamblers . . . —one big family hugging close to the ball of Earth for its life and being.
>
> Here or there [in the photographs] you may witness a startling harmony where you say, "This will be haunting me a long time with a loveliness I hope to understand better." . . .
>
> Everywhere the sun, moon and stars, the climates and weathers, have meanings for people. Though meanings vary, we are alike in all countries and tribes in trying to read what sky, land and sea say to us. Alike and ever alike we are on all continents in the need of love, food, clothing, work, speech, worship, sleep, games, dancing, fun. From tropics to arctics humanity lives with these needs so alike, so inexorably alike. [1955: 2]

Since this statement appeared, pan-human Brotherhood has continued to be vigorously championed by Leonard Bernstein, whose exuberance toward his Fellow Man gives special energy to his musical composition and forms a cornerstone of the role he plays in American society. His 1976 book, *The Unanswered Question* (based on the lectures he gave at Harvard's invitation as the Charles Eliot Norton Professor of Poetry), relates music to language and scholarship to feeling, all in pursuit of a goal which he describes as documentation of "the universality principle." Not only because Bernstein at Harvard represents a meeting of undeniable cultural and scholarly distinction, but also because aspects of his vision will reappear in our later consideration of Western attitudes toward Primitive Art, his line of argument merits our critical attention.

Confessing to a long-standing fascination with the idea of a universal grammar in music around the world, Bernstein tells how it all began when,

as an undergraduate, he made the "startling discovery" of the repeated occurrence in unrelated works of a single 4-note sequence.

> At that moment a notion was born in my brain: that there must be some deep, primal reason why these discrete structures of the same four notes should be at the very heart of such disparate musics as those of Bach, Copeland, Stravinsky, and the Uday Shan-kar [sic] Dance Company. [1976: 7]

In 1969, Bernstein's reading of Noam Chomsky's *Language and Mind* breathed new life into this long-dormant dream, which he then developed in the Norton lectures. The first of these explains his reasons for deciding to combine music and linguistics:

> The fact is that music is not only a mysterious and metaphorical art; it is also born of science. It is made of mathematically measurable elements: frequencies, durations, decibels, intervals. And so any explication of music must combine mathematics with aesthetics, just as linguistics combines mathematics with philosophy, or sociology, or whatever. It is precisely for this interdisciplinary reason that I am so attracted by the new linguistics as a fresh approach to music. Why not a study of musico-linguistics, just as there already exists a psycho-linguistics and a socio-linguistics? [1976: 9]

He then proceeds through some anecdotal evidence for the "common origin" of diverse languages (tracing, for example, Spanish *hablar* and Portuguese *falar* to the Latin *fabulare*). This builds up to his endorsement of the theory of monogenesis, which posits that all languages spring from a common source and which allows him, following in Sandburg's footsteps, to trace the unity of the human race to a precultural infant's cry.

> A fine word, monogenesis, and a thrilling idea. It thrills me, anyway, to the point where I stayed up all of one night making monogenetic speculations of my own. I tried to imagine myself a hominid, and tried to feel what a very, very ancient ancestor of mine might have felt, and might have been impelled to express verbally. I scribbled pages full of basic monosyllables which felt somehow right, which seemed to belong together, and which delighted me with their curious logic.
> I began by imagining myself a hominid infant, just lying there, contentedly trying out my new-found voice. Mmmm. . . . Then

I got hungry: MMM! MMM!—calling my mother's attention to my hunger. And as I opened my mouth to receive the nipple—MMM-AA!"—lo, I had invented a primal word: MA, mother. This must be one of the first proto-words ever uttered by man; still to this day most languages have a word for *mother* that employs that root, MA, or some phonetic variant of it. . . .

Well, that was a small triumph.

Then, following a string of hypotheses based on similar kinds of inferred experiences, Bernstein arrives at a theory equating words denoting "small" with those denoting "bad," and words denoting "big" with those denoting "good."

Somehow it all added up. Way back before and behind and beyond all these comparatively recent languages, there must lurk, I fondly hoped, one universal parent tongue, which contained the great simultaneous equation:

$$Big = Good$$

and

$$Small = Bad.$$

Triumph! [1976: 12–14]

In spite of his evocation of Chomsky, Bernstein makes no pretense that his theory would pass scientific muster. The admission of personal excitement (talking about being thrilled and using phrases such as "I fondly hoped") unambiguously removes his proposals to the realm of ideological discourse, and that is exactly what gives them particular interest in the present context. The ideology whose goals they serve is presented in a clear and straightforward manner: "If that [magnificent] goal [of documenting universals in human language] can be attained, and the universality principle proven, it can turn out to be a timely and welcome affirmation of human kinship" (1976: 11).

Bernstein's pursuit of a proof of the "universality principle" is a particularly daring one, since it takes what is least common to people around the world—the elements of specific languages—as its rhetorical point of departure. Its second questionable choice is the assumption that linguistics is a more accessible body of theory than music, since everyone uses language, but not everyone is a musician. "It is in the parallel with language that such difficult analysis as bar-phrasing becomes possible for

laymen to understand. Language is our common property, and therefore our universal area of syntactic reference—for musicians and laymen alike" (1976: 107, his emphasis). As we will see repeatedly in this book, however, ideological commitment can easily override such obstacles, and Bernstein is thus able to punctuate his arguments with the effervescent comment, "Triumph!"[5]

References to visual art as a reflection of the unity of human experience typically partake of the same joyous spirit that bubbles up in Leonard Bernstein when he talks about music. Artistic sensitivity represents a universal of a very different sort from, say, jealousy or ambition; it sits squarely on the admirable side of human nature, and when people write about sharing it with their Fellow Man, it is a generous, affectionate gesture:

> Art in all its forms has been historically the most enduring language for the mingling of souls in common enjoyment, for that is one of its paramount values—a joy to be shared by all who are willing to see and to feel, a great international tongue by which men can speak and be thrilled across the centuries and across the world. [Seligman 1961: 266]

Or again:

> Art is the great unifier, for it is the most obvious outpouring of the linking humanism of feeling between peoples. [Anon. 1970: 2]

This attitude of expansive admiration seems to be coming into ever-greater fashion. As Hilton Kramer remarked, in a review of the newly opened Rockefeller Wing at the Metropolitan Museum of Art,

> the disposition to regard primitive modes of culture and experience as equal in value to our own [referred to elsewhere in the review as "the primitivist ideologies of modern culture"] and in some respects even superior and more vital . . . has ceased to be a possession of a minority of cultural visionaries and achieved a new status as part of the mainstream of cultural life. [1982: 62]

Kramer went on to note the tradition

> of a certain strain in Western thought . . . [to tell us] that ours was a civilization that had reason to envy, and perhaps even to emulate, the

On the universality of
marital problems

emotional intensity and religious awe that we find so unhesitatingly expressed in the rituals and experience of primitive cultures[.]

Our own society, moreover, is still aswarm with therapies and cults promising to restore this primitive intensity and sense of wholeness to the emotional casualties of a civilization that can no longer count on the intellectual and moral loyalty of its most privileged members. In a world in which the primitive is looked upon as a sort of aristocrat of feeling and spirit—as being on easier and more exalted terms with instinct and appetite and even perhaps with God than any we could hope to achieve under the constraints of modern life—is it any wonder that primitive art should be elevated to a new cultural status? At times it seems as if the whole history of modernist culture, with its celebration of the irrational and the apocalyptic, has been an elaborate and protracted preparation for this grand apotheosis. [1982: 62]

At the same time, art can also be seen as addressing itself to the common problems and hardships known to people around the world. A *New York Times* interview with Susan Vogel (on the occasion of the opening of the Center for African Art in New York, of which she is the director) argued this point:

"[The pieces] deal," she said, "with life and death, birth, survival, the life after death, power." Despite the fact that most visitors to the museum will not know much about where the pieces come from, the sculptures are still able to have an effect, she added.

"Whether you live in Manhattan," Mrs. Vogel said, "and are hassled by the

giant corporation you work for, or you live in Mali and worry about insects and the drought killing your crops, the gut issues are the same: wealth and health and survival. These objects speak directly about such things." [McGill 1984b]

Regardless of who spoke these words (for this citation represents journalistic coverage, and its authorship may therefore hover somewhere between Vogel and her interviewer), they express a notion that one often hears stated almost as a matter of common sense. What this notion does not recognize, however, is that when a commentator talks about "gut issues," she or he is presuming to identify those things that particular people choose to care about above all others; for such an undertaking, it might be worth at least entertaining the idea that not everybody makes the same selection. It seems possible, for example, that many farmers in Mali would, upon acquaintance with the lifestyle of Manhattan corporation executives, contest (or else find somewhat platitudinous) the assertion that their respective lives center on the same kinds of struggles. It might be that lumping together the concerns of these two groups about "wealth" and "survival" is stretching those particular categories a bit beyond their admittedly elastic potential. Certainly, one of the questions that will arise frequently in this book is the degree to which we can see all art as being about the same "gut issues," and to what degree the artistry of different peoples reflects the very special manner in which each one views the world and its place in it.

Edmund Carpenter has commented on this same issue in the context of Eskimo art, pointing out the arrogance of claims that the art of Primitives is more "direct" and "elemental" than our own.

Henry Moore [is said to have claimed that primitive art] "makes a straightforward statement, its primary concern is with the elemental, and its simplicity comes from direct and strong feelings . . . the most striking quality common to all primitive art is its intense vitality. It is something made by people with a direct and immediate response to life."

Such statements are wrong. No matter how naked a people, no matter how tormented their situation, no one lives an "elemental," "simple," "direct," "immediate" life. People everywhere are pattern-makers and pattern-perceivers; they live in symbolic worlds of their own creation. [1983]

Or, as Raymond Firth had pointed out a half century earlier, in a discussion of the Surrealists' interest in Primitive Art,

The Freudian dogma of equating the savage with the child is taken as sufficient, the primitive is alleged to be free from the shackles which hamper civilised man, and to be capable of expressing directly in his art his instinctive impulses. The issue is not so simple. [1936/1979: 30][6]

The proposition that art is a "universal language" expressing the common joys and concerns of all humanity is based firmly on the notion that artistic creativity originates deep within the psyche of the artist. Response to works of art then becomes a matter of viewers tapping into the psychological realities that they, as fellow human beings, share with the artist. Lewis Mumford expressed this general point of view when he asked rhetorically: "if what we read into a Rorschach ink blot reveals our innermost nature, what do we not find and disclose about ourselves in the complex and deliberately evocative symbols of art?" (1979: 215).

A widely accepted belief within this general scheme is that, more than any art from the world's Great Civilizations (whether Western or Oriental), Primitive Art emerges directly and spontaneously from psychological drives. Just as children cry when they are hungry and coo when they are content, Primitive artists are imagined to express their feelings free from the intrusive overlay of learned behavior and conscious constraints that mold the work of the Civilized artist. And it is this quality that is most often cited as the catalyst for understanding between Westerners and Primitive artists. In Paul Wingert's 1962 book, *Primitive Art,* the decision to designate the peoples whose work he discusses by the term "primitive" instead of its possible alternates ("tribal" and "nonliterate") was based on this point of view:

this is not because they represent the fumbling, early beginnings of civilization; rather, it is because these cultures show developments more closely allied to the fundamental, basic, and essential drives of life that have not been buried under a multitude of parasitical, non-essential desires. [1962: 7]

Western enthusiasts of Primitive Art have always argued that its authors are in particularly close touch with the "fundamental, basic, and essential drives of life"—drives that Civilized Man shares but "buries" under a layer of learned behavior. The view of Primitive Art as a kind of creative expression that flows unchecked from the artist's unconscious is responsible for comparisons between Primitive Art and the drawings of children, and its racist foundation is rather transparent. In a discussion of

the attitudes of New York Dada artists toward Primitive Art, Judith Zilczer has noted: "For artists and critics who found merit in the naïveté of children's art, the African Negro represented the cultural childhood of mankind. Beneath their discussions about modern art and primitive art flowed an undercurrent of pseudo-scientific theories about race and culture" (1977: 141). Zilczer points to Leo Stein's argument that "the 'burden of sophistication'" weighing on modern artists "had necessitated their enthusiasm 'for every primitive period of art in which they could regain a sense of seeing with the uneducated gaze of the savage and the childlike eye'" (1977: 140). And for Marius de Zayas (who wrote a book in 1916 entitled *African Negro Art*), "while the vital and abstract qualities of children's or African art derived from unconscious expression, these effects in modern art must be achieved by conscious effort" (Zilczer 1977: 141).

These ideas, which originally represented a coherent if slightly misdirected intellectual theory (proposed by nineteenth-century anthropologists and then adopted in the early twentieth century by Western artists and critics), have over time become routinely accepted as a natural part of popular "common sense," voiced by people at all levels of cultural sophistication. A few years ago, for example, the Museum of Modern Art's public relations director analyzed the popular appeal of the Melanesian figure at the entrance of the 1984 "Primitivism" exhibit in terms of this variable, remarking that "In the environment of stark high tech and skyscrapers, he reminds us of very deep, intuitive feelings" (McGill 1984a).

In a poetic mood, even the best-informed and most empathetic of commentators can be seduced by the image of Primitive artists as purified bearers of the human unconscious, as survivors of our lost innocence: "They are what remains of the childhood of humanity. They are plunges into the depths of our unconscious. However great the artist of today or tomorrow, he will never be as innocent as the primitive artist—strangely involved and detached at the same time" (de Menil 1962). And Ladislas Segy, author of a large number of books on African art, declared in one of them that his goal was

> to show parallels between what the African projects freely in his art
> and what is buried in our own psychological roots. These parallels
> make possible our emotional identification with the content of African
> art. Such identification should then lead to a certain self-recognition,
> to personal rediscovery and renewed contact with our deeper instincts,
> now overlaid by "civilized" manners and conventions. By learning to
> understand the African sculptor's motivations and his relationship to

his art, we can increase our understanding of ourselves and of our
relationship to art. [1975: 4]

One rarely mentioned feature of this point of view is its one-
directionality. *We* partake of an identification with African art; this allows
our self-recognition and personal rediscovery and permits a renewed contact
with *our* deeper instincts; the result is that *we* increase *our* understanding of
ourselves and *our* relationship to art.[7] Admittedly, the authors of such state-
ments are writing for Western audiences, not African artists. But there is
also an implicit asymmetry which goes deeper than considerations of read-
ership. Because of the assignment of conscious aesthetic understanding to
Western minds, and unconscious primal drives to Primitive artists, com-
mentators eliminate the need to consider the potential reaction of the latter
to works of art from outside their own cultural universe. Western Man, who
is in full possession of conscious, analytical thought processes, can view the
creative output of His less civilized brothers and gain understanding. But it
is not generally thought that the complementary process would yield
worthwhile insights. Despite all the field studies in which natives of one
tribe or another have been presented with artistic specimens from their own
culture area to rank and comment upon, few researchers have pursued the
reactions of these same informants to reproductions of Gauguin's *Yellow
Christ* or the Sistine Chapel frescoes.

Is this because the "civilized overlay" in these works is thought to
have obscured their basic aesthetic genius beyond recognition except by
those who have been schooled to see it? Or is it because Primitives are seen as
being unable to deal conceptually with aesthetics, beyond the passive and
unthinking acceptance of forms and techniques that took shape—no one
quite knows how—in the mythical past of their people? These questions
could appear at first glance to be naïve and silly, or perhaps even conten-
tious, but an examination of their implications may be able to elucidate in a
constructive way some logical fallacies in the distinctive images that are
commonly drawn between Civilized and Primitive art.

Dealing with these questions requires consideration of the notion,
raised earlier in our discussion of connoisseurship, that aesthetic response
rests on innate feeling, rather than learned appreciation. If we were to
accept that notion as a working hypothesis, and if we were to agree as well
that all cultures allow for aesthetic response (which particular individuals in
each society develop to varying degrees), that Primitive Man is in particu-
larly close touch with His innate feelings, and that the Mona Lisa (for
example) is truly a great work of art . . . then might not the response of a

34

sensitive Inuit or Nambikuara or Ibo to such a painting be of interest? Is it
conceivable that these three representatives of Primitive Society (or any
other similarly constituted panel of judges) would single out for special
admiration those works of art that are accorded "masterpiece" status by a
consensus of Western opinion?

I would argue that subscribers to the universality of aesthetic response
have saddled their theory with an implicit and potentially disquieting *standand.*
corollary. It goes something like this: While Primitive societies, (like Ours,)
can nurture the production of certifiable artistic Masterpieces, and while
the sheer aesthetic power of Primitive Masterpieces penetrates linguistic
and cultural boundaries to reach sensitive art lovers in the West, the mem-
bers of these societies (including the most artistically endowed among
them) are themselves handicapped (whether by education or genetic heri-
tage is not specified) to participate in supracultural aesthetic experiences. It
is rare for this qualification to trip up the smooth functioning of univer-
sality-of-aesthetics discourse, but once in a long while it does set off an
alarm. A (generally enthusiastic) commentator on the Center for African
Art's exhibit catalog entitled *Perspectives: Angles on African Art* (1987) con-
fessed to being "disturbed" and "confused" by one of its angles (Silverman
1987: 24). As his review points out, the idea behind the exhibit was
intriguing: to elicit the artistic selections of ten diverse individuals—
archaeologist Ekpo Eyo, collector David Rockefeller, modern art historian
William Rubin, writer James Baldwin, and six others—and present their
commentary on the choices they had made. The point at which Susan
Vogel, originator of the idea, in effect allowed her slip to show was,
Silverman points out, in her treatment of the Baule sculptor, Kouakou
Kouame. First, despite the project's explicit focus on *individual* perceptions
and preferences in African art, this contributor's commentary—and only
his—was "amplified" with material from other Baule artists, and the
portion of the book devoted to his choices appears under the name and por-
trait of one of these others (whose perceptions, we are forced to surmise,
were considered roughly representative of—perhaps even interchangeable
with—his). In addition, Silverman goes on to note, Kouame is treated as if
he were "lacking the wherewithal to appreciate the art of any African
culture other than his own."

> In discussing the procedure followed in selecting the group of objects
> from which the co-curators would choose, Vogel says, "In the case of
> the Baule artist, a man familiar only with the art of his own people,
> only Baule objects were placed in the pool of photographs" (p. 11).

Why is he any less qualified to comment on a Luba sculpture than David Rockefeller or James Baldwin? The familiarity argument does not hold up, for one can be sure that many of the objects studied by the nine other people were as unfamiliar to them as they would have been to Kouame. In making the decision to show him only Baule art Vogel has contradicted herself, for she strongly argues that "part of the very definition of art is the object's ability to transcend its own cultural moment, to speak to us across time and space" (p. 17). Surely Kouame, as an artist, can appreciate the aesthetic merits of art from other cultures. Vogel has used a double standard here that does not make sense. [1987: 24]

3

THE NIGHT SIDE OF MAN

Bonet plays Epiphany Proudfoot, a voodoo priestess who performs an uninhibited tribal dance in which she smears the blood of a chicken over her face, and later thrashes around with co-star Mickey Rourke in a nightmarish love scene as blood streams from the ceiling. —*Washington Post* description of *Angel Heart,* starring Lisa Bonet, formerly of *The Cosby Show* [1]

The tenet that Leonard Bernstein referred to as the "universality principle" reflects a joyous faith in "human kinship," a celebration of the commonality that joins the world's peoples in brotherhood. Those who speak of art around the world in this mode are choosing to focus attention on the role of beauty in art and harmony in human relations. Like many kinds of ideological currency, however, this is a coin with two sides.

The Family of Man encompasses not only brotherhood but also sibling rivalry, and the recognition of shared concerns or pleasures coexists and competes with an insistence on those essential features that separate the Civilized and Primitive branches of the genealogy. The Noble Savage and the Pagan Cannibal are in effect a single figure, described by a distant Westerner in two different frames of mind; portrayals of Primitive Man can be tilted either way in their recognition that he is at once a "brother" and an *Love* . "other." The imagery used to convey Primitive Artists' otherness employs a standard rhetoric of fear, darkness, pagan spirits, and eroticism. As André Malraux once remarked, the study of Primitive Art is an exploration of "the night side of man" (quoted in Newton 1978: xx).

Jean-Louis Paudrat, among others, has acknowledged the duality of the European fascination with Primitive Art in his historical research on early reactions to the arts of Africa:

> The missionaries, about whom Voltaire humorously remarked, "every statue is a devil for them, every assembly a sabbat, every symbolic figure a talisman, every brahman a sorcerer," went out to exorcise the "demons" and to destroy their "fétiçaoes," their "charms." Thus, his superstitions place the Negro at the very origins of the history

of mankind, immediately after the Fall. His being in league with the Evil One even colours the terminology used. Nevertheless, as survivors of the earliest chapter in the history of the world, they are a living witness to the fantastic, the irrational and the imaginary in primeval man. This mixture of repulsion and attraction for the abscure [sic] and aboriginal is at the root not only of a lasting incomprehension of the sculptural creations of Africa but also of a long neglect in describing objectively the societies themselves and their organization. [1972: 252]

The tradition of envisioning the life of Primitives in terms of diabolical rites and superstitions did not die with Voltaire or the early missionaries, nor has it been significantly eroded, at the level of "received wisdom," by the ethnographic record that has been amassed over the intervening centuries. On the contrary, one finds its legacy, alive and well, permeating every corner of our late twentieth-century common sense, and promoting images of fear and darkness, often with side journeys into unharnessed eroticism and cannibalistic feasts. The contrasts it proposes—sometimes explicitly, sometimes implicitly—are between darkness and enlightenment, depths and heights, fear (superstition) and tranquility (knowledge), and primal urges and civilized behavior (especially in the realm of sexuality). As a link between cultures (Ours and Theirs), art may be viewed as the reassuring unifier, the "mingling of souls in common enjoyment," but in its own setting it becomes the dark expression of irrational terrors.

In some cases, depictions of Primitive Art that stress its "fear-inspired" and "ignorant" origins have amounted to a near total dismissal of the legitimacy of the intellectual climate from which it springs. Referring to both early humans and contemporary "primitives," Erwin O. Christensen asserts that

> what may appear to us as the limitations of primitive art . . . can be considered the by-products of man's slowly evolving intellectual powers. With little knowledge and few facts to reason with, primitive man's endeavor to explain the universe was largely swayed by his emotions. What beliefs he developed served to assuage his fears and thereby to contribute to his sense of security. Frequently the personified forces of nature were induced to serve his needs. In primitive cultures ritual was as important as belief, and art occupied a prominent place in ritual. Often, therefore, it is not art that is limited, but the underlying belief for which it serves as a vehicle. Although primitive art is admired today and is readily adapted by modern artists, we

have no comparable admiration for magic, known to us as superstition, that once impelled the primitive artist. [1955: 7–8]

Paul Wingert's *Primitive Art* (1962), which Simon Ottenberg has credited with inspiring much of the current interest in the subject among art historians (1984: 599), notes the existence of "numerous societies, practices, and ceremonies centered around strong traditions, often of a distasteful or even injurious nature to nonparticipants" (1962: 28). Focusing on the "injurious nature" of such art was far from a novel position. In a discussion of the contribution of Primitive Art to Surrealist art and philosophy of the 1920s and 1930s, Rosalind Krauss notes that Georges Bataille's interpretation of pre-Columbian art (developed in response to G. H. Luquet's "benign" view that the art of both children and primitives is motivated by "the pleasure principle") had stressed its destructive, and ultimately sadistic, intent:

> Doubtless, a bloodier eccentricity was never conceived by human madness: crimes continually committed in broad sunlight for the sole satisfaction of god-ridden nightmares, of terrifying ghosts! The priests' cannibalistic repasts, the ceremonies with cadavers and rivers of blood—more than one historical happening evokes the stunning debaucheries described by the illustrious Marquis de Sade. [Bataille, quoted in Krauss 1984: 510]

It is not rare for the very materials used to fashion Primitive Art to be regarded as somehow repugnant to the sensibilities of Civilized viewers. Wingert's book describes how "sculptured objects, including figures and masks, were often used in magical practices, together with a number of other, sometimes unpleasant materials, including grasses, blood, animal skins, and viscera" (1962: 24). This concern is shared by many art lovers. Katherine Coryton White wrote of "hair, beads, gum, bone, the crust of dusty air. It's like a poisonous mane, festering" (quoted in Richard 1984b: K2). Douglas C. McGill's attempt to account for the "sudden fascination with primitive art" in the United States during the fall of 1984 speculated that the exotic appeal of "sunken-eyed devils, sharp-toothed ancestors, [and] grimacing gods" was largely responsible (1984a). Many reviews of the Museum of Modern Art's "Primitivism" exhibit noted this aspect of its "primitive" pieces; Michael Brenson, for example, focused attention on a figure from the Austral Islands "with all the creepy-crawly

progeny figures doubling as facial features and clinging to the god's body like leeches [which] seems to turn the heart of the installation into the pocket of a swamp" (1984) and John Russell commented that "such a superabundance of hair and such chain-saw teeth have rarely come our way" (1984). I recently spoke with two serious collectors of modern painting who have tried to develop a taste for Primitive Art because their child has become professionally involved in the field. Ultimately, they told me, they have not been successful; the objects always strike them as "dirty," and they are covered with messy materials like monkey hair and leopard skin, making unattractive "beards" and "mustaches." Despite their best efforts to banish it, they said, a feeling of "uncleanliness" persistently interferes with their aesthetic enjoyment of Primitive Art. And the next generation of museum-goers may well cultivate similar reactions; a 1986 children's book about visiting the art museum devotes its pages on the Primitive Gallery to an exchange in which a little blond girl remarks, looking at an Asmat costume from New Guinea, "This is scary. Is it for Halloween?" to which her older brother replies, "It's just some straw and feathers and other junk. What's so scary?" (Brown and Brown 1986: 6).

At the same time, most contemporary analyses set the "dark" side of the image of Primitive Art within the context of the commentator's admiration for the accomplishments of Primitive Man; the stated intention is not to denigrate, but rather to contribute to greater appreciation.

Lewis Mumford, for example, in the course of applauding "a new respect for primitive races and cultures that came in with the twentieth century," justified this changing climate of appreciation in terms of "the primitive African['s]" success in expressing "certain primal feelings evoked by fear and death" (1979: 234).

And Kenneth Clark opened his immensely popular book *Civilisation: A Personal View* (1969; originally a television series of the same name) with an explanation of the difference between Civilized and Primitive arts along similar lines. Juxtaposing a classical sculpture of Apollo and an African mask, Clark explained that both objects

> represent spirits, messengers from another world—that is to say, from a world of our own imagining. To the Negro imagination it is a world of fear and darkness, ready to inflict horrible punishment for the smallest infringement of a taboo. To the Hellenistic imagination it is a world of light and confidence, in which the gods are like ourselves, only more beautiful, and descend to earth in order to teach men reason and the laws of harmony. [1969: 2]

Or again: the sculptor Jacob Epstein, referring to an African work known in the Western world as "the Brummer Head," remarked that "it is an evocation of a spirit that penetrates into another world, a world of ghosts and occult forces" (1963: 189).

Similarly, Werner Muensterberger chastized the belatedness of the West's recognition and appreciation of Tribal Art through melodramatic images of a descent "to the depth of [our] primal urges": "Why did we have to wait until our own time before man would dare descend to the depth of his own primal urges only to demonstrate the dynamic causations of our basic instincts regardless of race or origin?" (1979: 12).

An ambitious volume entitled *Art and Civilization* (Myers 1967) also lends authority to the image of fear-inspired Primitive artists. Beginning his discussion of "Modern Primitives" with an assertion that "the West African Negro . . . does not make our distinction between reality and unreality," the author proceeds to speculate on the degree of fear that African masks must evoke in those who wear them. "Emotionally the African sculptor is animated by fear of the mysterious elements about him: fear of the dead . . . ; fear of jungle beasts; fear of his fellow man; fear of the forces of nature." Again and again, this brief sketch of the arts of Africa cites "the fear-laden emotions of the creators and users of these objects" and reiterates the view that they are "so much dominated by intense emotionality and fear." Going on to Oceania, the writer finds much the same motivation for the art of the Maori: "the conventionalized human and

41

animal heads show overtones of fear as plainly as do the arts of Africa." And continuing his world tour, he states that artistic representations found among the Eskimo and Northwest Coast Indians "are abstract and fear-inspiring in the African and Oceanic sense." Remarking that such artistic expression tends to be produced within the context of "secret societies," he writes that "we can only guess" at the level of fear involved. But guess he does, without hesitation, calling on his own personal response to such features as "angularity," "jerkiness of application," "violent reduction of the human face to a series of elongated ellipses," "demonic figures," and "menacing teeth" to represent to his fellow Westerners the rather confused and timorous world view that must, he surmises, lie in the dark and mysterious head of the Primitive Artist. (All quotes are taken from Myers 1967: 13–17.)

More recently, William Rubin slipped the image of primal fear into his otherwise celebratory depiction of the arts of Primitive peoples when he presented a comparison of two visually similar branch sculptures—one created by Alexander Calder (right) and the other by an unidentified artist from Papua New Guinea (left; 1984: 58–59). Viewing them as a pair, Rubin read the elongated free-forms of one as communicating "whimsy" and those of the other as conveying "malevolence." This interpretive distinction was based, not on differing artistic treatment and not on documentation of the respective objects, but simply on the generalized (but explicitly articulated) notion that Primitive peoples live in fear of "monsters" while Calder and his public no longer do.[2] The assumption that

Primitives are so fear-ridden that they cannot engage in "whimsical" artistic creativity has the effect of diminishing the complex humanity of these artists who (as far as I can tell from having known at least a few such people firsthand) are absolutely as disposed as Calder to the full range of thoughts and emotions that bring out the lighter side of the human comedy.[3] To cite just one supporting example, R. F. Thompson discusses a mask whose grotesque features (especially a lipless mouth that is essentially a "gash framing warty teeth") tend to suggest "cosmic anguish or terror" to Western viewers, but mockery and derision to the Nigerians among whom it was collected; in its original setting, "the mask is said to poke fun at the pompous and the vain, mirroring a lack of propriety with a considered indecorousness of expression" (1968: 65).

Somewhat ironically, the book in which Rubin presented the Calder–New Guinea comparison was faulted by one reviewer precisely for its failure to recognize sufficiently the "fear and darkness" within which Primitive Art is created and used, and his criticism provides an even stronger example of the same image:

> in their native contexts these objects were invested with feelings of awe and dread, not of aesthetic ennoblement. They were seen usually in motion, at night, in closed dark spaces, by flickering torchlight. Their viewers were under the influence of ritual, communal identification feelings, and often alcohol or drugs. Above all, they were activated by the presence within or among the objects themselves of the shaman, acting out the usually terrifying power represented by the mask or icon. What was at stake for the viewer was not esthetic appreciation but loss of self in identification with and support of the shamanic performance. [McEvilley 1984: 59]

Paudrat has summed up—with considerable sensitivity in my view—the image of Primitive Art that focuses on its perceived monstrosity, coarseness, and involvement with witchcraft, highlighting the Western propensity to set it off, as Kenneth Clark did, from our own heritage of enlightenment.

> These writings inform us, for instance, that "primitive" art contravenes, among other things, the Greco-Roman ideal of the representation of the good and the true. Is not the "monstruousness" of these zoomorphic figures with their lack of conventional proportions opposed to the "verisimilitude of the delusion" which "civilized" art

43

seeks? Is not artistic expression in sculpture precisely the sign of primitiveness? Are not the anonymity of the works and their utilitarian character contrary to the strongly individualistic and disinterested creativity of the inspired artistic genius? Can the materials of this art and its rudimentary and archaic technology pander to the taste for what is perfect, brilliant, agreeable? Do not the immodest exaltation of sexuality and the coarseness of the sentiments expressed shock the moral sensibilities of the refined man? And, to crown all, can one talk of art at all when one knows that these figurines stained with the blood of innocent victims are employed in the rites of fetishism and witchcraft? [1972: 253]

Views of Primitive Art that stress nocturnal darkness and fear of monsters often claim, in a related vein, that it expresses a deep obsession with death. Mumford's identification of Primitive Art with "fear and death" was a fairly straightforward example, but other commentators have gone to greater lengths to offer interpretive explanations. One study of "the roots of primitive art" shows what happens to this aspect of the vision in the hands of a psychoanalytically inclined observer. Citing a "connection between the creative activity of primitives and . . . killing" and "the affinity between aggression and artistic activity" in various "primitive" societies, the author asserts that in some the "possession of an ancestral corpse or skull or its substitute seems . . . to be a prerequisite for making an image . . . [while] we observe among other peoples murder or a death wish as a condition for the realization of creative activity" (Muensterberger 1971a: 117–18). The conclusion of this essay reiterates "the widespread connection between death (often actual murder) and the making of an image . . . among these people" (1971a: 126, 125) and goes on to interpret it in terms of oedipal complexes. Citing Australian materials, the author argues that

the men who retreat into the "womb" make use of their pregenital defenses and "steal" the phallic mother's paraphernalia. Under the threat of being overpowered by their oedipal desires, the artists temporarily abandon reality. This can be interpreted as a regressive step toward an early phase in which the attachment to the nursing mother was the source for hallucinatory fantasies and creative imagination. Stealing her paraphernalia would then mean stealing the penis which was originally in her. The creative act would be a form of aggression against the phallic mother, so that the later act of killing could be interpreted as an oedipal repetition of preoedipal impulses. [1971a: 128]

Thus, the Primitive nursing infant, whose exuberance played such a central role in Leonard Bernstein's elaboration of the "universality principle," becomes, in Muensterberger's scenario, obsessed with murderous designs against his phallic mother.

Sexuality is clearly another important aspect of the image of Primitives as "the night side of man." Mumford accounted for the interest of African art partly by the idea that the people who created it "knew a great deal of essential lore about the erotic life, which the 'civilised' white had emptied out of himself" (1979: 234). And even today, the identification of unleashed sexuality as "primitive" permeates the "civilized" world:

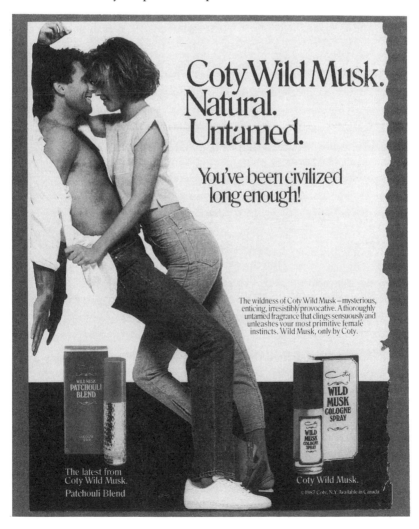

Jacques Maquet provides an illustration of the Western emphasis on nudity and sexuality in Primitive Art when he comments that African ancestral figurines "were usually represented in the nude, and their sexual organs were openly displayed. This is rather surprising as adult nudity was practically unknown in traditional Africa" (1986: 236). If one were to consider the infrequency of adult nudity in the Western world, and then flip through the illustrations in any history of Western art (perhaps starting with Giorgione and Titian, passing on to Courbet, Ingres, Manet, and Renoir, and finally eyeing a few Picassos), African statuary might well lose a bit of its novelty as an erotic medium. Something other than the art itself must be inspiring the kind of reaction that Maquet expressed.

I would argue that the place that Western observers assign to sexuality in the arts of Primitive peoples arises less from the objects themselves than from a logical juxtaposition of several associations that are deeply embedded in Western thinking.

The first is that artists in Western society tend to be linked in the public's consciousness with a life-style that is relatively free of bourgeois constraints—from monogamy and regular meals to sleeping patterns and verbal politesse. Nonconformity is allowed for artists much more than for bankers or dentists or librarians because it is seen as an integral part of the creative process; and creativity, in the sense of rupture with tradition, is what Western art is alleged to be all about.

Second, Primitives are also seen, from a Western perspective, as nonconformists: they have been known to share their spouses, to expose their breasts, to decorate their genital areas with gourds and feathers, to cut gashes in various parts of their bodies, to worship snakes, to eat human flesh, to allow pagan gods temporary control of their minds, and to dance gaily at funerals. At some gut level of the Western imagination, they appear to be "free" from socially imposed rules. In the context of the evolutionary associations we have already touched on, their life "predates" the constraints under which we live; in a less time-oriented vision, it is simply "outside."

Third, art in Primitive societies has generally been thought to represent communal ideas conveyed through communally developed modes of expression. This belief forms a cornerstone of the wall that marks the boundary between Western and Primitive art and will be discussed in detail in a later chapter. For present purposes, its importance is that it implicates the community as a whole, rather than selected individuals, in the process of artistic expression.

Together, these associations are capable of casting Primitive societies into the mold of an artistic counterculture or bohemian community in the Western sense. It is not difficult to arrive at the conclusion, then, that the artistic expression of Primitive societies is erotically focused, since sexuality is the vehicle par excellence for the expression of deviance from mainstream cultural norms, and Primitives are, from a Western perspective, culturally deviant.[4] One result is the tendency to see in every breast an obsession with fertility and in every penis a fixation on eroticism (see, for just one recent example, Rubin 1984: 36). Similarly, abstract lozenges are, in the absence of strong evidence to the contrary (and sometimes even in its presence), frequently read as vaginas. Edmund Leach's highly "hypothetical" interpretation of a Trobriand shield (1971, his characterization) as depicting the folded-over figure of a naked flying witch (with design elements representing breasts, anus, pubic hair, clitoris, malevolent "testicles," and so on) is one of the cleverer and more innovative examples of this genre, but less-inspired versions are scattered throughout the literature on Primitive Art. Some of my own field research has focused on calabash carvings whose appendaged tree-form designs are understood by almost everyone except the artists themselves as explicit depictions of coitus. It is also clear that sexual attributes affect an object's chances of being both collected and appreciated in Western circles. One Primitive Art dealer with whom I spoke in Paris volunteered that "Objects that are strongly sexed sell well." Another told me about a woman whose decision to buy a piece of sculpture was generally preceded by the ecstatic remark, "Oh! How wonderfully *phallic!*" And Edmund Carpenter has noted, speaking of tourists' reactions to Maprik carvings from New Guinea, that "figures with erect penises are especially popular" (1973: 6).[5]

Ideas about Primitive eroticism are complemented by undercurrents of popular evolutionism in the depiction of non-Western peoples as uncivilized savages. We saw in the last chapter how the tendency to confuse ontogeny and phylogeny (i.e., to transfer understandings about the psychosocial development of individuals to the evolutionary development of the human species) influences idyllic views of the Other as "brothers." That same tendency also plays a role in depicting "the night side of man." In both cases, the vocabulary of European languages, shaped in the context of early understandings about race and evolution, contributes to the ease of wandering inadvertently from one context to the other.[6] The peculiarly elastic (multireferential) applicability of the term "primitive" is especially crucial in this context, encouraging the conceptual association of "primi-

tive instincts" in children, in stone-age humans, in the mentally ill or emotionally disturbed, and in contemporary peoples who have not been "civilized" in the specifically Western sense of the term. A 1985 journalistic report on madness and artistic creativity may help to illustrate the point:

> Dr. Barry M. Panter, an associate professor of psychiatry at the University of Southern California and the director of an annual conference on "Creativity and Madness," cites a . . . chemistry between emotion and creativity. "The material artists use for their art," Panter said, "comes from the primitive levels of their inner lives—aggression, sexual fantasy, polymorphous sexuality. What we know about the development of personality is that we all go through these stages and have these primitive drives within us. As we mature and are 'civilized,' we suppress them. But the artist stays in touch with and struggles to understand them. And to remain so in touch with that primitive self is to be on the fine line between sanity and madness." [Freedman 1985: 11]

The article then quotes a playwright as saying that a particular play, written after he had given up alcohol, "was hard for me because I didn't have that moment of madness at night. . . . I had to ask myself, could I still get into my dark side?" (1985: 11).

This passage evokes a popular conceptual opposition that feeds directly into the received wisdom about Primitive Art. On the one hand, it cites the "primitive drives" that represent "the dark side" of human nature—aggression, sexual fantasy, polymorphous sexuality, and so forth. On the other, it alludes to the complementary image of civilized behavior, locating it in the suppression of these "primitive drives" and identifying it with the gradual process of personal maturation. With two very different processes—maturation and civilization—dependent on a common vocabulary, there is virtually no allowance for the existence of (emotionally balanced) adults who do not belong to the "civilized" world. Primitives then come to represent not only the childhood of human evolution, but also the children of the twentieth-century world.

In the course of embedding themselves in our most "commonsensical" understandings about progress and civilization, the popular associations that cluster around the term "primitive" take on a life of their own. As a tightly integrated package of characteristics, they may even be called

THE NEW YORK TIMES, SUNDAY, DECEMBER 23, 1984

Dance

"The 'Christmas Revels' from Boston provided some of the most interesting dancing seen all year."

DANCE VIEW
ANNA KISSELGOFF

Pagan Rituals Live On in British Folk Dance

into service to conceptualize phenomena that have nothing to do with people whose lives are exotic by standard ethnographic measures such as dress, rituals, kinship, or technology. These metaphorical extensions of the imagery of primitivism are particularly revealing, since they are so isolated from the realities on which they are, in some sense, based.

As illustrations, I offer two descriptions, one journalistic and one cinemagraphic, which apply the standard vocabulary of primitivism and savagery to twentieth-century European dance.

The first is a review that appeared in the *New York Times* (Kisselgoff 1984). After dismissing in a single sentence the "civilized" portion of the program in question ("True, its singers engage the audience in many a medieval or Renaissance carol from the British Isles"), the reviewer turns her attention to the way in which the performance "digs even deeper in time" and she proceeds with an ecstatic account of the "ancient British pagan rituals that have been preserved in dance form." Without the accompanying photo of a young woman wearing what appears to be a long-sleeved lace blouse, an embroidered velveteen jacket, a pleated plaid kilt, argyle socks, and ballet slippers, the text might well have conjured up images of primeval cave dwellers wearing animal skins and wielding clubs. One of the dances was "beautiful and occult [and] had an extra mystery about it," while another

> looked barbaric in its symbolic significance . . . [some] older pre-Christian sword dances associated with fertility rituals [utilized] primitive hilt-and-point swords. [Another had] dark ritualistic undertones. . . . Among the dancers . . . were the traditional fertility figures [and] a young boy . . . who was related to the identification of the dance as "an ancient ritual dance for good luck in hunting the stag." . . . The entire image of the dance, performed in near darkness, was magical.

The opening paragraph of the review alludes to these performances as "carefully researched festivities," but in the continuation, on an inside page of the section, more cautious expressions are introduced: a dancer with a dagger "puts it on the ground *as if* to worship it" and "*Presumably,* in ancient days, the divine king was sacrificed so that the crops would grow." Readers are thus not totally unprepared for the admission, toward the end of the review, that "there is more legend than fact about the origin of most of these dances"; and by that point the question of whether or not they were actually a Celtic tradition no longer matters, for the images of barbaric fertility rites and magic-filled darkness have already taken hold.

It is not possible, viewing the performance only through the journalistic prose, to evaluate how much of this rhetoric was inspired by the dance troupe and how much by the reviewer. In either case, there is little doubt that the final presentation qualifies for inclusion in the now-amply documented phenomenon known as "the invention of tradition" (Hobsbawm and Ranger 1983). That its subject is a dance program from the British Isles merely heightens its relevance for an understanding of the Western image of Primitive Art, for it demonstrates the cohesiveness of that image's diverse elements (darkness, magic, paganism, fertility rites, human sacrifice, and unchanging tradition) regardless of the culture in question. Once readers have been tipped off that the performance "looked barbaric," they could almost write the rest of the review themselves; its essential message represents a ready-made package well known to anyone who has been educated in the Civilized world.

In our second dance example, we are once again dealing with both a performance and an audience's reaction to it, this time as seen through the creative imagination of Federico Fellini, in his film, *E la nave va* [And the ship sails on].

The year is 1914. A luxury liner is taking the cream of the Italian opera world on a funeral cruise to spread the ashes of one of its most beloved divas, Edmea Tetua, over the sea near the island of her birth. Several days out, a large group of half-starved, dirty Serbian refugees is rescued and allowed to camp out on the open deck. One night, the Serbs' singing and dancing attracts the attention of the opera crowd, whose reactions are manifestly ambivalent.

One person characterizes them as "riffraff." Another excitedly points out their "savage eyes." A third exclaims, "How expressive! Understanding the words isn't necessary!" Someone comments that they are "like monkeys." And the dancing masters are urged, "You're better than they;

teach them to dance." After watching, fascinated, from a distance, the spectators boldly descend to the deck—some to join in the dance and others to explain to the Serbs that what they are performing is an ancient pagan ritual, a celebration of the fertility of the earth in honor of "the spirits that govern the growth of the seeds," in which the women's arm-raising gestures symbolize the coming of the rains and the men's stomping dance the sowing of seeds.

Like the review of Celtic dances, Fellini's scene exoticizes a European folk dance through use of the vocabulary of primitivism—labelling it as pagan, asserting that it is ancient, talking of "savage eyes," drawing a comparison with monkeys, and interpreting the whole dance (performed on a ship's deck in the Mediterranean Sea) in terms of the fertility of the soil. Here, the high society passengers play the role of the *New York Times* dance reviewer, for they are genuinely excited to have access to such an exotic scene in such a convenient location, and, as sophisticated participants in the world of High Culture, they have no hesitation in providing an authoritative interpretation. Part of Fellini's mastery as a social satirist is in recognizing the importance of having the two groups isolated by language (which precludes the potential awkwardness of an alternative view of the dance by the performers themselves) and in communicating the absolute unimaginability, among the high society passengers, that the dancers might receive their analysis with anything other than deference and gratitude.

Focusing in, once again, on static art, and keeping in mind the whole range of elements that make up "the night side of man," let us consider what happens to this image when it leaves the hands of professional writers, film makers, museum curators, and other members of the educated elite. I offer for consideration a verbal treatise on the nature and meaning of Primitive Art that was presented spontaneously in November 1984 by a security guard patrolling the Michael C. Rockefeller wing of the Metropolitan Museum of Art in New York.

Richard Price and I had entered the Oceanic section of the exhibition space, which was otherwise devoid of visitors, and were reading the opening label, which accompanied a photomural of Michael Rockefeller in the company of several Asmat tribesmen in New Guinea, when a quiet but confident-sounding voice behind us volunteered:

> You know who that is, don't you? That's Michael Rockefeller. He's the one who was cannibalized. And just look at that guy next to him [referring to a youth whose smile included a slightly thrust-forward

tongue]. If you understand anything about body language, it's clear what's on *his* mind!

A little taken aback both by what we had heard and by the very idea of a museum guard commenting on a display, we finished reading the label and moved on. Out of the guard's earshot, I wondered aloud what she could have meant by body language: surely she couldn't be connecting the protruding tongue with her fantasy that Rockefeller had been "cannibalized"! Considerably less sure that she couldn't, RP encouraged me to go back and talk to her, which I did.

She was very pleased at my interest in her opinions and launched into an informal lecture that lasted nearly a half hour. First, she confirmed that the body language she had alluded to was indeed the protruding tongue of a cannibal about to enjoy a feast, noting parenthetically that Michael Rockefeller was only 21 (sic) at the time. (Whether she meant by this that he would have provided an especially tender feast was a fine point about which I chose not to inquire.)[7]

She assured me that the Metropolitan Museum of Art had some very beautiful things in it—she knew because she had not always worked in this wing—but warned me that I would find none of them here. The collection in this part of the museum consisted exclusively of objects that were involved in killing. In fact, these people had killed everyone who had ventured into their territory. "We lost a lot of good missionaries that way," she volunteered. "All they were trying to do was to change the people's habit of worshipping idols, but in the end they were all killed and eaten."

She walked me over to the carved *mbis* poles and explained that after eating the bodies of their victims, the Asmat would hang their heads from these "totem poles." Then, after a while, they would throw the heads away because they weren't worth anything anymore. She spent some time elaborating the point that there is no such thing as a natural death among the Asmat; everyone ended up being killed, mutilated, eaten, and hung up on the poles. "Look at those costumes," she said, pointing out one of the displays. "Whenever someone was killed, people would get dressed up in those costumes and creep up to the houses of the dead person's relatives in the dead of night—they *always* did this in the dead of night—and pretend they were the spirit of the dead person. And—you'll never believe this part—that would make the relatives *happy* because they would know that the spirit was OK!" She explained that they didn't have any religion; all they had was voodoo, and that's essentially why they killed everybody.

She then moved on to an area of the exhibit where a ceiling with shields was intended to represent the men's house and told me that women and children were never allowed to enter that house or to see those objects. "They would cut a scar along every boy's arm when he was twelve, and if he cried he couldn't become a man or enter that house. Not only that, but they cut off the clitorises of all the women—just cut them right off! We lost a lot of good missionaries there," she repeated. "People really can't go there."

At this point she seemed to emerge from her vision of the Asmat world long enough to wonder how I was reacting to her description and what my interest in the subject was. She looked at me intently and asked whether *I* had ever been over there in Africa. Trying to maintain intact my role as a listener rather than a contributor to this conversation, I refrained from pointing out that the Asmat had nothing to do with Africa and answered noncommittally that I had once passed through briefly. "That explains it," she said. "You must have only gone to the tourist spots. Otherwise you'd have never returned. They leave you alone if you stick to the tourist areas. In fact, that's how we got a lot of these things; they sell stuff to tourists. Well, you really can't blame them. That's the only thing they've got that's worth anything—tourism. Otherwise all they have in life is voodoo and killing."

There were many other ethnographic details and evaluative comments sprinkled into the speech, but I have chosen to include here only those that I was able to write down on the spot and in her own words; I believe that they constitute a representative sample of this woman's vision of Primitive Art and Society, several aspects of which deserve comment.

The first is that it was not completely uninformed. Far from being simply a product of her creative imagination, these understandings had emerged from diligent readings of available sources, interpreted with a conscientious (if not always successful) effort to maintain the factual accuracy of the ethnography. Consider, for example, the following text, printed on one of the labels in the area where she worked:

> The Asmat celebrated death with feasts and rituals that both commemorated the dead and incited the living to avenge them. Carvings made specially for these events include *mbis* poles. The basic form of the *mbis* is that of a canoe with an exaggerated prow that incorporates ancestral figures and a phallic symbol in the shape of a winglike openwork projection. Many other Asmat head hunting and fertility symbols also appear on these objects.

> To the Asmat, death was never natural; it was always caused by an enemy, either by head hunters or by more insidious agents such as sorcerers. Death created an imbalance in society that the living were called upon to correct by then imposing death on the enemy. When a village suffered a number of deaths, it would hold the *mbis* ceremony. This ritual took various forms, the most spectacular of which were practiced by the southern Asmat. Several *mbis* poles were carved for each occasion and displayed in front of the men's house, where they formed the center of a mock battle between men and women. The poles were kept until a successful headhunt had been carried out. The victims' heads were then placed in the hollow ends of the poles. After a final feast, the hunters abandoned the poles in the jungle.
>
> The initial phases of the *mbis* ritual expressed the power of the Asmat to avenge their dead, thus restoring order to their world. The last phase symbolized the journey of the dead, who traveled in their canoes to the afterworld across the sea. Invigorated by the *mbis* celebration, the Asmat dead were able to assist the living.

This text, together with others of the same sort, furnished many of the specific ethnographic details that appeared in the museum guard's lecture. She was probably not the only person to misread the statement that "death was never natural" and understand it to allude to physical murder; and the fact that sorcery commonly involves, not the actual concoction of a fatal potion or incantation of a deadly spell by a wicked individual, but rather the community's declaration that someone has been acting as a supernatural aggressor, is not belabored in the label copy.

The overall structure on which these details are hung, however, seems to reflect a more global vision of Tribal Life, which could not have emerged purely from museum labels about Asmat ethnography. Like many of the observers I have cited in this chapter, the museum guard was selecting customs that *have* been documented for *some* non-Western societies under *certain* conditions—simply exaggerating and distorting their pervasiveness in order to construct in her imagination an internally homogeneous society located somewhere out beyond the frontier of the Civilized World. In her casual merging of Africa, totem poles, and voodoo, the museum guard was solidly on the side of one of the participants in an academic symposium on *"Primitivism" in Twentieth Century Art* (held that same month at the Museum of Modern Art), who insisted on phrasing her remarks (regarding the arts of Primitive people in general) as observations about "the tribal community."[8]

Other features of the guard's lecture are also readily recognizable. The emphasis on night and darkness, on sexual mutilation, on physical violence, and on the power of malevolent spirits should all be familiar from the examples presented earlier in this chapter. For she was drawing on a body of received wisdom in which the life of Primitives is characterized by "magic, known to us as superstition" (Christensen), "terrorist methods [and] distasteful or even injurious" ceremonies utilizing "sometimes unpleasant materials, including . . . blood . . . and viscera" (Wingert), "primal feelings evoked by fear and death" (Mumford), "fear and darkness" (Clark), "ghosts and occult forces" (Epstein), the "depth of [man's] primal urges" (Muensterberger), "fear-laden emotions" (Myers), "malevolence [and the] fear of monsters" (Rubin), "feelings of awe and dread [and the] terrifying power represented by the mask or icon" (McEvilley), "polymorphous sexuality" (Panter), "dark ritualistic undertones [and] sacrifice" (Kisselgoff), and "ancient pagan ritual" (Fellini's Italians). Readers who object that this melange of features was never intended to be lumped together in a single list have only to call to mind the symposium participant who held forth on "*the* tribal community," and they will be able to make sense of the harmonious coexistence of voodoo and totem poles among the Asmat of Africa.

4

ANONYMITY AND TIMELESSNESS

Fire in Gold Mine near Johannesburg Kills 177 Workers. A South African mining company said Wednesday that 177 people, most of them black mine workers, died Tuesday when a fire sent toxic gas fumes through underground shafts in the nation's worst gold mining disaster. . . . A statement from the mine owners, General Mining Union Corp., identified the five dead whites by name, occupation and marital status, giving details of how many children they had. The blacks were identified only by tribe. —New York Times Service [1]

It would probably be reasonable to characterize the academic study of art as focusing on the life and work of named individuals and on the historical succession of distinctive artistic movements. Like music, literature, and drama, the story of the visual arts is presented as a mosaic of contributions by creative individuals whose names are remembered, whose works are distinguished, and whose personal lives and relation to a particular historical period merit our attention. The prominence of a historical dimension in the study of visual art is equally striking; most university catalogs that list departments of Comparative Literature or Music introduce the word "history" for the equivalent entry on painting, sculpture, and architecture. Our very conceptualization of art is inseparable from its historical chronology; with few exceptions, scholarship glossed under the rubric of "Fine Arts" is situated in the temporal sequence of successive schools, designated in terms of centuries and an orderly progression of styles and aesthetic concerns.

One exception is made, however, to this general focus on individual creativity and historical chronology. [In the Western understanding of things, a work originating outside of the Great Traditions must have been produced by an unnamed figure who represents his community and whose craftsmanship respects the dictates of its age-old traditions.] The present chapter will suggest a closer look at this composite fellow and the restrictions on his creative spirit. And it will attempt to establish the authorship of his famous anonymity and traditionalism.

What is the role of individual creativity in the context of communal cultural tradition? The anthropological record on human societies contains

abundant evidence of a kind of disciplinary waffling in the answer to this central question. On the one hand, many of the descriptions available on Primitive Societies are written in a tense known as the "ethnographic present"—a device that abstracts cultural expression from the flow of historical time and hence collapses individuals and whole generations into a composite figure alleged to represent his fellows past and present. Bronislaw Malinowski's "Trobriand native" or E. E. Evans-Pritchard's "Nuer herdsman" were constructed more to tell us about cultural norms and generalized patterns of behavior than to explore the nature of individual differences or chronological developments in their respective societies. This mode of description, which is not limited to anthropological monographs, survives today, only slightly bruised and selectively discredited by a growing debate about the role of history in the lives of nonliterate peoples.

On the other hand, there have always been anthropologists advocating greater attention to creativity, innovation, and historical change. Franz Boas, even while stressing the conservatism of Primitive Art and the heavy weight of tradition on its makers, radically rephrased the task of understanding such art, by placing the artist, rather than the object, at center stage. In both his writing and teaching, Boas insisted on thorough, first-hand field research, on the elicitation of native explanations, on attention to the "play of the imagination" (1908/1940: 589) and the role of virtuosity, and on consideration of the artistic process as well as the finished form. His students, who dominated a whole generation of American anthropology, carried on these concerns through research that treated the interplay of tradition and creativity as a matter for careful empirical investigation rather than logical deduction; their efforts began to put on record the degree to which individual non-Western artists could implement conscious, and sometimes innovative, aesthetic choices within the broad outlines of the artistic traditions in which they were trained. As a result, readers of Ruth Bunzel's study of Pueblo pottery (1929/1972) become familiar, not only with the characteristics of Zuni, Acoma, Hopi, and San Ildefonso styles, but also with the more individualized attributes of the work of potters such as Maria Martínez and Nampeyo.

At the same time in England, Raymond Firth, whose approach to the study of social life stressed the freedom of individuals within the normative systems that circumscribe acceptable behavior, focused attention on "the position of the creative faculty of the native artist in relation to his conformity to the local style" (1936/1979: 28) and pioneered the use of personal names, portraying in his work the specific individuals whose lives contributed to his ethnographic understandings. (For a more detailed sum-

57

mary of early explorations into the interplay of individual creativity and communal tradition, see the introduction to Biebuyck 1969.)

Among art historians, nonliterate peoples have sometimes represented a "control case" that highlights the uniqueness of the role of artists in Western society. In this comparative context, the artists of Africa, Oceania, and Native America have often been cast as the servants of communal tradition, fashioning objects according to prescriptive rules inherited from past generations. Over the past few decades, however, growing numbers of scholars who are applying an art historical background to the study of Primitive Art (most notably in Africa) are significantly nuancing this image, as they contribute to our knowledge of individual artists' lives, document art historical developments through time, and refine the stylistic distinctions that identify the proveniences of particular pieces. Scholars such as Roy Sieber and Robert Farris Thompson have been particularly vigorous in pioneering recognition for the dynamism of African artistic traditions and the creativity of particular artists; there are now significant if not overwhelming numbers of art historians attempting to differentiate the work of individual Primitive artists much as they would that of their European or American counterparts. And their influence is even beginning to show, in some cases, in the attitudes of their more Western-oriented colleagues. William Rubin, who approaches Primitive Art from the perspective of his research on twentieth-century Western painting, is not atypical of his contemporaries in combining the view that "Tribal art expresses a collective rather than individual sentiment" (1984: 36) with an admission that "individual carvers had far more freedom . . . than many commentators have assumed" (1984: 11). For contemporary historians of art as well as for anthropologists, then, there is growing recognition of the need for subtlety and caution in describing the delicate interaction between individual creativity and the dictates of tradition.

But in spite of this interdisciplinary research (and contemporaneous with it), many accounts of Primitive Art, both popular and scholarly, continue to insist that aesthetic choices are governed exclusively by the tyrannical power of custom. Herschel B. Chipp, a distinguished scholar of modern art who has also written on "the art styles of primitive cultures," characterized Maori art as being circumscribed by

> a drastic limitation upon the field within which the artist's own personal inventiveness had to be confined. . . . The commission of a technical error—a mistake by a sculptor in observing traditional procedures of work—might interrupt or destroy the customary chan-

nels of communication with the spirit world, and might be atoned for with penalties as severe as death." [1971: 168]²

Writing about Primitive artists in the singular is a popular convention which has the effect of underscoring their interchangeability, not only within each of their respective societies, but in the larger context of their colleagues throughout the world. Even their personal feelings toward their work may be depicted as common property; to cite one of my favorite images of this generalized fellow, "The primitive artist moves from naturalism to abstraction without embarrassment" (Newton 1981: 53).³ The denial of individual creativity is often proclaimed in rather sweeping generalizations. Henri Kamer has asserted: "In Africa there is no creative artist, as such. . . . He [the African artist] produces the masks and fetishes according to the needs of the moment, always on order of the dignitaries of the tribe and never following his inspiration of the moment" (1974: 33). From this perspective, the identity of particular artists loses its importance, since they are participating in aesthetic production much as a factory worker would contribute labor to an assembly line. A conceptual jump is then made from the artists' lack of individual creativity to the artists' lack of individual identity. The artist becomes "anonymous."

An editorial in *African Arts* confused "tribality" with "anonymity" and went on to discuss the implications of this characteristic for the recognition of individual artists. "With the artist himself thus reduced to anonymity there cannot develop that cult of the individual that can surround the works of a single European or even Japanese master carver or painter" (Anon. 1971: 7; the use of the word "even" is perhaps worthy of note.) Another writer sees anonymization as a less voluntary choice on the part of the artist: "The identity of the individual African sculptor has tended to become obscured, because he is manipulating forces which exist outside himself, so that once he has caused those forces to enter into the sculpture, he sinks into anonymity" (Duerden 1968: 16; note the final verb).

One question that is rarely probed about the "anonymity" of tribal artists is who produced it. When Grace Glueck remarked, in a review of the Center for African Art: "In our name-oriented Western culture, it boggles the mind that such works as these are anonymous" (1984: C28), *perhaps* she intended to be signaling our own ignorance of the artists' names. Yet I suspect that many of her readers understood her to be alluding to the anonymity of African artists less as a mind-boggling lapse in the Western preoccupation with names than as a feature of tribal art that inheres in its

native context. Some commentators rather easily accept Western ignorance of artists' identities as grounds for dismissing their individuality and assuming that art is produced by the community as a whole; one contributor to *African Arts* remarked nonchalantly, "As little is known of the names of individual African artists, a work is generally considered to be the product of a culture" (Sigel 1971: 52). And others who are demonstrably aware of the individualized role of particular artists sometimes express themselves rather loosely about "anonymity," failing to clarify that they are referring to *Western* reception of non-Western arts, and thus contributing inadvertently to a popular vision of Primitive artists as undifferentiated producers of cultural artifacts. When Paul Wingert listed "the anonymity of the artist in most, but by no means all, cases" (1962: 377) as one of the "features common to the arts of all primitive areas," he volunteered no suggestion that he was discussing anything but the realities of life in "primitive areas." And when Georges Rodrigues characterized African art as being "with only very rare exceptions anonymous" (1981: 23), the same distinction was left undrawn.

The popular image of Primitive artists as the unthinking and undifferentiated tools of their respective traditions—as people who are essentially denied the privilege of technical or conceptual creativity—raises interesting questions about the ways in which "exotic" peoples are used to legitimize Western society and culture. Labeling such portrayals racist or patronizing would oversimplify, but I believe a case can be made that the "anonymity" (and its corollary, the "timelessness") of Primitive Art owes much to the needs of Western observers to feel that their society represents a uniquely superior achievement in the history of humanity.

An article in a 1973 issue of *Réalités* argued that the suppression of individuality in favor of a homogenized communal ideology is a fully generalizable characteristic of African and Oceanic societies and that it is expressed through art forms in which personal identities are collapsed into abstract schematizations.

> The art of Africa is anonymous. Its products are emblems rather than reproductions of reality, symbols rather than copies.
> The reason for this lies in the nature of the civilizations that create them. They reflect communal societies, where the individual exists only as a part of the group. . . . In Africa and Oceania, art . . . has to offer the community mirror images in which it can recognize itself. . . . art is the cement that holds the community together; but for it the tribe would die. [Darriulat 1973: 42, 45]

Later on in the same issue, René Huyghe picked up on the theme again, explaining the absence of individuality through an explicitly evolutionary scheme whose suggestions of racism were only poorly concealed by disclaimers that "There is no one 'correct' view" and "African and Oceanic art is in no way inferior to Western art" (1973: 67). "Little value is set on individuality, which in more developed societies plays an increasingly important role," he argued, and this phenomenon cannot be properly understood without distinguishing the language of words ("connected to thought-processes which take place in the upper brain") from the language of images (which "originate in those areas of the brain where the drives, instincts and emotions are based"). Associating this latter language with (need I specify?) the "less developed societies . . . where words are less closely bound to the intellectual process than to the imagination," Huyghe explained that "in these societies art is a complete communal language in itself."

> There is no room for individual expression in art of this kind. Forms can be reduced to their primary geometric state, because they are governed by a psychological law, which is itself the reflection of the universal biological principle of the conservation of energy.
>
> Straight lines involve the least expenditure of energy, and the easiest way to remember any given feature of the real world is to reduce it to geometric shapes, which are basic and universal. African and Oceanic art is geometric because its creators are instinctively imitating the ways of nature. It is not in any way the result of sophisticated and concerted research, as modern Western art is, but of an innate way of looking at the world. [1973: 67]

Once having determined that the arts of Africa and Oceania are produced by anonymous artists who are expressing communal concerns through instinctual processes based in the lower part of the brain, it is but a quick step to the assertion that they are characterized by an absence of historical change. Even some of the most well-meaning correctives to the misapprehension that Primitives have no sense of history have a hard time completely abandoning this bit of received wisdom. Claude Roy begins his book, *Arts Sauvages,* by pointing out that some "primitives" *do* have writing and histories, but adds a clarification to this statement that completely undermines its message: "These are not people without memory; they are simply people with bad memory" (1957: 7).

But a categorical denial of the historical dimension is more common

in the literature on Primitive Art. A 1972 essay entitled "Art as a Universal Phenomenon" is typical: "The primitive artists . . . are rooted in religious, mythical conceptions. These anonymous artists feel they are a link in an unending chain of generations" (Bihalji-Merin 1972: 7).[4] Or, as Wingert had generalized a decade earlier:

> the traditional art styles in every area of the vast primitive world were perpetuated and held fast by the conservatism of the group that maintained the apprenticeship tradition. . . . The basic premise of this system was that the apprentice be trained to follow the age-old ideals of representation and expression common to his village or tribe. [1962: 15, 16]

And to elaborate the case for traditionalism even further:

> Africa has no written records, it has no memory. . . . Africa and Oceania have no history. The story of primitive art is written in the present tense. This is also the lesson of the dance: forget the past, lose yourself in the gesture and rhythm of the moment.
>
> Africa has no history, and historical chronicles would be laughable there, as the sense of time past does not express itself in the memory of the fall of empires or the division of kingdoms but in a consciousness of the creation of the world. . . .
>
> [Its mythical character] is what is so overwhelming about African and Oceanic art. Consider for a moment the living conditions of the people responsible for it—poor, naked, weak and lost in the natural environment. Then balance this image against the solemn majesty of the myths they have created, of the ageless traditions handed down to us in the objects we see today. This great inheritance has a single meaning and purpose: to perpetuate the act of celebration, the loss of self in the community, the human warmth of dance and chant. [Darriulat 1973: 50]

While for this author "the story of primitive art is written in the present tense," a more common choice is to utilize the past (see, for typical examples, Christensen 1955, Maquet 1986, or the Rockefeller Wing label mentioned in chap. 3). Strictly speaking, if we envision Primitive Art as timeless and unchanging, this particular decision may appear to have relatively little importance. Yet the practice of writing about Primitive Art in the past tense does communicate something more than a chronological dimension.

Recent reflections on time and culture have produced important in-

sights into two aspects of the problem that seem particularly relevant to the present context. Johannes Fabian's *Time and the Other* (1983), for example, analyzes the social-cultural (as opposed to strictly chronological) nature of certain conceptualizations of temporality, and Patrick Manning's "Primitive Art and Modern Times" (1985) calls into question the standard view of Primitive-Modern artistic interaction which operates in only one direction.

Within Fabian's classification, it is what he calls "Typological Time" that is most frequently called into play in discussions of Primitive Art. In contrast to his "Physical Time," this concept

> signals a use of Time which is on a (linear) scale, but in terms of socioculturally meaningful events or, more precisely, intervals between such events. Typological Time underlies such qualifications as preliterate vs. literate, traditional vs. modern, peasant vs. industrial, and a host of permutations which include pairs such as tribal vs. feudal, rural vs. urban. In this use, Time may almost totally be divested of its vectorial, physical connotations. Instead of being a measure of movement it may appear as a quality of states; a quality, however, that is unequally distributed among human populations of this world. Earlier talk about peoples without history belongs here, as do more sophisticated distinctions such as the one between "hot" and "cold" societies. [1983: 22–23]⁵

Fabian's analysis of different kinds of temporality helps explain how it is that certain art objects produced in the 1980s are systematically excluded from membership in the category of "modern art," for *modern* here refers to the artist's sociocultural identity, not to physical contemporaneity with the present moment. By contrasting Primitive and Modern art, we are in effect utilizing a temporal metaphor to distance people and cultures that are fully our contemporaries in historical terms.

A second sleight of hand that plays into popular perceptions of Primitive and Modern art is the frequent limitation of our vision to one lane of a two-lane highway. Manning's critique of the MOMA "Primitivism" exhibit and several others contemporaneous with it focuses on the case of African art to make this point. Likening their presentation of artistic influence to "a Zen contemplation of the sound of one hand clapping," it proposes the importance of

> treating African artists, and the societies for which they created, in historical terms. It may appear, to viewers contemplating the shows, that the link between African and modern art consists entirely of the

appropriation of the former by the latter. The museums do make it
appear as if collectors from a dynamic and changing Euro-American
tradition of artistic creation and appreciation have swept through and
captured the gems of a timeless tradition of African creativity, only to
display them utterly bereft of their cultural context. Appearances
aside, however, cross-cultural interaction is a two-way street. As I
shall show, the arts of Africa have changed significantly over the
centuries in response to changing conditions of life. [1985: 168–69]

Joseph Alsop comes tantalizingly close to grasping the limitations of
traditional art historical perspectives in dealing with exotic arts when he
insists that "the ways all of us look at and think about works of art are
culture-bound in a degree so extreme that it too often traps aesthetic
theorists not accustomed to range beyond our own culture's historical
boundaries" (1986: 29). However, rather than entertaining the possibility
of authentic histories that have not surfaced under traditional kinds of
historical investigation or that have gone unnoticed because no one has
taken the trouble to look hard enough for them, Alsop concludes that the
very search for history in these cases is an ethnocentric enterprise, and that
it leads art historians to pose inappropriate questions.

> In reality, the vast majority of past human cultures we now know
> about, whether tribal, national, or imperial, whether long lasting or
> soon crushed by history's iron tread, have not even remembered their
> own great artists from generation to generation, let alone writing their
> own art histories. Included among these cultures whose artists lost
> their identities in death, are many famous higher civilizations which
> have left records of one sort or another. If you search these records to
> the best of your ability, you will find the merest handful of artists who
> were remembered . . .
> As will be very easily understood, the uncounted cultures that
> never wrote their own art histories, nor even remembered their own
> great artists of the past, could not possibly generate anything remotely
> resembling our concept of authenticity in art. To say that a visual work
> of art is "authentic" is simply another way of saying that it really is
> what the dealer, owner, or resident art historian or connoisseur repre-
> sents it as being; and such verdicts are not merely unheard of, they are
> also entirely impossible for obvious practical reasons, in the cultures
> without art history. [1986: 29–30][6]

Putting on hold for a moment the popular image of the Primitive
Artist working within an age-old tradition governed by communal custom,

let us consider the alternatives. In order to do this, it will be necessary to shift our attention from a prototypical world citizen known as The Primitive Artist to the actual individuals who are responsible for producing objects of Primitive Art.

Bill Holm has commented sensitively on the nature of tribal "anonymity" in an article devoted to the work of the Kwakiutl artist Willie Seaweed.

> Northwest Coast Indian artists, like "primitive artists" of other cultures, have been largely anonymous in our time. Moreover, when modern man, a product of a society which puts great emphasis on names, fame, and individual accomplishment, looks at a collection of masks or other works of art from such exotic cultures, he is unlikely to visualize an individual human creator behind each piece. Seldom will he be helped toward personalizing the faceless "primitive artist" by the labels he might read. Work might be identified as "Northwest Coast," "Alaska," or "British Columbia Coast." At best a tribal identification might be made, although the likelihood of its being inaccurate is considerable. The idea that each object represents the creative activity of a specific human personality who lived and worked at a particular time and place, whose artistic career had a beginning, a development, and an end, and whose work influenced and was influenced by the work of other artists is not at all likely to come to mind. [1974: 60]

Others have also been exploring the possibilities for illuminating the darkness in which Primitive artists' identities have been shrouded. Robin K. Wright describes progress that has been made in de-anonymizing Haida artists such as Charles Edenshaw, John Robson, John Cross, Tom Price, Gwaitehl, and others. Even for objects crafted in the early or mid-nineteenth century, she has demonstrated the potential of careful stylistic analysis for delineating the work of particular individuals, creating epithets such as "Master of the Long Fingers" where retrieval of the carver's proper name is no longer feasible (1983).

Researchers have been coming to similar conclusions in other parts of the world as well. In their study of Igbo arts in Nigeria, Herbert M. Cole and Chike C. Aniakor note that "individual hands are recognizable in Igbo sculpture, as they are in most African art, and artists were and are well-known locally" (1984: 24). In spite of the fact that a majority of the pieces illustrated in this catalog were loaned by collectors unable to supply artists' names, the authors' documentation of those identities that were available

supports their generalization and communicates their appreciation of Igbo carvers as artistic individuals rather than as interchangeable technicians for some mythical communal spirit. For a few objects in this book, the indication of authorship was altogether unavoidable (e.g., a mask bearing large black letters, on a white background, that announced: "BY ODOIMILIKE" [pl. 25]); for many others it seems to have involved a relatively straightforward inquiry; and I suspect that further attributions would have been possible through an even more persistent application in Nigeria of art historical and ethnographic methods. Robert Farris Thompson has also championed the recognition of named artists.[7] In short, although much more can be done to recognize non-Western artists as real people, a start has certainly been made.

One recent effort in this direction provides a particularly poignant illustration of the way in which inadvertent cultural assumptions contribute to the ongoing anonymization of Primitive Art. David Bennett has chronicled the story of Malangi, an Australian artist from Arnhem Land, under the epithet "the man who was forgotten before he was remembered" (1980). It all began in 1963 when a Hungarian art collector, struck by the "astonishing personal style" of Malangi's bark paintings, took one of them back to Paris and donated it to the Musée des arts africains et océaniens. During the course of the same year, photographs of several bark paintings (including Malangi's) were passed on to an official involved in the conversion of Australia's currency to a decimal system, who in turn passed them on to designers working on the new banknotes. Through this route, Malangi's painting eventually made its way onto the Australian one-dollar bill, but his identity had been lost in the shuffle. Thanks to the combined intervention of a journalist and a schoolteacher who recognized Malangi's design and mentioned the possibility of a lawsuit, the oversight was caught and Malangi received both financial compensation and an inscribed medal in recognition of his work (though on the bill itself credit still appears in the form of the Western designer's initials). When the governor of the Reserve Bank was questioned about how all this had come about, his answer was revealing. He said that everyone involved had simply assumed "that the designs were the work of some traditional Aboriginal artist long dead" (Bennett 1980: 45). The conceptual distancing of Primitive Art into an anonymous past is clearly of more than abstract importance in the lives of those who create it; Malangi's story is better documented than most, but it is far from being unique.

Just as it is useful to specify, in discussing unidentified tribal artists, to *whom* they are "anonymous," it is proving instructive to look more

carefully into the question of *who* needs to "awaken from a jungle sleep" (see note 4 for this chapter) in terms of historical knowledge of Primitive peoples. Recent research that applies historical and anthropological sophistication to materials in Africa, Oceania, and the Americas is building a persuasive case that the nonhistorical reputation of Primitive societies is a construction of Western cultural biases and the limitations of traditional Western modes of scholarship (see, for example, Cohen 1977, Dening 1980, R. Price 1983 and 1990, Rosaldo 1980). Once we do not require our knowledge of the past to come to us in black-and-white pages of date-sprinkled text, this research is showing, the historical dynamism of other peoples, as well as their memory of it and interest in it, are much greater than Western commentators have traditionally imagined. The study of art in these societies has some catching up to do before it reflects this increased awareness of historicity, but the groundwork has been laid, and the material necessary to document the art history of nonliterate peoples is, contrary to much popular opinion, still available to those willing to tolerate long hours in museum storerooms and colonial archives and to engage in the challenging enterprise of field research.

In chapter 8, I will focus attention on one society in which knowledge about past artists, art styles, aesthetic principles, and production techniques is maintained, in spite of the absence of art museums, an art market, and even literacy. But before addressing the nature of art historical perceptions through the realities of a particular case, I wish to offer one general caution to those who might dismiss the validity of such traditions in Primitive societies. The fact that the art history of a nonliterate people represents a highly selective memory of the past—motivated by contemporary ideology, political considerations, gender constructs, and any number of other social or cultural factors—only underscores the similarity of those art histories to our own.

5

POWER PLAYS

Clever, but schoolteacher beat him anyway to show him that defi-
nitions belong to the definers—not the defined.—Toni Morrison,
describing an argument between a white man and a slave about
whether the latter had committed a theft or simply "improved Mas-
ter's property" by killing and eating a hog that belonged to the estate.[1]

As this book is being written, preparations are underway throughout the
modern world for a celebration of the Discovery of America. The momen-
tous event occurred exactly 500 years prior to 12 October 1992, on a sandy
beach whose identity has recently been reassessed through a five-year inves-
tigation conducted by historians, archaeologists, navigators, cartogra-
phers, and other experts (*National Geographic,* November 1986). Why is
such attention lavished on the details of this event, and why is it described
as "one of the grandest of all geographic mysteries"? The answer is not, I
believe, entirely irrelevant to a consideration of the place of Primitive Art in
the Civilized World.

Just as it can be argued that a tree falling in a forest makes no sound
unless an ear is present to register it, the Americas are in some sense thought
to have become part of the world only when Europe discovered them; it is in
the context of this particular logic that our globe can be conceptually
divided ino "the New World" and "the Old World." Similarly, there is a
line of reasoning by which objects of Primitive craftsmanship do not consti-
tute art until Western connoisseurship establishes their aesthetic merit.

The control assumed by the Western world over the arts of other
peoples exists on several dimensions. First, like the ear in the forest, the
Western observer's discriminating eye is often treated as if it were the only
means by which an ethnographic object could be elevated to the status of a
work of art; this alone is a definitional prerogative of tremendous power.
Second, collectors and museums act largely according to their own pri-
orities when they employ Western technology to rescue Primitive Art from
physical extinction; they decide on the life or death of objects that have been
fashioned from perishable materials by people whose own priorities repre-
sent, to Westerners, little more than a naïve insouciance of the need to

conserve their heritage for future generations. Third, Western connoisseurs assign themselves the job of interpreting the meaning and significance of artistic objects produced by people who, they argue, are less well equipped to perform this task. Fourth, these same experts employ, at their own discretion, the considerable financial and communicative resources at their disposal to bestow international artistic recognition on their personal favorites from the "anonymous" world of Third World craftsmanship. And finally, members of the Western world are the ones who, again with their access to material wealth and communication, are taking it upon themselves to determine the nature of artistic production in virtually every corner of the world, in the final decades of the twentieth century. In short, Westerners have assumed responsibility for the definition, conservation, interpretation, marketing, and future existence of the world's arts.[2]

The process by which all this happens divides into several stages. The first occurs "in the field," where the adventurous souls who track down Primitive Art in its native settings come face to face with their suppliers. (Although my primary concern here is contemporary realities, I begin with the early twentieth-century encounters between the original owners of exotic artifacts and those eager to take possession of them, not only because these experiences are heavily responsible for stocking the museums of the world, but also because they contributed so importantly to the assumptions that have since been made on both sides of the divide.)

As non-Western owners and would-be collectors conduct their business, rights, procedures, and meanings are often less negotiated between the two parties than simply defined independently by each one. Occasionally, particular individuals become victims of the discrepancies, as allegiances are manipulated and new concepts of ownership introduced. The experience of Louis Shotridge (1886–1937), a Tlingit Indian who was persuaded by the director of the University Museum in Philadelphia to "infiltrate his own culture to obtain its treasures," illustrates the tensions inherent in the phenomenon of ethnographic collecting (Carpenter 1976: 64; see also Cole 1985: 254–66). Equipped by the museum with a still camera, a movie camera, a typewriter adapted for Tlingit texts, a live-in powerboat, and sizeable amounts of money for his purchases, Shotridge set out to collect for Science.

> When I carried the [Kaguanton Shark Helmet] out of its place no one interfered, but if only one of the true warriors of that clan had been alive the removal of it would never have been possible. I took it in the presence of aged women, the only survivors in the house where the old

object was kept, and they could do nothing more than weep when the once highly esteemed object was being taken away. . . . it is not going to be an easy thing to take away the Bear Emblem. . . . My plan is to take the old pieces one at a time. [Shotridge, quoted in Carpenter 1976: 65–66]

you mean rob? on steal??

Shotridge eventually turned in frustration from offers of money to clandestine theft to acquire the Rain Screen and houseposts from the Whale House of his own village. Carpenter describes how

First he offered $3,500. There probably wasn't $100 cash in all Klukwan at that time. He spoke eloquently, at great length, in the Whale House. He said that the museum would protect these treasures, that they belonged to the world and would forever reflect the glory of the Whale House. The answer was an unequivocal no.

Finally, with the museum's knowledge, he laid plans to steal the Rain Screen and houseposts while the men were away fishing. "We plan to take this collection," he wrote, "regardless of all the objections of the community." The reply: "I am glad you have found a way to overcome the serious difficulties in obtaining full possession." But a "gun went off," narrowly missing him. This traditional Tlingit custom, midway between execution and assassination, was no mere warning. Shotridge sponsored a feast to reestablish peace. [1976: 66]

A close reading of almost any anthropological work from the 1920s or 1930s reveals how recently the question of natives' feelings about the collection of material objects by Western visitors became an issue for thought or debate. The *Instructions sommaires pour les collecteurs d'objets ethnographiques* (Anon. 1931), a field manual prepared in connection with France's Dakar-Djibouti expedition of 1931–33, went into great detail about the scientific value of collecting, the criteria for selecting objects, the data to record on each item, the methods to use for labeling, classifying, photographing, and packing, and the phonetic symbols and orthography to employ in documenting native terminology; nowhere is there any mention of such matters as appropriate compensation, native opposition to scientific collecting, or other issues touching on the personal relations or ethics of the enterprise. And the famous British equivalent, *Notes and Queries* (1874/1951), defines its scope in exactly the same way.

Michel Leiris's candid personal chronicle of France's first major ethnographic expedition in Africa is particularly staggering, from a 1980s perspective, in its matter-of-fact entries about the acquisition of objects for

scientific study. I present excerpts from this journal, not because the tactics they describe are extreme, but rather because Leiris's combination of openness and literary skill makes them particularly accessible.

6 September [1931]
[In a small structure housing sacred relics, we find] on the left, hanging from the ceiling amidst a bunch of calabashes, an unidentified bundle, covered with the feathers of different birds, and containing, thinks Griaule after palpating it, a mask. Irritated by the foot-dragging of the people [who have been making an annoying string of demands for a sacrificial offering], our decision is made quickly: Griaule picks up two flutes and slips them into his boots, we put things back in place, and we leave.

[Following further irritating discussion about the sacrificial offering,] Griaule then decrees . . . that since it's clear that people are making fun of us, it will be necessary for them, in recompense, to surrender the *Kono* to us in exchange for 10 francs, and that otherwise the police hiding (he claimed) in the truck would have to take the chief and the village dignitaries into custody and drive them to San, where they could explain their behavior to the Administration. Dreadful blackmail!

. . . The chief of the village is devastated. The chief of the *Kono* has announced that, under the circumstances, we would be allowed to carry off the fetish. . . . With a dramatic flourish, I give the [sacrificial] chicken back to the chief, and . . . we order the men to go inside and get the *Kono*. After they all refuse, we go in ourselves, wrap up the holy object in the tarpaulin, and emerge like thieves, as the agitated chief runs off and, some distance away, chases his wife and children [who are not allowed to lay eyes on this sacred object] into the house, beating them with a stick.

. . . The 10 francs are given to the chief and, amidst a general confusion, we take off in haste like unusually powerful and daring bastards, bathed in a demonic glow.

7 September
Before leaving Dyabougou, visit the village and abduct a second *Kono*, which Griaule had spotted when he slipped unnoticed into its special hut. This time it's Lutten and I who manage the operation. My heart beats very fast; ever since yesterday's scandal, I understand much more clearly the gravity of what we are doing. With his hunting knife, Lutten severs the mask from the feathered costume to which it's attached, passes it to me so I can wrap it in the cloth that we've brought with us, and gives me also . . . [another figure] weighing at

least 15 kilos which I wrap up with the mask. All is rapidly removed from the village, and we regain the cars by way of the fields. . . .

In the next village, I spot a *Kono* shrine with a door in disrepair; I show it to Griaule and the decision is made. As before, Mamadou Vad [a local assistant] announces bluntly to the village chief, whom we've brought before the shrine in question, that the commander of the mission has given an order to seize the *Kono* and that we are prepared to offer an indemnity of 20 francs. This time I'm the one who takes charge of the whole operation single-handed, entering the sacred hut, gripping Lutten's hunting knife which I'll use to cut the ties of the mask. . . .

6 November
Schaeffner and I sent to an ossuary near Bara to bring back skulls. . . .

Heading out past Bara, we find in a horizontal fissure (formerly a cave for [storing] masks) a large piece of wood, eaten away and water-logged: it's a prototype of the mask in the form of a snake that is no longer made now. . . . Once broken in two, the mask is carefully wrapped up.

. . . During our climb back up, . . . a bracelet and some neck ornaments are picked up.

12 November
Yesterday people refused, horrified, our request for several rain-producing statuettes as well as a figure with raised arms that had been found in another sanctuary. If we took away these objects, it would be the life of their land that we would be taking away, explained a boy who . . . nearly wept at the idea of the misfortunes that our impious act would cause to happen. . . . Hearts of pirates: while saying an affectionate farewell to the elders . . . , we keep watch over the green umbrella that is ordinarily opened up in order to shade us but today is carefully tied shut with string. Swollen with a strange tumor that makes it resemble the beak of a pelican, it now holds the famous statuette with raised arms, which I myself stole from the base of the conical mound that serves as an altar for this statue and others like it. I first hid it under my shirt. . . . Then I put it in the umbrella . . . pretending that I was urinating in order to turn away people's attention.

In the evening . . . my chest is blotched with earth, for my shirt has served once again as a hiding place, during our departure from this village's cave of masks, for a kind of rusty, double-edged saw blade, which is nothing other than an iron bull-roarer.

14 November
. . .the abductions continue. . . . Sanctuaries and trenches where old masks are thrown are systematically explored. . . .

15 November
Yesterday our friends Apama and Ambara surreptitiously brought the fiber costumes to go with the masks that we had asked them for. They begged us, above all! to hide them well. Today with their help I make the file cards for these objects. Apama and Ambara are attentive to the slightest noise. A child who wants to come in gets reprimanded.

There's no doubt: our procedures have gained us a following, and the two courageous boys have gone off to the mask cave to get the fiber costumes where they were hidden. The influence of the European . . .

The sneakiness continues and I sometimes feel like breaking everything, or else just going back to Paris. But what would I do in Paris?

16 November
Apama's "little" brother didn't want to sell [a certain mask], because he got it from his older brother, the hunter who died on October 20. Today he agrees to, on the condition that we go to steal the object ourselves so he can say that he was coerced. . . .

18 November
[In another cave,] the villagers authorize us to take one of these objects, but as soon as we reach out to take it, all of them look away, afraid perhaps of seeing us horribly punished for our sacrilege. . . .

Toward the right side of the cave, in a small sanctuary, a beautiful wooden statue. We avoid looking at it too much, in order not to arouse suspicion, but it's understood that that night Schaeffner and I will take it. [1934/1981: 82–128]

And so on.

Such abductions were also going on in other sites of Western exploration. Contemporaneous with the Dakar-Djibouti expedition, for example, André Malraux was engaging in activities of a similar nature in Cambodia, for which he served a brief term in jail (Guiart 1985: 16); the Imperial National History Museum in Vienna was installing a New Zealand collection that included mummies stolen by Maoris recruited for the job because they were "sufficiently Europeanized to be willing to renounce their national and religious principles for gold" (Reischek 1930/1952: 215–16);[3]

and Melville and Frances Herskovits were wheedling carvings from dis-
traught Maroon women in the interior of Suriname (see chap. 8). These are
the encounters that have supplied our museums, from the Musée de
l'homme to the Metropolitan Museum of Art, with the great bulk of their
non-Western artistic treasures.

It was only after these kinds of open experiences in wresting objects
from native settings, and in large part because of the ethical doubts they
inspired in some of those who carried them out, that anthropologists and
museum personnel began to regard the thoughtful consideration of conflict-
ing interests in the field as part of their professional responsibility. Soon
after the expedition that he chronicled, Leiris became active in promoting
the concept of respect for other peoples' cultures, and the International
Committee on Museums in which he and several of his close colleagues
played an important role went far, especially after World War II, toward
producing a shift in public opinion about these matters (Guiart 1985: 16).
In 1950, when Leiris addressed the Association des travailleurs scientifi-
ques, he was both geographically and ideologically distanced from his relic-
collecting adventures in the caves and sacred shrines of Africa.

> Whenever religious objects or art objects are transported to a metro-
> politan [European] museum, regardless of how the original holders
> may be indemnified, it is still part of the cultural patrimony of a whole
> social group that is taken away from its rightful owners, and it is clear
> that that aspect of the [ethnographer's] job devoted to the constitution
> of collections—if we allow ourselves to see this as anything other than
> a pure and simple plundering (in view of the scientific interest that it
> offers and the fact that the objects have a better chance of being
> conserved in a museum than if they were to remain in their original
> settings)—belongs among those activities that create responsibilities
> for the ethnographer toward the society that is being studied: the
> acquisition of an object that was not originally intended for sale
> produces, in effect, a shock to custom and thus represents an interven-
> tion such that the person who is responsible for it cannot, anymore
> than someone else, consider himself completely detached from the
> society whose customs have been so disturbed. [1950/1969: 86]

Because of the efforts of a variety of organizations formed expressly to
help protect the rights of native peoples against exploitation of various
kinds, the publicly acceptable stance on appropriating material objects has
shifted dramatically toward a respect for native rights, and the balance of

power that allowed Griaule's 1931–33 expedition to abscond with the most sacred treasures of the African villages they drove through has altered to some degree. An optimistic appraisal of contemporary ethics would cite increased sensitivity toward the feelings and interests of those who provide materials for our museums, documented in numerous articles and even whole journals devoted to the subject. At the same time, it is far from clear that the face-to-face dealings by which specimens of Primitive Art are now being acquired has changed in more than a statistically negligible propor-tion of cases.

Visits to remote cultural backwaters, whether by scientific inves-tigators, tourists, or entrepreneurs, are lonely ventures. Not only are there ample opportunities for individuals to set aside institutionally endorsed ethical guidelines in favor of personal interests, but there are also real disagreements on the exact parameters of responsible behavior.

Many professional researchers simply shy away from "collecting" alto-gether, regarding the activity as too potentially compromising to the rela-tionships that allow them to conduct their work, and returning home with only those items that were offered to them as gifts of friendship. Others formulate principles for collecting objects and ethnographic information that are designed to show respect for the interests of both individual owners and the larger community; the exact nature of these principles varies from one researcher to another and involves different considerations for each cultural setting, but all share a common concern for the perspectives and interests of the people being studied. There are also researchers whose dreams for their data and personal careers virtually displace ethical consid-erations; while their methods of collecting (or filming or photographing or tape recording) are generally kept away from the attention of publishers and academic promotion committees, they represent a common subject for discussion among the people whose villages such researchers have visited and they contribute importantly, if quietly, to the reputation of Westerners in the non-Western world.

The most commonly cited justification for field collecting, even at some ethical cost, is that the documentation and preservation of Primitive Art constitutes a contribution to human knowledge. In this view, Western-ers have a moral obligation to protect the artifacts of Primitive cultures regardless of the original owners' assessment of the scientific importance of the rescue operation. Anyone involved with museums necessarily subscribes to this position to some degree. The distinguished elder of African art studies William Fagg (anticipating in a sense the similar though more

massively documented argument of Joseph Alsop [1981]) has proposed that the conservation of culture is what distinguishes "civilization" from "tribal culture"[4] and that "tribal art, like any other art, belongs to the world" (1979: ix); from this point of view, it seems only proper that "civilized" people should control the fate of "tribal" art, enshrining it in their cultural conservatories for the benefit of "the world."

Defenses of this perspective crop up repeatedly in the literature on "tribal art." One typical statement is found in an article about collecting Yoruba art by Philip Allison, which describes how people "were often reluctant to part with these relics of a vanishing culture [figures, brasswork, masks], though they took little care to protect them from decay" (1973: 66). Allison explains his approval of the "sometimes irregular methods of acquisition" by which they were finally included in his collection:

> it was better that these important pieces should be preserved in the national collection than that they should fall into the hands of private dealers and collectors, or be left to rot on neglected shrines. Even works in less perishable materials than wood were not safe. In Igalla, I found antique brass balls being broken up to mend iron cooking pots. [1973: 68]

Henri Kamer provides another statement of the same perspective, pointing out the fate of objects that African villagers refuse to hand over to the care of Western institutions.

> If an important event (funeral, drought, epidemic) were to take place in [an African] village today, masks and fetishes would be made in order to conjure the evil spirit, and according to their rarity and artistic quality, these objects would have a more or less important ethnographic or commercial value among museums and collectors. Under no pretext would the inhabitants of the village give them up and in certain cases they would destroy them or hide them in the bush where they would be lost forever or simply destroyed by termites and the elements. [1974: 20]

Once rescued from their homes among the termites and the elements, the objects come into the protective custody of Western owners, something like orphans from a Third-World war, where they are kept cool, dry, and dusted, and where they are loved and appreciated. Collectors are sometimes quite explicit about the kind of attention on which these artifacts thrive.

Like any serious art collector, I have always felt that it was the respon-
sibility of collectors to preserve, protect and respect the art in their
care until it was passed along to its next guardian.

By respecting the art, I refer, of course, to displaying it to best
advantage.

[After a series of pointers about how to accomplish this goal in the
home . . .]

Above all, make your collection a part of your life. Live with it,
look at it, fondle it. [Alperton 1981: 1, 3]

In addition to the justification of Primitive Art collecting as a contri-
bution to Science, there is what might be labeled the "light-hearted real-
ist's" attitude, which introduces the profit motive and which can be applied
equally well to both field collecting and the art market. With an indulgent
chuckle, adherents of this position hover somewhere between a gentle "tsk
tsk" and a recognition that "boys will be boys." Although they are, of
course, aware of the ethical problems of both field collecting and the art
market, and sometimes even discuss them as a concern, they are careful not
to let any such considerations interfere with their sense of perspective about
the human condition. Their most outspoken and eloquent voice is incon-
testably that of the "First Word" column of *African Arts* magazine.[5] Many
of these editorials are clearly designed to assuage, through humor, any
malaise that subscribers might feel about approaching their shared passion
with an eye toward material gain, referring with gentle sarcasm, for ex-
ample, to "masterpieces . . . that create in the present writer that distress-
ing evidence of one of the more shameful deadly sins—covetousness" and
making amusing allusions, "if this is not thought to intrude too capitalist a
note," to African art as "one of the most promising of blue chip investments
in art, even from the sordid aspect of the capital appreciation that will
undoubtedly come" (Anon. 1971: 5, 7). From this perspective, the wish to
employ Primitive Art for personal financial profit is, if not the loftiest of
Man's motivating drives, at least a supremely understandable and accept-
able one.

The departure of particular objects from homes, shrines, and public
spaces is only the first of many changes that collecting produces in the
cultures used to supply Western museums, galleries, and living rooms. The
creation of a "market" (however undervalued it may be in comparison with
that in the West) inevitably affects the nature of a community's encounters
with outsiders, its economic workings, the role and meaning of the classes
of objects that are collected, and, ultimately, the physical forms that are

produced. The process has been documented for many different settings over the past decade or so; collections of essays that have given thoughtful attention to this general theme include, for example, Graburn 1976, Stocking 1985, and Wade 1986, and it has become almost standard for books on particular non-Western arts to deal not only with long-standing "traditions," but also with those arts that have been born of the contact situation. My own writing has dealt with some of the subtle and not-so-subtle ways in which the social life, economy, gender constructs, kinship relations, and artistic production of an Afro-American people in northeastern South America have responded over the course of this century to outsiders' interests in acquiring specimens of their artistry; their experience is examined briefly in chapter 8.

Although some commentators have proposed that a monetary incentive disqualifies an object of native manufacture for inclusion in the category of "authentic primitive art," producing art for money is not really the problem. As Edmund Carpenter has pointed out, "A recent book on Inuit souvenirs reminds us that Michelangelo worked for money without loss of integrity. Yet he never mass-produced debased Christian altar pieces, suitably modified to meet Arab taste, to peddle on the wharfs of Venice" (1983). I would suggest that paying artists for their labor and their talent is one thing when it occurs within a well-defined cultural setting in which both the creator and the owner-to-be share basic assumptions about the nature of the transaction. When Rembrandt painted a portrait on commission and then sold it to the sitter for an agreed-upon price, an exchange occurred between fully informed consenting adults. The same could be said of the purchase of an unabashed piece of airport art in a souvenir shop; the status of the object and of the transaction are understood and agreed to by both parties. It is quite another thing, however, when a Western traveler in Africa spots an interesting looking wooden figure and offers to purchase it for a price that represents a negligible amount to the traveler and a large sum to the owner; in this situation, the buyer lacks understanding of the meaning of the object in its native context, the seller lacks understanding of its meaning in its new home, and there is no common ground in the evaluation of the price for which it has been exchanged.

In my view, the most sensitive portrayal of the ironies inherent in this now-common situation has been offered by Edmund Carpenter, describing the evolution of a marketable Inuit art. (I urge readers to consult Carpenter's full texts, which constitute an eloquent homage to the Inuit "symmetry of silent assumptions" and a devastating chronicle of Western cultural arrogance.) Citing Henry Moore's fascination with Inuit carving, Carpenter

points out that "the Inuit were trained to make these souvenirs by a Canadian artist who admired Moore to the point of imitation. Inuit souvenirs bear more than a coincidental similarity to Moore's work, a similarity that helps market them" (1983). For Carpenter, the emblem of this process is Sedna, the spirit of a young woman whose family pushed her from their walrus-skin boat in order to survive, cutting off her fingers as she clung desperately to the gunwale and gouging out one of her eyes before she finally sank, battered and tangle-haired, into the sea, whence she now controls the destiny of humans.

> In the past, Sedna was rarely depicted and then only as a surreal form, experienced first as an inner vision. Here [in an "Eskimo art" gallery in New York] she was rendered naturalistically, as a mermaid, that sexually inaccessible figure who frustrates mariners. Her hair was combed; her fingers intact; her tale forgotten. [1983]

Lamentations on the disappearance of "original" traditions can be found in the writing of almost anyone concerned with the current artistic production of Primitive people. But not all of them are inspired by the same motives. Carpenter decries the development of soapstone carvings because it was imposed from outside and because it has deprived the Inuit of something that gave value to their life. Collectors decry tourist art with equal vehemence but tend to view it as a ruse perpetrated by wily natives and to resent its existence because it deprives them of value for their money. The frequency of the word "meretricious" in *African Arts* editorials is a telling reflection of this latter interpretation; deriving from a Latin root meaning "harlot" (of which the erudite editor is almost certainly aware), the term suggests a sleazy motive (on the part of the artist) of guile and deception, which the informed collector must oppose with firm and uncompromising standards of aesthetic worth. It might be suggested, however, that when we consider who was responsible for introducing the notion of marketing art objects beyond the domain of their intended homes and when we consider the (im)balance of wealth within which these transactions occur, it becomes a bit awkward to assign blame to the artists themselves.

Like its now aging parent, colonialism, and its somewhat younger cousins, travel journalism and tourism, Primitive Art collecting is based on the Western principle that "the world is ours." Two examples may illustrate the parallels:

I was sitting recently in a small cafe in a Martiniquan fishing village, when a Chriscraft pulled into the bay and anchored. Four sunburned men in

string bikinis disembarked into the waist-high water and four lithe, bikini-bottomed women climbed onto their shoulders, delicately keeping their high heeled scuffs elevated enough to stay dry. Once on shore, they lit their cigarettes and paraded down the main road, eight abreast so to speak, in search of a restaurant. Local fishermen and their wives watched the jiggling tits, colorfully bagged testicles, and wiggling asses and politely refrained from audible comment. For the hungry vacationers, the question of whose customs carried weight in this particular setting was an issue that was never raised.

A *Washington Post* correspondent described his attempt to score "the journalistic equivalent of a surgical strike" in the Sudan—an interview with Colonel John Garang, the rebel leader (Harden 1986). His sketch relates how confidence and optimism quickly gave way to the frustrations of "dizzying hunger," "a water supply usually reserved for lions," and swarms of "blue-bottle flies, biting ants, malarial mosquitoes and, circling above us, vultures." Most ridiculous of all, readers are told, were the "singularly unhelpful" hosts of this party; some, annoyingly, "spoke no English," others stupidly erected a tent for the reporters that later collapsed in a thunderstorm, and all responded to the visitors' problems with a combination of empty promises and irritating cheerfulness. It comes as no surprise, then, that after our reporter describes how Colonel Garang requested copies of the clippings, photographs and videotapes in exchange for granting the long-sought interview, he goes on to note simply, "Of course we would, we all lied." The journalist got his byline, as well as the opportunity to ridicule Garang for using pretentious words such as "irrespective" and for liking peanut ice cream, in a prelude to his discussion of the war being fought. The colonel obviously did not get xeroxed clippings, photographs, videotapes, or anything else.[6]

These scenes, hardly rare in the Third World, are repeated in spirit on a daily basis by Westerners who like exotic art. To pick a recent example once again at random, we might cite an article written for the *New York Times* and reprinted in the *International Herald Tribune*. "Trading in the Rich Art of Nepal" employs the standard vocabulary for such pieces, describing the "teeming mass of colorfully garbed Tibetans" who trade in "age-old" silver coins and other objects that are "jumbled together in shops" located in a "decaying 100-year-old former palace."

> A good place to search for antiques is Bodnath. This stupa is ringed by houses of lamas who turn prayer wheels set into the octagonal base. Everybody can walk the circumference turning the wheels; you

can, too, (clockwise), and at the same time have a preview of uninter-
rupted shops encircling the stupa along the wide cobblestone walkway
crammed with Tibetans in soft boots and black or red robes.
[Tregaskis 1986]

The key words are "you can too." With a credit card and sensible walking
shoes, nothing is out of reach.

Of course, the observation that art is used for power plays is neither original
nor limited to the situation of Primitives. Indeed, the interested participa-
tion of personal gain in the definition, evaluation, distribution, and exhibi-
tion of art threatens to produce a veritable holocaust for the credibility of art
connoisseurship. When the Metropolitan Museum of Art agreed, in return
for $350,000, to feature mention of Ralph Lauren and his "Polo" line of
clothing in all publicity for their exhibition "Man and the Horse," the
integrity of the museum can hardly be seen as having come out on top of the
bargain (McGill 1985). Or again, when a painting by the American ab-
stractionist Jasper Johns, *Out of the Window,* which he had sold in 1960 for
$2250, fetched $3.63 million in a 1986 auction, the artist enjoyed no share
in the proceeds (Higbee 1987). More generally, Lucy Lippard has noted
that for late twentieth-century Western artists, "it's all part of a life style
and a political situation. It becomes a matter of artists' power, of artists
achieving enough solidarity so they aren't at the mercy of a society that
doesn't understand what they are doing" (1973: 8–9; see also Honan
1988). It could be argued, however, that while the basic issue is the same
for Primitive Art, the way in which its makers are victimized bears witness
to a very particular kind of cultural arrogance. If New York artists feel
misunderstood and manipulated by forces beyond their control, they at
least have a clear awareness of what is going on and some access to modes of
communication that allow their voices to be heard. But Primitive artists,
who have never been permitted more than a partial glimpse of the market
they have been pulled into, do not enjoy even these small privileges. The
exploitation of their creativity thus takes on a slightly different flavor, for
they lack both familiarity with the beast they are feeding and any kind of
power over how it plans its meals.

6

OBJETS D'ART AND ETHNOGRAPHIC ARTIFACTS

Nor is the problem of museological contextualization limited to the case of Primitive Art:

PEOPLE

Georgia O'Keeffe Work Hung Wrongly 30 Years

A **Georgia O'Keeffe** painting hung the wrong way at the University of Minnesota Art Museum for nearly 30 years before the error was discovered. "Oriental Poppies," a 1928 painting, was placed vertically, instead of horizontally, said **Lyndel King**, the museum director. She discovered the mistake while doing research for an essay on the museum's permanent collection. The museum purchased the work in 1937 from an exhibition organized by the photographer **Alfred Stieglitz.** The original purchase record in the museum's archives also shows the painting is a horizontal, King said. "What the heck, it looks terrific either way," she said.

□

The "what the heck" reaction to the O'Keeffe painting might have been applied equally well to a carved openwork door that was included in an

exhibit of African and Afro-American art at the Yale Art Gallery in the late 1960s. Hung at eye level and illuminated from the rear, the piece was labeled a window, despite the fact that such an architectural concept did not exist in the South American village where it was crafted. Visitors to the exhibit thought it was pretty anyway.

How much should we care about maintaining knowledge of artists' original intentions when we display their works? And does Primitive Art differ from Western Art in this regard? We hereby open a can of worms that deserves to be placed on the desk of every museum director who has authority over the display of "exotic" objects.

For displays presenting objects *as art,* the implied definition of what should "happen" between object and viewer is relatively constant; the museum visitor's task-pleasure, for both Primitive and Western objects, is conceptualized first and foremost as a perceptual-emotional experience, not a cognitive-educational one. As one writer commented, the contextualization of art through didactic labels offends "those who consider the masterpiece more important than what it means to the uninitiated and . . . those who like their aesthetic stimulants straight" (Lynes 1954: 261).

For these same displays, the main distinction between Western and Primitive objects is that only the former are presented as having been made by named individuals at specific points in an evolving history of artistic styles, philosophies, and media. In this way, the status of Western art as part of a documented history of civilization (with names, dates, political revolutions, cultural and religious rebirths, and so forth) is acknowledged (signaled), even though the elaboration of details is reserved for other contexts (catalogs, art history texts, scholarly lectures, art magazines, etc.).

For most displays presenting objects *as ethnography,* information about technical, social, and religious functions is elaborated, thus erasing the notion that the aesthetic quality of the work is able to "speak for itself"—or rather, erasing the entire notion that the object possesses any aesthetic quality worthy of transmission. In this mode of presentation, the viewer is invited to form an understanding of the object on the basis of the explanatory text rather than to respond through a perceptual-emotional absorption of its formal qualities. In terms of the nature of the text, an emphasis on the object's cultural distance replaces the focus on its place within a documentable historical framework.

In the case of Primitive Art, a kind of either/or situation thus seems to constrain the composition of most labels. Exhibits tend to present objects *either* as works of art (in which case it is standard to supply a "dog collar" text, giving its owner's name and address) *or* as ethnographic artifacts (in

which case the object's geographical origin, fabrication, function, and esoteric meaning are elucidated at length).

Looking at art objects with perceptibly different kinds of "identities," we detect a tendency for perceived worth (a combination of artistic fame and financial assessment) to be inversely related to the amount of detail on the accompanying labels. An "ethnographic object" in the crowded case of an anthropology museum is typically explained through extensive prose, initiating viewers into the esoterica of its manufacture, use, role in the society, and religious meaning. If this same object is selected for display in an art museum, it is common for its financial appraisal to rise, for its presentation to become more spatially privileged (i.e., for the clutter of competing pieces to drop away), and for almost all of the didactic information to disappear. The isolation of an object both from other objects and from verbose contextualization carries a definite implication of Value. It is no doubt this principle that dealers recognize and exploit when they show their collections with only a small round sticker on each piece bearing a number that customers may use, discreetly, to learn the price of a particular item whose purchase they are contemplating.[1] The continuum from ethnographic artifact to objet d'art is clearly associated in peoples' minds with a scale of increasing monetary value and a shift from function (broadly defined) to aesthetics as an evaluatory basis; in terms of display all this correlates with an increasingly cryptic written contextualization.

Given the differential cultural familiarity, for Western viewers, of Western and Primitive art, it is not completely surprising when the accompanying labels accord more extensive didactic information to objects deriving from "exotic" societies; that is, there exists a logical rationale for explaining a Gelede mask in greater detail than, say, a twentieth-century painting of bathers on a French beach. It seems defensible, for example, that a sculpture in the Musée d'art moderne de la ville de Paris carries a label with nothing more than the work's title and the artist's name and dates: "*Hommage à Chagall* / Pau Gargallo (1881–1934)." In this case, curators could reasonably count on the general public to supply, in addition to their appreciation of the piece on formal grounds, an interpretation of the artist's intent; the spiraling ribbon that defines an openwork head and the ephemeral female figure that floats dreamily through the interior space thus formed make a sufficiently obvious connection with the work of Chagall so that no exegesis is needed. In contrast, an Australian aborigene viewing the same work might be well served by an explanation of the relationship between its title and the particular form in which the head was executed; and a Westerner faced with the work of an artist from New Guinea might

need the same kind of assistance in making sense of the allusions that, to "native" eyes, are equally self-evident.

The consideration of how much information viewers can supply on their own is, however, not usually the criterion responsible for the decision between dog-tag labels and didactic discourses; it is not always the case that Western Art is presented with minimalist identifying labels and Primitive Art with exhaustively ethnographic labels. Rather than the *object's* cultural identity, the decisive factor is often that of the museum. The kinds of artifacts that fill Paris's Musée de l'homme are also on display at the same city's Musée des arts africains et océaniens; many of the individual pieces could be transferred from one to the other almost without notice. The same redundancy of material exists in New York's American Museum of Natural History and the Center for African Art, as well as the museums of other cities around the world. Nonetheless, visitors to these exhibits are made to understand—through a variety of cues ranging from lighting, spacing, grouping, and so forth, but most directly through label copy—that one set of objects represents the artifacts of exotic or savage ways of life, and that the other represents world-class works of art, sometimes even "masterpieces."

The Museum of Primitive Art in New York represented a pioneering effort in the presentation of Primitive works as *art,* and the philosophy behind it was evident in the way that its pieces were displayed. As one critic remarked,

> Primitive arts, when not displayed like a boy-scout's collection of arrowheads, usually are swamped in raffia, spot-lighted with jungle colors and given a special Muzak of clicks and bongos.
>
> But the fact remains that we are inescapably who we are and any leaps of the imagination can take us only deeper into ourselves—or into the pathetic fallacy.
>
> The Museum of Primitive Art works with the simple but brilliant idea of accepting this truth. It judges its acquisitions and collections by modern esthetic standards. In other words—by what looks best to the best informed eyes. It does not attempt the impossible act of putting itself in the minds of the primitive artists nor does it try to revive a sense of the blood and magic which originally informed so many of its possessions. It plays it straight. [Hess 1968: 27]

The advocacy of decontextualization can be found wherever the value of Primitive Art has been boosted by outside interest. Adrian Marrie (1985: 17) has called attention to a discussion by Ann Stephen (1980) pointing out, in a discussion of Australian aboriginal art, that "ignorance of the

meaning of aboriginal culture is preserved as a positive value," and citing the words of Margaret Preston, "Mother of Kitsch Australiana": "The student must be careful not to bother about what myths the carver may have tried to illustrate. Mythology and religious symbolism do not matter to the artist, only to the anthropologist." Marrie also cites the similar views of J. A. Tuckson, who extols the exhibition of objects in art galleries (as opposed to anthropology museums) because it allows people "to appreciate visual art without any knowledge of its particular meaning and original purpose" (Tuckson, cited in Marrie 1985: 17).

There are definite hierarchical schemes involved in how an object of Primitive provenience is presented, but these have not been constant through time. Michel Leiris once described to me how, when the collections in the Trocadéro Museum were rehoused in the Palais de Chaillot (built in 1937 in the same location, and marking the founding of the Musée de l'homme), the objects were installed in austere metal cases and laden with exhaustive ethnographic contextualization, out of an explicit desire to stress that anthropology was a legitimate *science;* increasingly didactic labels thus allowed the objects to be upgraded from curios to scientific specimens. During the past several decades, with less concern about the status of anthropology as a science, the prestige of particular pieces is more frequently upgraded through a *reduction* in the label copy; ethnographic artifacts become masterpieces of world art at the point when they shed their anthropological contextualization and are judged capable of standing purely on their own aesthetic merit.

The popular insistence on distinguishing Primitive Artifacts from Primitive Art, with a higher status (as well, of course, as a correspondingly higher financial value) implicit in the latter, is evident throughout the contemporary popular literature. Kenneth Murray, for example, is said to have criticized one collector's offerings of Yoruba art for the Nigerian Museum because their "artistic standard" was "too high" for a museum that was "an ethnographical collection not an art gallery" (Allison 1973: 67). The editor of *African Arts* subscribed to this same hierarchy when he wrote:

> Such a huge number of superb examples of the arts of Africa have undoubtedly been on display for many years, but they were to be viewed amidst the usual associated mixture of spears, cloth, and cooking utensils that often mark anthropological displays in museums. The change in appreciation must be partly in our eyes; in the way in which we now choose to examine these works—as works of art, as means of communicating that essential aesthetic experience *rather*

than as mere evidence of how others in the world live. Now we are able to respond with our awareness of beauty *rather than* our sense of social curiosity. [Anon. 1971: 5, emphasis added]

Through a "rather than" construction, aesthetic experiences and beauty are not *joined with* ethnographic evidence and social curiosity, but opposed to them. In the same spirit of isolating aesthetic from anthropological sensibilities, a *New York Times* entertainment column commented that "The new exhibition at the African-American Institute . . . seeks to bring out the beauty, not the anthropology, of the objects" (29 September 1984, p. 10). And Paul Richard showed his awareness of this division when he wrote that the curator of the MOMA "Primitivism" show, William Rubin, "is not an anthropologist. What he has been looking for is quality" (1984a: H8). Indeed, Rubin cited the failure to draw this line as the essential handicap that prevented field ethnographers from collecting significant art: "as ethnologists did not generally distinguish between art and artifact . . . the majority of objects they brought back have little or no artistic interest" (1984: 21).

For people who *do* draw a line between art and artifact, as Rubin would like, and who wish to grant recognition to true art regardless of the society in which it was produced, the task takes on something of the character of a rescue mission. Susan Vogel situated the opening exhibit of the Center for African Art in this tradition when she wrote that "among the thousands of ethnographic specimens in the Musée de l'homme are many works of art, and among these a smaller number are masterpieces. This book is a selection of them. . . . the Musée de l'homme has long recognized that works of art lurked among the ethnographic specimens in its galleries" (Vogel and N'Diaye 1985: 11).

Responsibility for identifying those rare, lurking pieces of Primitive manufacture that embody Aesthetic Quality is accepted fully by Westerners. Although scholars occasionally put native aesthetic criteria under a microscope for social scientific study, African villagers are rarely asked to advise exhibit organizers about which masks merit the epithet of "masterpiece," and South American Indians do not generally serve as consultants about which feather headdresses deserve center stage in museums. In fact, the artists themselves (like the anthropologists chastised by Rubin) are often claimed to be oblivious to the aesthetic distinctions that define true art. Henri Kamer has rationalized this viewpoint by claims that African art "has not been conceived as such by its creator. The 'object' made in Africa . . . became en [sic] 'art object' upon its arrival in Europe" (1974:

33). Daniel Thomas noted the same sentiment in another part of the world when he remarked that "Australian Aboriginal Art became art, as far as the European-Australian art world was concerned in the 1940s. Previously it had been anthropology" (quoted in Marrie 1985: 17). And Jacques Maquet, who endorses André Malraux's distinction between "art by destination" and "art by metamorphosis" (1986: 18), places Primitive Art in the latter category, stating flatly: "Objects we have labeled 'primitive art' were ? not art for those who made them. . . . In the reality constructed by the men and women of the nonliterate world, art was neither a linguistic category nor a social practice" (1986: 66).

In the end, the problem of how much information to supply about works of art has to depend on an assessment of what goes on in the heads of artists and viewers. Ultimately we must deal with the artist's intention, the viewer's response, and the degree to which an appreciation of art demands a meaningful connection between the two. Are artists in conscious control of the aesthetic choices they adopt? Or are they rather producing objects through some combination of instinctive behavior and inherited tradition? And do Western and Primitive artists differ in this regard? For the viewers of a work of art, does aesthetic discrimination depend on a mastery of learned principles and social, cultural, and historical contextualization? Or is it largely a matter of innate taste and a good eye? And do Western and Primitive arts differ in this regard? These questions have been raised and partially discussed in earlier chapters; I would like at this point to reconsider them with special attention to the ways in which popular ideas about the distinction between Primitive and Civilized artists influence the presentation of their respective products in the context of museums and galleries.

Beginning with the artist's intention, let us consider whether the respective modi operandi of Primitive and Civilized artists distribute themselves differently on a continuum ranging from conscious mastery to unthinking expression. Writing about works of European conception, Michael Baxandall asserts that "Behind a superior picture one supposes a superior organization—perceptual, emotional, constructive" (1985: 135). The entire enterprise of Western art criticism is founded on a belief that, at some (arguable) level of awareness, the artist is making motivated choices by creating a work of art in a particular form, with the inclusion of certain details and not others, with lighting and shadows, angles of perspective, color combinations, and so forth all contributing to an *intended* effect. To cite just one example, Michael Fried's analysis of Thomas Eakins's *Gross Clinic* (1985) is important precisely because it succeeds in specifying ways

in which the artist's intention, previously imagined to have been limited to his choice of subject and a general commitment to realism, in fact extended in subtle and complex ways into numerous details of his composition and linked this painting to other works by the same artist that might seem, at first glance, to be unrelated.[2]

But it is not the case that the basic premise of intentionality is extended to all artists. As one visitor to the Rockefeller Wing volunteered, Picasso was different from Primitive artists because "even if he drew three eyes, he knew what he was doing" (Novack 1982). A common ingredient in Western conceptualizations of Primitive Art is that it is produced more spontaneously and less reflectively—with less artistic intentionality—than works of Western authorship. African, Oceanic, and Native American craftsmen may care about the ritual efficacy of their creations, the thinking goes, but they recognize neither the aesthetic options open to them nor the aesthetic consequences of the choices they make, and in the end do not even consider that what they are producing is "art." Some statements of this point of view are presented as expressions of open-mindedness and liberalism, arguing that the category of "art" is an exclusively Western construct and that to expect it of Primitive peoples represents an ethnocentric fallacy. But the convenience of this conclusion, which gives Westerners complete control over the aesthetic judgment of the world's art on the grounds that it would be culturally inappropriate to call on native aesthetic conceptualizations, may encourage many people to adopt it a bit too hastily. Just as glossing exotic arts as "anonymous" frees Westerners from the laborious task of determining and acknowledging the individual authorship of particular pieces, claims that Primitives have no concept corresponding to our notion of "work of art" dispenses with the need to take native *aesthetic* frameworks seriously.

The available options then become extremely neat and clear-cut. One is to present a given object in its anthropological context, grouped with related artifacts and made accessible to viewers through didactic labels that elaborate its manufacture, its role in the traditional life of the community, and its social or religious meaning. The second is to give it its own pedestal or museum case, indicate roughly the continent or archipelago in which it was collected, and, by the very fact of letting it "speak for itself," grant it membership in the elite society of art works that pass muster on the basis of pure aesthetic merit.

Once an object is channeled into this second category (that is, once it is defined as art rather than artifact), the logic by which it would have deserved more extensive contextualization than a work of Western prove-

nience undergoes an interesting inversion. As an ethnographic specimen, a Yoruba mask or a Kwakiutl totem pole or an Easter Island dance staff clearly needs a more detailed explanatory text than, say, Van Gogh's painting *The Potato Eaters* in order to be appreciated by museum-goers. As a work of "art," however, it may need even less if we accept certain received ideas about Western and Primitive cultures. For people to whom Vincent Van Gogh is an individual creative artist, who lived at a particular point in history and even has (thanks to his self-portraits) a visualizable presence, whose personal struggles and family relations are more or less generally known, and whose total artistic output is conceptualized as a coherent whole, related to that of certain other specific, equally well documented individual artists, there is a rationale for trying to explicate his artistic "intention," his aesthetic choices, the development from one period of his life to another, and other issues of art historical interest. On the other hand, a kachina whose "native meaning" (including technological, religious, and social considerations, but not aesthetic ones) has been left behind in the anthropology museum, and whose "anonymous" maker is thought to have operated on the basis of raw emotion, in combination with the age-old traditions of the community, that precluded artistic reflection or the innovative solution of design problems—this is an object about which it is difficult to know what to say in terms of art historical exegesis. Faced with such an object, we have little left to do but commune with its universal beauty—gripping, inarticulable, and mysterious.

This is, in fact, what happens. The "mystique" that envelops the communion between the world's great art and the world's great connoisseurs intensifies in the case of Primitive Art, for this latter, in its role as objet d'art, appears to be more adaptable than its Western counterparts to distillation into a context-free aesthetic essence. Let us listen to some personal testimonials to capture the flavor of this very special experience.

> There are inner forces in one's life that sometimes seem to be unrelated to conscious thought. This can be true of appreciation as well as creation of art.
>
> Much of so-called primitive art was created as a direct response to strong feelings. My appreciation has been a direct response to the power and beauty of that creation—in different forms and by different peoples—but always an expression of those inner forces interpreted with compelling directness and simple beauty. . . .
>
> I was fortunate to be able to acquire—through osmosis, I guess—an appreciation and enjoyment of art in various forms. It was

not a conscious intellectual effort on my part, or a matter of discipline. Thus, primitive art never seemed strange to me. [Nelson Rockefeller, in Newton 1978: 19]

Or again:

[Upon my first view of African statues,] I felt a strange excitement mixed with anxiety.

This sensation, which combined pleasure and pain, I have never forgotten. Although I did not know then what had happened to me, I recognized it as a powerful, even an overwhelming experience . . . , the quality of which I could not define. . . . What moved me so deeply in those days, I did not know. I had no knowledge or information about the background of African art. . . . The plastic aspect of African works "spoke" to me, without my knowing about the coordination of those exciting shapes. . . . only now do I realize that I approached these art works from the phenomenological point of view, that is, without any presuppositions or information *about* them. I faced them, I was exposed to them as they appeared in my field of vision. [Segy 1975: 3, emphasis his]

In a similar spirit, Werner Muensterberger argued:

As spectators of works of art and imaginative conceptions we cannot cling to the notion of their designated or documented meaning. We would confine ourselves to a rigid determinism as spelled out by the tribal lore. . . . our reaction to these works of art is inextricably interwoven with the contribution made to these objects from the realm of our own unconscious. . . . The intention [of tribal art,] being pre-cognitive[,] often transcends concrete description. Moreover, searching for footprints, that is to say the indigenous idea or ideas attached to these examples, may perhaps lead one away from one's own aesthetic sentiments. [1979: 9–10; see also Kamer 1974: 38, quoted in chap. 1]

And finally, UCLA anthropologist Jacques Maquet provides us with a variant of this approach which was colored by the meditative techniques he learned as a resident trainee in Buddhist monasteries in southeast Asia and which reminded at least one of his readers of the 1980s trend in "out-of-body experiences" as endorsed by Shirley Maclaine and parodied by Garry Trudeau. In his contemplative mode, he describes being lifted "outside of

my usual stream of thoughts, worries, and feelings" (1986: 29), and this represents a necessary precondition for the aesthetic experience: "Beholding art requires silencing discursive activities; it is not compatible with an analytical attitude" (1986: 33). Maquet cultivates these powers of "bare attention" for the contemplation of everything from Calder stabiles and Pollock paintings to Sri Lankan Buddhas and the curvaceous bodies of nude sunbathers (1986: 29, 80–82, 112, 137).

> After a few minutes of aesthetic contemplation, I was struck by the inner vitality conveyed by the forms. It was as if a force radiated from the statue. My body assumed a position analogous to the one of the statue, my breathing became slower, deeper, and more regular. My eyes focused on the visual center, the lower abdomen, chosen by many meditators as the place where they perceive each inhalation and exhalation. I had the visual perception of mental concentration. The statue was a symbol of mental concentration, and the statue made it visible. The statue was mental concentration itself. And this gave me an experience of mental concentration.
>
> At the time of this experience, the perception of concentrated force was not even verbalized, and still less, analyzed. Described above is the experience-as-recalled; during the experience-as-experienced, I did not use words. The perception was pure intuition. [1986: 112]

It should already be clear that my various involvements as ethnographer and exhibition curator lead me to entertain some doubts about the nature of these silent encounters between Primitive objects and Civilized viewers. As Paul Richard gently commented, "Perhaps all tribal masterworks, and all great works of art from whatever culture, share a certain something—'I know it when I see it'—that subtle connoisseurs are able to detect. Perhaps and perhaps not" (1984b: K2). And David Attenborough has employed a well-justified analogy with language-based arts to raise much the same question:

> No one would judge a poem in a foreign language entirely in terms of its formal qualities of metre and rhyme, no matter how beguiling or inventive these may seem. It would be almost as unjust to limit an appreciation of the Primordial Couple [a Dogon statue illustrated in his text] to a consideration of its geometrical characteristics. [1976: 138]

The crux of the problem, as I understand it, is that the appreciation of Primitive Art has nearly always been phrased in terms of a fallacious

choice: One option is to let the aesthetically discriminating eye be our guide on the basis of some undefined concept of universal beauty. The other is to bury ourselves in the "tribal lore" to discover the utilitarian or ritual function of the objects in question. These two routes are generally viewed as competitive and incompatible, especially in the context of museum presentations, where, as we have seen, curators are expected to choose between the "beauty" and the "anthropology" of their material.[3]

I would propose the possibility of a third conceptualization that sits somewhere between the two extremes and may reflect a more realistic picture of both the nature of the aesthetic experience and the nature of art in Primitive societies. It requires the acceptance of two tenets that do not as yet enjoy widespread acceptance among educated members of Western societies.

—One tenet is that the "eye" of even the most naturally gifted connoisseur is not naked, but views art through the lense of a Western cultural education.

—The second is that many Primitives (including both artists and critics) are also endowed with a discriminating "eye"—similarly fitted with an optical device that reflects their own cultural education.

In the framework of these two tenets, anthropological contextualization represents, not a tedious elaboration of exotic customs that competes with "true aesthetic experience," but rather a means to expand the aesthetic experience beyond our own narrowly culture-bound line of vision. Having accepted works of Primitive Art as worthy of representation alongside the works of our own societies' most distinguished artists (as recent exhibits at major art museums around the world make clear), our next task is to acknowledge the existence and legitimacy of the aesthetic frameworks within which they were produced. Contextualization would then no longer represent a heavy burden of esoteric beliefs and rituals that distract our psyches from the beauty of objects, but rather a new and freshly illuminating pair of glasses.

The differences and similarities between Modern Art and Primitive Art have been singled out for scholarly attention and analysis on several dimensions—formal characteristics, the kinds of reality (e.g., visible, conceptual, or symbolic) they are intended to capture, and their respective roles within the societies that have produced them. But the comparison has not yet (to my knowledge) taken into consideration the role of Western notions about "authenticity."

Much of the conceptualization of the quality of things that we of the

Western World tend to take for granted posits a relationship between "originals" and their "copies" in which the former has greater legitimacy and value. An authentic Rembrandt is better than a forged one; the Hope diamond is better than its rhinestone imitation; a chiseled sculpture is better than its duplicate from a plaster mold; a printed and typewritten birth certificate is better than its xeroxed look-alike. What separates "originals" from their competition is temporal priority and superior value. Without an acknowledgment of value, there would be no reason to create a copy; and by definition, a copy can only come after an original.

We do acknowledge the excellence of skillful copies. Reinhold Vasters' gold work fakes are recognized for their finesse; a book publisher may be congratulated on a color reproduction of the Sistine Ceiling; and clothing distributors sometimes remind us of the perfect respectability of a high-quality imitation:

In most cases, it is the original that sets the standard; the original is by definition superior to even the cleverest and most painstaking of the copies. The goal of the copyist is to come so close to the original that the gap separating them will go unnoticed. But the gap is still there, and the original is still the acknowledged winner; it alone is considered "authentic." Usually,

all the copy can offer in compensation for its second-place status is readier availability or a cheaper price.

Considering that the Western understanding of the relationship between Primitive and Modern Art includes an acknowledgment of some sort of artistic imitation (which explains the importance of determining, for example, exactly when Picasso first visited the Trocadéro Museum and which pieces he saw there), it comes as no surprise to see that these, too, have been marketed in a "guess which is which" juxtaposition:

The beaded tops and the distorted faces are promoted through an identical format, taunting us with look-alikes and implying that in some respects they are on a par with each other. In each case, the riddle is posed, the two alternatives are presented side by side, and the answer is given in upside-down printing at the bottom of the space. Each one is designed to convert readers into customers.

Focusing more attentively on the two pairs, however, we begin to see that the standard format for the original/copy challenge can be turned on its head, with intriguing results.

In the case of the clothing ad, a paradox is created by the disjunction between higher value (which remains, implicitly, with the original) and lower cost to the consumer. Why should one pay $800 for a copy, it asks, when one can have the original for $80?

The paradox presented by the MoMA ad runs along different lines. Picasso's artistic genius has, in Western eyes, allowed his "copy" to best the "original" on which it was modeled. Both are, by the very fact of being displayed in the Museum of Modern Art, acknowledged as artistic masterpieces; the crucial difference between them, like that between the two ladies illustrated in chapter 1 who were *charmante* and *charmeuse,* is imagined to be more a matter of underlying intention than one of visual appearance. In what ways, then, did the ad writers expect associations of originality, value, artistic genius, and authenticity to distribute between these two images in the minds of their readers? In a sense, Picasso's image is cast in the role of the "original," with the African mask representing a startlingly close second-best whose status depends on its affinity to a recognized masterpiece. Historically, the African mask came first, and Picasso was influenced by it; but for potential visitors to an exhibit at the Museum of Modern Art, Picasso's name and fame are of long-standing, and it is the African mask that is being newly introduced. The history of creation and the history of appreciation are, in this case (as in the case of Modern and Primitive Art more generally), inversely related. Primitive Art is elevated in status by being shown in the context of Modern Art; the reverse procedure (that is, the elevation of a European artist by means of an exhibit that introduced Modern Art into an anthropological museum) would not achieve the same effect. Modern Art holds claim to the titles of authenticity and recognized masterpiece status, and much of the popular admiration of Primitive Art is based on associations with features that first caught our interest through the work of twentieth-century Western artists.

Many readers of the above paragraphs will already have dismissed their argument on the grounds that Picasso cannot be said to have "copied" the work of his African colleague, but rather to have drawn inspiration from it, which is a very different matter indeed. This is certainly true. But the documentation of art history and the marketing of art exhibits are two different matters, and the latter is much more closely linked with popular consciousness. By choosing this particular format, the advertising agency charged with promoting Philip Morris and the MOMA exhibit cleverly manipulated a publicity device based on the notion of comparative value between competing products. Readers are meant to be impressed at the realization that these two art objects are so similar. Set in the context of the advertisement section of the newspaper, similarity of juxtaposed images can mean nothing other than comparable value. And if one of the two objects depends for its status on being virually "as good as" the other, it is certainly not the Picasso, for Picasso is sufficiently established in the public's mind in his own right to render an "as-good-as" status unthinkable.

Thus, it is the African mask that is marvelous by being "as good as" the Picasso. Despite its temporal priority (which would normally accord it the status of an "original"), the mask is presented as deriving its value from its striking similarity to an art object of Western-authenticated importance, thus taking on, in some sense, the status of a "copy." Even when Primitive Art serves as a model for Western art, then, it can be viewed through Western lenses as a lesser achievement.

The issue of the relative worth of different societies' art exists on at least two dimensions. What an object is worth in terms of critical attention is paralleled by what it is worth in hard currency, and along both dimensions Primitive Art is generally quite low on the list. One former dealer (who has had galleries in both Paris and New York) responded to my question about what attracted his customers to collecting Primitive, as opposed to other, art by saying that a central consideration was the possibility of assembling a respectable collection at a fraction of the cost that other art would have required. It raises no eyebrows, then, when Douglas Newton recounts how he paid Kwoma artists in New Guinea one dollar for each of the bark cloth panels that are displayed in the $18.3 million Rockefeller Wing of the Metropolitan Museum of Art (Kramer 1982). Even with a spectacular rate of inflation between field collecting and gallery sales, such art starts out at a low enough price so that it can always remain easily affordable for any

art collector's budget. Along with the undeniable aesthetic enjoyment that collectors derive from Primitive Art, there is an assumption that, wherever one's tastes run, it should be possible to satisfy them at a reasonable price.

I conclude these reflections on the art-ethnography distinction with a brief violation of my stated intent to avoid discussion of disciplinary categories. My remarks are offered in the hope that they will encourage a more actively constructive interplay between anthropological and art historical perspectives and a heightened awareness of the assumptions that have colored their respective representations of Primitive Art.

It seems important to recognize that the learned cultural background we draw on when we view works of art includes an aesthetic component. In the face of unfamiliar art, we therefore need special help not only with its social, economic, ritual, and symbolic environment, but also with its aesthetic surroundings—that is, with the ideas about form, line, balance, color, symmetry, and so forth that contributed to its creation. For the documentation of the world's art makes abundantly clear that the aesthetic goals of its makers and critics are *not* universal; assessing an African mask on the basis of our own culturally acquired aesthetic criteria is roughly analogous to assessing a Miro painting according to aesthetic criteria valued by Michelangelo. The existence of shared cultural knowledge and perspectives among Western art viewers contributes to the illusion that what they esteem in a work of art is its aesthetic quality, pure and unadulterated. When cultural knowledge and perspectives are implicit rather than explicit, aesthetic evaluations can assume an authority that seems unarbitrary, timeless, and unconditional. This context has encouraged what Gary Schwartz calls "the axiom that 'the work itself' is the starting point, guiding light and destination of art history" (1987: 4), which in turn defines (and limits) the goal of art historical scholarship; writing about the case of Dutch art, Schwartz notes that most art historians

> see as their essential task the direct confrontation with the work of art itself. The study of historical or social circumstances may sometimes be of aid to them in that task, or may be so compelling as to be unavoidable. But to set out to integrate art into daily life would be seen as a dilution of the central value of art history as a disipline. [1985: 8]

From this perspective, a gap of monumental proportions is created between the commonly perceived raison d'être of art historical and anthropo-

logical research. If the value of art history is seen as diluted by attention to the integration of art into "daily life" (which in Schwartz's study of Rembrandt includes everything from economics and art patronage to politics and personality clashes), the value of anthropology may be seen as largely confined to it. As one art historian objected, responding negatively to a proposal for a joint graduate program in anthropology and art history, "Anthropology denies the uniqueness of the art object." This difference of focus goes far toward accounting for the intellectual tension that characterizes the relationship between students of cultural expression from the two disciplinary backgrounds. Although it refers to interpretive approaches, the difference has traditionally been closely linked to specific subject matter as well. Thus, European painting has generally been studied in terms of "the work itself" and Northwest Coast Indian painting has generally been studied in terms of its place within a cultural environment. Much of the recent "valorization" of Primitive Art has simply been a matter of removing selected Masterpieces from one realm and depositing them in the other, without in any way narrowing the great divide that separates them. My own view is that the next step, in working toward an insightful understanding of the nature of artistic expression and its reception, must be taken in a double direction: supplementing the aesthetic discourse on Western Art with in-depth discussion of its social and historical environment, and supplementing the ethnographic discourse on Primitive Art with serious investigation into the nature of the specific aesthetic frameworks within which it is kept alive.

7

FROM SIGNATURE TO PEDIGREE

If the artist isn't anonymous, the art isn't primitive.—An art dealer, Paris, 16 February 1987

Questions of authorship further muddy the already murky canal through which objects pass on their way from tribal obscurity to Western authentication as art—with profound and occasionally farcical consequences for transcultural artistic encounters.

> While superintending Pueblo pottery revivals, Kenneth Chapman of the Museum of New Mexico insisted that Maria Martínez authenticate and increase the value of her pottery by signing it—something that Pueblo potters had never done. When the other potters in the village realized that pots with Maria's signature commanded higher prices, they asked her to sign their pots as well and she freely did so until the Santa Fe authorities realized what was happening and put an end to this semiotic riot. [Babcock 1987: 394–95; see also Warner 1986: 185–87]

Between the perspectives of art lovers who satisfy their passion in museums, books, and magazines and those who go on to possess the art itself, a subtle but crucial change takes place. Of course, these two populations exhibit a substantial overlap, but let us consider, for analytical purposes, the limiting cases of (*a*) people who attend exhibits regularly and absorb the texts and images of books and magazines but do not generally consider buying original works of art and (*b*) those who complement exhibit visiting and reading by participating regularly in auctions, collectors' events, and gallery openings. Clearly, both "amateurs" and professionals (art historians, museum directors, and the like) vary in terms of whether and how much they extend their involvement into the area of collecting.

The common ground of collectors and noncollectors is extensive: a responsiveness to line, form, visual balance, and texture; an interest in the chronological unfolding of individual careers and of larger schools and movements; the development of particular preferences and areas of spe-

100

cialization; a subtle interweaving of spontaneous reactions and acquired knowledge; and an enjoyment of the kinds of discussions that transform a personal passion into a social pleasure.

But there are at least two considerations that distinguish collectors from other art lovers: possession of the art itself and major financial commitment. With the personal ownership of a work of art narrowly restricted in its availability (compared, on the one hand, with art museum visits, reproductions, books, and magazines and, on the other, with consumer goods such as cars, televisions, and clothing), collectors and dealers are operating in a system strongly characterized by the image of limited good. Pieces therefore change hands through auctions, and individual sales can instantly redefine the financial range of the market; the law of supply and demand is king, with the supply being small and the demand malleable. The social world of those who collect original works of art is an exclusive one, simply because relatively few people have the resources to engage in it. And because its members are united by their shared goal of expanding personal ownership in a limited pool of objects, their relationships are characterized by a mixture of collegiality and rivalry.

While the central interest of both noncollecting and collecting art lovers is in principle the work of art itself, their secondary interest in its history is somewhat differently defined in the two groups. Overstating the case slightly in order to introduce a point that will be refined in the following pages, I would propose that collectors sometimes allow a work's artist to be upstaged by its owners. Still generalizing broadly: noncollectors tend to focus their attention on the object itself and the history of its original creation, while collectors tend to focus theirs on the object itself and the history of its subsequent reception. This should hardly surprise, since collectors are—*in addition* to indulging all the aesthetic enjoyment that forms the raison d'être of their passion—committing vast personal resources to playing a game whose stakes are defined by an exceptionally precarious structure of personal judgments which, even if we carefully avoid the label of arbitrariness, must be seen as ultimately unverifiable by anything other than a general consensus among the players.

This game of competitive acquisition produces a special exhilaration that is not known to noncollecting art lovers. The metaphors that collectors call on to evoke the emotions of collecting vary from game hunting to drug addiction to sexual conquest; people have described the thrill of collecting as being like that of stalking wild animals, others have referred to their obsession as a toxicomania, and others have spoken of their desire for possession as Don Juanism. One dealer told me that he placed museum |

curators in the same category as men whose only knowledge of women derived from reading pornographic magazines; collectors, by possessing the objects, are the ones who know how to make love. Just as headhunters have always understood, he proposed, "Knowledge is founded upon possession." [1]

Viewing the phenomenon of connoisseurship within the special context of serious collecting, we see that aesthetic and historical considerations lose none of their relevance, but that several new elements come into play as well. The additional factors reflect the identity of a given work of art, not in terms of its physical form or original creation, but in terms of its subsequent history of ownership. Collectively, they define the object's pedigree.

The pedigree for a work of art, like that for a dog, constitutes an authenticated line of descent, providing for the potential buyer a guarantee of the value of the purchase. In this sense, it is not unlike the deed for an historical landmark or the yellowing book plates in a rare volume; it specifies the company one will be keeping, in retrospect, by assuming ownership. The pedigree for a work of art lists, not only previous owners, but also the exhibits and publications in which it has appeared, the sales at which it has changed hands, and the prices that have been paid at each transfer.

Pedigrees can be negative as well as positive, and sometimes need to be "cleaned up." A highly unpopular collector-dealer who put his African sculpture up for sale through a Sotheby's auction with great publicity received scarcely a bid, and those few pieces that were sold fetched prices far below the market value they would have had without his name; I have been told that any remarks about a particular object looking like a piece from that collection is taken as a nasty put-down. Or again: some acquisitions conducted under the protection of Nazi uniforms have been laundered by stories that their original collectors were German hobbyists.

But let us turn to the case of Primitive Art, for collecting in this area involves some special considerations that do not characterize the collecting of other types of art.

After a Primitive artifact has been removed from "the field" (whether by sale, theft, or some other variant of the transfer to Western ownership), it is customarily issued a new passport. The pedigree of such an object does not normally provide detailed information on its maker or its original (native) owners; rather, it counts only the Western hands through which the object has passed. [2] An African figure that was once owned by Henri Matisse or Charles Ratton or Nelson Rockefeller is unrelated, in this system, to a sculpture by the same artist that was not.

The "anonymization" of Primitive Art, as described in chapter 4, is

essential to this specialized identity, for by glossing over both the artist and the native owners, people who deal in Primitive Art free themselves to concentrate on a pedigree of more readily recognizable distinction. Edmund Carpenter has pointed out that American Indian artifacts are routinely named after famous previous owners (personal communication, 17 October 1986); the "Brummer Head" mentioned in chapter 3 got its name, not from the African sculptor who made it, but rather from a Hungarian one who owned it,[3] and of course museum labels that accept the anonymity of Primitive artists show less indifference (and more gratitude) toward the people who have taken over possession of the objects once they reach the Civilized World.

The actor Vincent Price has stressed that the seductive appeal of "anonymity" contributes importantly to his own enthusiasm as a collector of African art: "the anonymity of the creator actually enhances a work of art . . . it is our very ignorance of the men which supplies some part of the mystery of [its] creation" (Anon. 1972: 22–23). And a Parisian collector with whom I spoke volunteered: "I am completely enchanted by the artist's anonymity. Not knowing the artist is something that causes me enormous pleasure. Once you learn who made an object, it ceases to be primitive art."

For collectors of Primitive Art, it is not surprising that pedigrees hold a special importance. If we imagine the identity of an object to be built out of its known history, then it is clear that that of a European painting, for example, begins at the moment of creation, within a specific context of artistic movements, interacting schools and personal relationships, innovative responses to a known past, and perhaps the patronage of a historically documented figure; in addition—but always in addition—the identity of a particular piece depends on its subsequent life history. For an Ashanti gold weight or a Xingu feathered headdress, this is not normally the case. The establishment of its "anonymity" effectively reduces its documented history to Western collectors, museums, auctions, and catalogs.

In discussions with Primitive Art dealers, I have several times brought up the lost artists and raised the possibility of their relevance. Two kinds of response have been given.

One argues that it is the gifted or trained connoisseur (by definition, a member of Western civilization) who first "sees" the artistic quality of a piece. One dealer was willing to talk to me at length about his understandings of connoisseurship, sensitively analyzing his own "eye" for quality— what aesthetic elements were decisive, what role was played by subjective emotion, how he evaluated closely comparable pieces, and through what kind of discourse he was able to persuade other collectors of the beauty that

he had identified. At the end of this rather detailed discussion, I asked whether he thought any of what he saw in a given object would have been recognized or perhaps even intended by the artist who made it. His answer was immediate and emphatic: "Certainly not!" The artist of such an object, he explained, was at most interested in crafting it well, according to the (technical and other nonaesthetic) standards of the community; he had no appreciation of its artistic qualities, which depended on the European's gaze to be discovered. According to this line of reasoning, responsibility for objects *as works of art* resides with Western connoisseurs, and there is really no point in fussing over the exact identity of those who happened to produce them, for these people are both interchangeable as artists with others in the community and insensitive to the aesthetic value of what they have created. Collectors and dealers used terms such as "artistic intervention" and "the imposition of taste" to make me understand that their role was a vigorously active one, not unrelated to an artist's act of physical creation; one glossed it as a *geste artistique*. In the view that many collectors urged upon me, they bore responsibility for creating an "aesthetic whole" by selecting, according to their personal vision, exceptional works crafted by people who had no comparable vision, people whose criteria of excellence had no significant aesthetic component. They essentially see themselves as doing for African sculpture (for example) what Andy Warhol did for Brillo boxes or, more strictly speaking, Marcel Duchamp for urinals.

The second argument makes no reference to the locus of connoisseurship, but asserts, rather, that information concerning the identity of artists is, lamentably, not available. According to this view, the practice of documenting a collector's name but not that of the artist (whether on museum labels or in dealers' dossiers) results simply from the untraceability of personal identities, which have been lost through a combination of native inattention to named artists (since the intent of the art is purely "communal"), the absence of written documentation, and the unfortunate but now irremediable insouciance of early collectors. This perspective has already been documented by several examples in chapter 4. Let us make a brief detour into the realm of classical art history to consider the implications of this claim.

It is true that a great many pieces of Western art bear a "signature" of a sort that is lacking on objects from, say, Native America, Africa, or Oceania. However, even a cursory brush with art historical scholarship suffices to abolish the dream that these signatures neatly match objects to makers in any incontestable manner. Rather, a significant number of them serve as the point of departure for a complex, ongoing discussion that calls

on (and sometimes even exceeds) the considerable erudition of the most specialized devotees, not to mention the most advanced techniques of visual and chemical analysis in the laboratory. Because Joseph Alsop's "The Faker's Art" (1986) contains one of the best illustrations of the phenomenon that I have read recently, I return to it to make my point.

In summarizing the art historical research on what was once known as "the Cellini Cup," Alsop offers a brief overview of the devoted attention that Dr. Yvonne Hackenbroch lavished on this object. His story focuses on her conversion from the position she assumed on the basis of her analyses of it in the 1960s (that it was stylistically too late to be the work of Benvenuto Cellini and was instead the creation of a sixteenth-century Delft goldsmith named Jacopo Bilivert or Biliverti) to the stance that she adopted a decade and a half later and supported in her "sober one-hundred-plus[-page] copiously illustrated" contribution to the *Metropolitan Museum Journal* (that it was a "fake," probably crafted in the nineteenth century by a German locksmith's son, the notorious Reinhold Vasters).

The conclusions that both Hackenbroch and Alsop draw from the story are fascinating in their own right. But there is an additional lesson to be gleaned from them when we set them side by side with the widespread anonymity of Primitive artifacts in Western settings. Scholars of the Fine Arts spare no effort in their search for the true origin of masterpieces; they learn many languages, fly around the world, hire technicians to peer through microscopes, sit for endless hours in libraries, tolerate the dust of archives and museum storerooms, and devote countless learned discussions and published debates, with their equally intense and well versed colleagues, to the probability of alternative attributions. The process often consumes the researcher's working hours for a period of many years, without even mentioning, as Sherman E. Lee did in his reply to Alsop's commentary on the "Cellini Cup" (1986: 76), all the sleepless nights.

Partly because of the traditional segregation of art history and anthropology as disciplines, it is rarely suggested that the same kind of energy might go far toward establishing the identity of the person responsible for, say, a piece of statuary from Nigeria. Given that a relatively small proportion of such objects predate the nineteenth century, there is a good chance for most that their authorship is ascertainable with as much certainty as that of Reinhold Vaster's gold cup. In the case of early twentieth-century art from the rain forest of Suriname, for example, I have found specific attributions to be a challenging task, dependent on language learning, methodological skills, and theoretical background, but no more of an impossible undertaking than research described in traditional art historical scholarship.

An inattention to the social and cultural setting in which an art object was originally created not only allows its worth to be defined according to more comfortably familiar variables, but also nurtures an environment in which viewers can participate in "pure aesthetic experience" of the sort discussed in chapter 1. The incompatibility of a collector's passion and a scholar's erudition was a recurrent theme in the discourse of the collectors and dealers I interviewed in the course of my research for this book. For many (not all) of them, avoidance of scholarly analysis was seen not only as acceptable, but as *necessary* to satisfactory aesthetic enjoyment. Like Paul Valéry and others who have written about Western art in terms of this variable (see chap. 1), many connoisseurs of Primitive Art—particularly those involved in collecting—characterize academic knowledge as interfering with spiritual communion between viewer and object. Alain Schoffel was kind enough to share with me a manuscript he was writing, in which this perspective is set out with clarity:

> I believe the time has come to recognize that, in order to appreciate a work of art, whatever it may be, we must remove it from its context, stop explaining, justifying, and analyzing, and limit ourselves to looking at it with eyes that see. In other words, let it not be veiled by an encumbering knowledge that prevents us from looking at the beauty of its style and the intrinsic content of the work in its own right.

He went on to elaborate his position by remarking that

> The eye is a reflection of the soul. The eye doesn't think; the eye sees. The brain interprets. Vision [*le regard*] is when the brain yields to the eye. True vision is the vision that is not self-aware [*qui s'oublie*].

Stripped of its original authorship and, more generally, of conceptual footnotes, the object stands nakedly before the gaze of the Western viewer. The discourse of a few of the collectors with whom I spoke reminded me of Claude Lévi-Strauss's reference to Brazilian adventurers who intermarried with Caduveo Indians and later described to him "with quivering emotion the bodies of nude adolescent girls completely covered with [painted] interlacings and arabesques of a perverse subtlety" (1958/1974: 280). In the art collecting equivalent, the object's mystery (cultural exoticism explicitly enhanced by its "anonymity") and the collector's sense of power (through physical possession and "the imposition of taste" within a market context) combine, for some, to create strongly passionate emotion.

When a piece of Primitive Art enters a Western collection, there is a perceived transfer of aesthetic responsibility. One collector laid out this aspect of the process through the following explanation:

> With this kind of art, there is no such thing as a signature. What fills the void is the who-possessed-what. If you know that an object was owned by Epstein, Rasmussen, Ratton, or Paul Guillaume, that tells you something, because those are people who had an eye for art, who had taste, who had real standards. . . . A dated photograph of an object with Kahnweiler is worth more than any signature ever could be. . . . A pedigree—that's equivalent to a signature.

As pedigrees replace the artist's signature (unlike Western art, where they merely complement it), even the notion of authenticity is reshaped. A "good" museum label "assures the authenticity" of an object offered for sale, and the idea of publishing (a photo of) an object is explicitly viewed as a device to "establish its authenticity."

In discussing his passion for African art, Vincent Price is said to have remarked that the artist in communal societies chooses to "write himself out of his creation" (Anon. 1972: 22). When we consider that one of the criteria commonly cited to justify the category of Primitive Art is the absence of writing, it may be appropriate to question—in analyzing the Primitive's undeniable removal from the world of recognized artistic creativity—whether he is in fact the one who has taken pen in hand.

8

A CASE IN POINT

The huts along the rivers of Surinam are like the huts beside the
Congo, as they were in the days of Stanley and the early explorers. And
in these huts, polygamously, the Bush Negroes live. —Morton C.
Kahn [1]

As we near the end of this little book, it is time to explore more pointedly
what the generalities and abstractions discussed up to this point mean in the
actual lives of real people. Rather than continuing to build a patchwork of
anecdotal secondhand evidence from around the world, it will be useful
to lend some firsthand attention to a single case, looking at the ways in
which Western notions about Primitive Art have operated. The Suriname
Maroons, descendants of Africans imported to South America as slaves in
the seventeenth and eighteenth centuries, will be the focus of this chapter,
simply because I have, together with Richard Price, been studying their
way of life since 1966 and have extended experience with their arts, both in
their villages and in museological settings.

The Maroons are united by a heritage of rebellion from the oppression
of plantation slavery but divide into six politically distinct groups; the
Saramaka and Djuka each number some 22,000, while the Paramaka,
Aluku, Matawai, and Kwinti together include roughly 6,000 people.
Their ancestors' sustained wars of liberation ended with peace treaties in the
eighteenth century which granted them independence from the Dutch
colonial government, territorial rights in the interior, and periodic tribute
in the form of manufactured goods from the coast such as soap, cooking
pots, cloth, guns, and axes. The Djuka, Paramaka, and Aluku (in eastern
Suriname) speak variants of one language, the Saramaka, Matawai, and
Kwinti (in central Suriname) variants of another; and cultural differences
(in dress, diet, rituals, and so on) tend to follow the same bipartite division.
When Suriname became independent from the Netherlands in 1975, the
bulk of the Maroon population still lived in small villages strung along the
rivers of the tropical rain forest, though the men (like their fathers and
grandfathers) spent a significant part of their adult lives engaged in wage
labor outside of tribal territories, and even women were participating in
this pattern, as communities began allowing lineage daughters to accom-

pany their husbands to the coast for periods of a year or more. In 1986, the peaceful expansion of Maroon involvements with the other population groups of Suriname was brutally arrested, as a new rebellion (a Djuka-led attack on the regime of Desi Bouterse) met with the military resources and tactics of the Modern World. The Maroon populations have been decimated by death squads, the bombing of villages, and "interrogation" sessions in the courtyard of the seventeenth-century fort that, as the Suriname National Museum, once housed the artistic treasures of Maroons and other inhabitants of this culturally diverse republic. As of this writing, the future of the Suriname Maroons—as individuals and as social-cultural groups—is very much in question.

The artistry of the Maroons is one of the better documented aspects of their cultural life. Their best-known medium is woodcarving, which Maroon men produce both for internal use and for sale to outsiders. In the villages, handsomely carved objects—from combs, food stirrers, winnowing trays, and peanut-grinding boards to paddles, canoes, doors, and whole housefronts—serve as gifts to wives and lovers. In return, women sew garments elaborately decorated with embroidery, patchwork, and appliqué, as well as crocheting colorful calfbands for the men to wear and carving elegant calabash utensils to serve at their meals. The art of cicatrization, too, is focused on sexual relations; women (and to a lesser extent men) adorn themselves with raised keloids designed to contribute to their erotic appeal through both visual and tactile means. In contrast, ritual objects—from funeral masks to ancestor shrines—are decorated crudely and do not, in the Maroon vision of things, belong to the realm of aesthetic concerns. In these societies, then, art is more part of social than religious life. Indeed, art objects are the primary currency in the ongoing exchanges between the sexes. [2]

Black, cicatrized, polygynous, nonliterate, snake- and ancestor-worshipping, and either naked, barebreasted or loincloth-clad (depending on age and sex), the Maroons (or "Bush Negroes") meet the most demanding criteria for primitive exoticism. That their communities were formed in response to European colonialism only adds to the image, imbuing it with the proud defiance of rebel warriors against an imperialist society distant enough in time to pose no threat of association with Ourselves. Those aspects of their life that outside observers gloss as "the arts"—dancing and drumming, songs in both everyday and esoteric languages, a variety of decorative media, and carved "fetishes," ancestral shrines, and masks—contribute importantly to the fascination of Westerners with their way of life.

The Maroons' historical and cultural ties with Africa have been central to the image. One commentator suggested that they constituted a "little Africa in America" (Kahn 1954), another wrote a book called *Bush Negro Art: An African Art in the Americas* (Dark 1954), and a third labeled Maroon woodcarving "an original African art form" (Volders 1966: 141). The titles of articles written about Maroon life are sometimes quite explicit: "We Find an African Tribe in the South American Jungle" (Vandercook 1926b), "African Customs and Beliefs Preserved for Two Centuries in the Interior of Dutch Guiana" (van Panhuys 1934), and "Africa's Lost Tribes in South America: An On-the-spot Account of Blood-chilling African Rites of 200 Years Ago Preserved Intact in the Jungle of South America by a Tribe of Runaway Slaves" (Kahn 1939). The pioneer Afro-Americanist, Melville J. Herskovits, whose first foreign fieldwork was with the Saramaka, wrote an article called "Bush Negro Art," which characterized Maroons as "having remained faithful to their African traditions [thus presenting] the unique phenomenon of an autonomous civilization of one continent—Africa—transplanted to another—South America" (1930: 160). The recent assertion that twentieth-century Maroon communities are "more African than much of Africa" (Counter and Evans, n.d.) suggests how unbounded the enthusiasm for this idea can be.

In addition to the implication of primitivism in such depictions of the Maroons, the assertion that their customs have been "preserved intact" over the centuries is of central relevance for the problems we have been confronting in these pages. As one author expressed the vision,

> The flush tides of imperialism have passed over these people, leaving them practically unaltered and unknown, unique among the Negro peoples of the world. They still maintain the life of jungle dwellers of the immemorial past. Today they are hunting game with the long bow. Tonight their bodies will be contorted with the sinuous movements of African dances, to the dull thudding of the tomtom. [Kahn 1931: 3–4]

Or, as a more recent description put it,

> We had never expected the people to be this classical, . . . this purely African and isolated from the outside world. . . . it seemed that for every mile we had traveled into the rain forest we had traveled back about a year in time, until we had gone back more than two centuries. [Counter and Evans 1981: 32–33]

Like other aspects of Maroon life, the arts are understood by many outsiders as static traditions, originally imported to Suriname in the seventeenth and eighteenth centuries by enslaved Africans whose descendants now faithfully carry them forward in time, intact and unaltered. The demonstration that this view has been created and nurtured by Western preconceptions at least as much as by valid historical or ethnographic documentation has been presented elsewhere (Price and Price 1980: chap. 8; R. Price 1970; S. Price 1984, 1986). Rather than rehearsing the full, and rather complex, argument here, I cite just a few of the findings that have persuaded me of the relevance, for the Maroon case, of the concept of "art history"—including the presence of stylistic and technical change, recognized individual creativity, and communal attention to chronological development.

It is important to note that the existence of a Maroon "art history" emerged from discussions in the field (between Maroons and us or, more frequently, among Maroons within range of our hearing), and was only later confirmed and enhanced by our consultation of museum collections and written documentation. Dealing mainly (but not exclusively) with Saramakas, we learned about the named styles and techniques that characterized different periods since the mid-nineteenth century, the individuals responsible for introducing them, the ways in which particular innovations were adopted and expanded, and the relationships among different media, with designs and styles often passing from one to the other. If Joseph Alsop had scrutinized traditional scholarly resources for evidence of a known art history in the villages of the Suriname interior, he surely would have concluded that such a notion did not exist. Maroons have no museums and no written documents, nor do they maintain a body of oral historical traditions, transmitted *formally* from generation to generation, of the sort one can find in many African kingdoms. There is, however, a great deal of knowledge of the past and, more important, interest in it.

Saramakas think about their art of woodcarving in terms of four named styles, which they can place quite precisely in time (not in terms of dates, but by association with individual personalities and contemporaneous events). Similarly, they are aware of important changes in their calabash art (e.g., the shift from external to internal decoration, and the associated transfer of the medium from men to women). And they show equal knowledge and articulateness about the periodization of their textile arts, which have gone from free-form embroidery to a mosaiclike style of patchwork, to narrow-strip compositions, and finally to an elaborate art of cross-stitch embroidery. Their discourse differs in its rhetoric from Western

"art history" and the examples they cite are not preserved in local museum cases, but the level of analysis constitutes in every respect the kind of attention to artistic developments in time, as well as the aesthetic ideas that accompanied them, that we associate with our own notion of art history.

Images of timelessness, as we saw in chapter 4, are often reinforced by assumptions of anonymity, and the treatment of Maroon art is no exception. One literary device that has frequently served to bolster the anonymity of Maroon artists is the use of the masculine singular to refer to the roughly 50,000 men, women, boys, and girls who belong to the six Maroon groups. Many authors tell us about "the Maroon" (or "the Bush Negro") and "his" wives and children. "He" clears the forest for gardens, hunts and fishes, performs rites for spirits and ancestors, and fashions beautiful woodcarvings for "his" women. This practice not only helps perpetuate distortions in the depiction of Maroon women as artists (see, for discussion of this point, S. Price 1982/1988, 1984), but also contributes to the process of forgetting that the people under discussion are as varied in personality, temperament, and talents as, for example, Cézanne, Gauguin, and Matisse.

Maroons, however, do not generalize their fellows, past or present. Nor do they ignore or minimize the particular contributions of individual artists. Saramakas from the Upper River region recognize the work of Seketima, a carver of the early twentieth century, as readily as an habitué of the Museum of Modern Art recognizes a Jackson Pollock. Most women distinguish with confidence and accuracy calabashes carved in the 1960s by Keekete from the many imitations they inspired. And innovations in both design and technique in any medium are credited to the persons originally responsible for developing them. In short, the blurring of individuals to form a composite "Bush Negro artist" is one aspect of Maroon art history for which the Maroons themselves cannot properly be given credit.

The Universality Principle is also relevant to the representation of Maroon art. As we saw in chapter 3, Primitives are often taken to represent human nature stripped to its essentials and are thus central figures within the Brotherhood of Man. In this context, Maroons, like other Primitives, are depicted as simpler, more childlike versions of ourselves, subject to the same "primal drives," but less encumbered by the "overlay of civilization" that blankets our own, more sophisticated, life experience. Linguistic support for this view is particularly pervasive. The *Guinness Book of World Records* memorializes the languages of "bush blacks" (misunderstood as a single language, mislabeled as "Taki Taki" [a pejorative term for the language of coastal Surinamers], and mislocated in French Guiana) by crowning it the "Least Complex" of the world's languages and asserting that its

vocabulary, with an alleged total of only 340 words, is the smallest in the world (see R. Price 1976: 44).

The presence of English-derived words in the actual languages spoken by Maroons has encouraged many observers to conceptualize their speech as a kind of badly broken English or baby talk. This facilitates the citation of direct discourse in writing for English-speaking readers. Morton Kahn's report of an attempt to secure woodcarvings gives an idea of the style. He begins by offering some practical advice:

> The only way to acquire these objects is to bargain for them in Dutch money or tobacco, or cheap knick-knacks. Among the more distant villages money is useless. Blue beads are very effective in bargaining, for blue is the Djuka's favourite colour. Ear-rings are also good, but not perfume; they prefer the acrid odour of insecticides.

Kahn then goes on to relate his own experience:

> We say: "*Me wanny buy timbeh*"—"I want to buy wooden pieces."
> The Negro's common reply is that he has none to part with: "*Me no habbe, massra.*" The word *massra* is a corruption of "master," a vestige of the slave days.
> We point to a pierced and inlaid stool and say "*How many?*" meaning, how much does he want for it.
> "*Me no wanny fu selly*"—"I don't want to sell it."
> To show him we mean business, a concrete offer is made, "*Me gon gibbe sixa banknoto*"—"I'm going to give six banknoto."
> The bargaining is in silver half-guilder pieces, called *banknoto*. The Dujkas do not understand large sums of money, except when counted in half-guilder pieces.
> If he refuses six coins, we offer seven, eight, nine, and throw in the added temptation of some tobacco leaves. To each of these offers he shakes his head in negation, saying doggedly, "No, no."
> Finally, in a tone of voice that indicates we are amazed at our own generosity, we say: "*Me gon gibbe tena banknoto, nanga twee weefee tabak.*"—"I'm going to give ten banknoto, as well as three leaves of tobacco."
> The reply is short and spirited.
> "*Gimme.*"
> Which does not have to be translated. [1931: 48–50]

This utterance (and perhaps the entire dialogue) does not have to be translated for Kahn's readers, but it might well for the Maroons who are

alleged to have participated in it. The exchange took place, according to Kahn's account, in Saramaka territory, where, even making generous allowances for orthographic liberties, the words reported have little overlap with the local language. If we were to adopt Kahn's spelling conventions, "I want" could be rendered *Me kay,* but not *Me wanny;* "I'm going to give you" would be *Me o da-ee,* not *Me gon gibbe;* and "three leaves" would be *dee u-wee,* not *twee weefee.* The Saramaka language *does* contain English cognates (e.g., the word for "tobacco" is—in Kahn's orthography—*tabaku* and "six" is *seekeessee*), and Saramaka men *do* employ the more anglicized coastal language for contact situations, but that does not mean that their speech is mutually intelligible with American baby talk.[3]

Kahn's linguistic fallacy is far from being simply a relic of early twentieth-century innocence. During a summer that I spent in Suriname in the late 1970s, I heard two Saramaka men reminiscing with considerable amusement about how an Afro-American visitor to their village from the United States had recently combined gesticulations with simple English utterances, appropriately simplified for a tropical context, to present his own vision of cross-cultural Brotherhood; with an index finger poking first at the forearm of the Saramaka listener and then at his own, the speaker is said to have insisted repeatedly, "You blackah. Me blackah. We bruddahs."

Morton Kahn's account of bargaining in the bush reflects, in addition to linguistic misunderstandings, the nature of the encounters which allow Maroon art to be transferred into non-Maroon hands. Beginning the bargaining with "cheap knick-knacks" and a claim that insecticides are preferred over perfume, the escalation of prices never threatens to exceed the White Man's admittedly amazing generosity. All that is then required is perseverance. Melville and Frances Herskovits gave another account of bargaining for woodcarvings in the same region of Saramaka.

> When we suggested that we might care to acquire the board, the woman became apprehensive. She took up the board, and excusing herself, disappeared with it inside her hut.
>
> "No, no," she called from the house, when her brother went to tell her of the offer we had made for it. "I don't want money for it. I like it. I will not sell it."
>
> The sum we offered was modest enough, but not inconsiderable for this deep interior. We increased it, then doubled our original offer. There was still no wavering on the woman's part, but the offer began to interest her family. Such wealth should not be refused. Bassia Anaisi began to urge her in our behalf.

"With this money you can buy from the white man's city a hammock, and several fine cloths. You should not refuse this."

The old woman took up the discussion, then another sister, and a brother. At last the bassia took us aside, and asked us to leave his sister alone with them.

"We will have a krutu [meeting], and tomorrow you will hear. She is foolish not to sell. But she cares for the board. It is good, too, when a woman loves what her man has carved for her. We will krutu about it, and you shall hear."

Three days passed before the woman's permission was given to dispose of the piece.

"When they see this, your people will know our men can carve!" she exclaimed in a voice which held as much regret as pride. [1934: 281]

Interpretations of the meaning of this art have followed a similar pattern, with Maroons giving in to the determination and apparent power of outside visitors. Here, Western preconceptions about erotic symbolism pervading the life of Primitives have been reinforced by Maroon attitudes toward literacy, which has always been viewed as a powerful and somewhat mystical phenomenon. Although very few Maroons have had the opportunity to learn to read, they have always had contact with people who are literate (plantation bookkeepers, government officials, missionaries, storeowners, employers, etc.), and have great respect for the power it conveys. In principle, they view any marking as potentially communicative, but themselves as untrained in the art of deciphering. It is for this reason that Maroons use blank (undecorated) calabash bowls for ritual purposes. Any carved calabash, they reason, must carry some message, but since they are unable to "read," they do not know what it says; rather than risk offending the spirits for whom a particular ritual is being performed, then, they utilize special unmarked bowls.

Books and articles on Maroon art, however, give no hint that this is the case and present a unanimous vision of symbol-laden motifs. An urban Surinamer named F. H. J. Muntslag wrote a very popular book on Maroon art (1966, 1979), which is essentially a dictionary of motifs and their (alleged) iconographic meaning. One page, for example, illustrates a circular design element, identifying it as *koemba,* a word that in the language of eastern Maroons means "navel." The text explains that "the navel has a very mystical significance to the Bush Negro. Young women are frequently tattooed [sic; their decorations are cicatrizations, not tattooing] around the

navel. It is the symbol of erotic love" (1979: 59). Another page presents a crescent-shaped design element with the label *liba,* a word that in the language of central Maroons means "moon"; the text is about fertility and love symbols, projecting onto a more poetic plain the Herskovitses' assertion that it represented "the male member" (1934: 280). How, we asked ourselves in the course of our fieldwork, do Maroons react to this sort of lexicon?

First, Maroons do, in fact, attach labels such as *koemba* and *liba* to design elements, as part of a larger practice of assigning names to everything in the physical environment, from particular cloth patterns and styles of hairbraiding to subtly differentiated varieties of rice and kinds of machetes. For them, however, these names are descriptive labels, not symbolic allusions. A design element known as *koemba* ("navel") is being identified in much the same way that we might use the term "navel" in talking about a kind of orange—that is, without implications of fertility, eroticism, or mystical associations. Claims that a crescent shape has sexual meaning are put in perspective by the reaction of a 60-year-old Maroon who had divided his adult residence between eastern and central Maroon villages. When we reported the Herskovitses' discourse on this motif, the man looked somewhat puzzled and declined to comment, but the next day he returned to ask the question that had been bothering him; with apologies for his ignorance on the matter, he wanted to know whether perhaps *white* men's penises took on a curved and pointed shape like that when erect.

Those writers who include descriptions of their encounters in the field give us some insight into the process by which the Maroons' reputation as symbolism-focused artists maintains its vigor in spite of its lack of fit with the Maroons' intentions and understandings. The Herskovitses, for example, described with frustration being "completely balked by the unwillingness of the Bush Negroes to discuss their carvings" during the first of their two visits (1934: 276), but they also made clear their own refusal to take no for an answer on the matter of symbolic interpretation. On their second trip they prodded Saramakas with explanations of their own invention which their hosts finally accepted, along with enough money to pay for the pieces under discussion (1934: 276–77).

This approach has been adopted by many subsequent visitors to the Suriname interior. Even when Maroons refuse to acquiesce to a proposed interpretation, it is always the person who writes up the report who has the last word. In an article on "folk art in general and that of Suriname in particular," the author's determination to establish a "pagan" meaning for

an embroidered cloth hanging in the doorway of a Christian Maroon's house was pursued as follows:

> On inquiry concerning the meaning of [the central] motif, no one gave a direct answer. The women of the village . . . answered: . . . 'a flower.' As this response was not very enlightening, a very old man was asked. His unsatisfactory answer was the same, 'a flower.' Obviously, people considered it inappropriate to clarify the meaning of this private decoration to foreign visitors, especially when it referred to religious beliefs that were no longer (openly) professed. [De Vries-Hamburger 1959: 109]

Sometimes native exegeses have been reported only as examples of faulty thinking; the prolific student of Maroon culture L. C. van Panhuys, for example, favored this method. One design, he wrote, depicted "a human form, even though the Bush Negroes explained to us . . . [etc.]." Another represented "what my informant thought to be perhaps . . . [etc.], but what is, in reality . . . [etc.]." Regarding a third, a Maroon informant "could give no other explanation than . . . [etc.]. But if we place the drawing upside down as is done in our illustration, we presume the whole represents . . . [etc.]" (1928, 1930).

The most recent attempt to establish a lexicon of symbols for Maroon art was carried out by Jean Hurault, who declared his aim as the pursuit of "a better understanding of *the intention of the artists* and of their principles of composition" (1970: 94, emphasis added). He described his method as follows:

> We have enumerated and classified the entire body of symbolic and ornamental motifs on these [4000] objects by examining the way in which they are grouped and opposed [in this book's analysis]. This inventory has allowed us to establish with almost absolute certainty the meaning and value of a large number of motifs that have been forgotten by present-day Maroons. [1970: 94]

While Hurault's technique is ostensibly more systematic and scientific than those of van Panhuys or the Herskovitses, it still shares with them a disregard for what *Maroons* have to say about the meaning of their art. They all allow the tradition of interpreting Maroon art to be relatively unperturbed by the understandings and intentions of the Maroons themselves.

The consequences of such cavalier attitudes toward the interpretation

of other people's art are varied. When Western authors write books for Western readers, the dissemination of ideas that would puzzle Maroons (such as a pointed crescent representing a penis) rarely creates a problem. But sometimes such misunderstandings make their way into contact situations, and when this happens it is usually members of the Primitive rather than the Civilized world who end up making concessions in order to maintain harmonious relations. An example may illustrate.

In the 1960s, a Saramaka man set up a stall next to the road leading to the Suriname airport, where he carved a variety of objects and offered them for sale to passing tourists. In response to his customers' repeated requests for the symbolic meaning of the pieces they were buying, the artist explained each time that his carvings were intended only to be decorative. Perceiving their dissatisfaction in one case after another, and sometimes being drawn into arguments with them on the subject, he finally gave up and adopted a different strategy. He purchased Muntslag's dictionary of Maroon motifs (the source of the "navel" and "crescent" examples discussed earlier in this chapter), even though he could not understand it because he had never learned to read. He then used its illustrations as models for the motifs in his carvings, and simply showed the book to his customers so they could look up the meaning of their purchases. Through this self-service technique, the man's life became more tranquil, his profits picked up considerably, the tourists boarded their planes in better spirits, and the myth of a pervasive iconography in the arts of the Maroons circumvented a potentially troubling setback.[4]

The "collecting" of Primitive Art, whether by field anthropologists or by souvenir-buying tourists, often allows discrepancies between the views of artists and patrons to surface (at least momentarily) simply because both parties are involved in the encounter. Once an art object leaves its original setting, however, intercultural dialogue is transformed into intracultural discourse. The criteria for evaluating interpretive claims are then drawn from the realm of related knowledge, as preserved in written form and in Westerners' conceptual understandings. With the fit between native and outside exegesis unavailable for assessment, the fit between the general body of Western knowledge and a new candidate for inclusion in that body becomes the crucial factor.

The mode of presentation for a particular art form from an "exotic" setting is thus often selected on the basis of its compatibility with received ideas, on its lack of abrasion with what an audience already has in mind. Again, a specific example from my own experience will serve to illustrate the point.

As curators of an exhibition of Maroon art that traveled across the
United States during 1980–82, Richard Price and I participated in nu-
merous aspects of its organization and promotion. One of these involved
the designing of a poster to publicize the exhibit in each of the four cities
where it would appear. We suggested featuring a textile that was both
attractively colorful and stylistically representative of the little-known
Maroon art of patchwork, and this proposal was greeted with enthusiasm
by the designer of the catalog, who even adopted a piece of the same
textile for the cover and dust jacket. Once the idea reached the public
relations office of the sponsoring institution, however, objections were
raised, and it was only after a certain amount of debate that our choice was
reluctantly approved.

The problem, we were told, was that the cloth looked too much like a
painting by Mondrian to be effective in publicizing an exhibit of Primitive
Art. We were strongly urged to select instead a mask or a "fetish."

Indeed, nothing about this cloth makes the statement: "Primitive
Art." The raw materials are not woven fibers stained with local dyes, but
rather a cheap trade cotton imported to Suriname and sold to Maroon men
during their wage-labor trips to the coastal region. Its colors are not the
muted tones of earth, shells, and berries, but rather commercial hues
ranging from yellow and blue to red and even shocking pink. Its design is
not irregular and free-form, but rather symmetrical and rigidly geometric.
And, unlike a mask or "fetish," this patchwork cape appears unlikely to
lend itself to symbolic interpretation of motifs or to associations with exotic
rituals. It should be no surprise, then, that a public relations officer—
thinking about how best to promote a collection of art objects made by
people with immodest clothing, scarified faces, pagan beliefs, "talking"
drums, polygynous marriages, lineage-based kinship, menstrual taboos,
and slash-and-burn tropical gardens—leaned toward a poster that would
convey that ensemble of characteristics through a quickly absorbed, unam-
biguous visual image.

The debate about this cloth's appropriateness as an emblem of Primi-
tive Art came up again over a year later, when a professional agency de-
signed an ad for the exhibition that appeared, full-page, in the *New York
Times.* Playing on the same apparent irony of primitive forest dwellers
producing a design that resembled the work of one of the Western world's
most famous modern painters, the ad writers counted on New Yorkers'
familiarity with Mondrian's colorful geometric compositions and left the
comparison implicit on the level of visual imagery.

IF WE DIDN'T TELL YOU IT CAME FROM THE SURINAME RAIN FOREST, YOU'D THINK IT WAS MODERN ART.

It looks like a painting by Mondrian, but it isn't. It's a man's cape, designed and worn by the Suriname Maroons in the 1920's.

The Maroons live in the rain forest of South America, descendants of slaves who escaped from Dutch plantations in the 17th and 18th centuries. And in the rain forest, they created a distinctive art style, drawing upon their African heritage.

Now, the art of the Suriname Maroons is the subject of a special exhibition at the American Museum of Natural History. On view are 350 spectacular pieces: wood and calabash carvings, metalwork, a decorated canoe, carved stools and, of course, their intricately patterned textiles. Not to mention photographs of their daily life. So come see the art of the Maroons. For them, art is more than decoration. It's a way of life.

"AFRO-AMERICAN ARTS FROM THE SURINAME RAIN FOREST." NOW THROUGH JANUARY 24 AT THE AMERICAN MUSEUM OF NATURAL HISTORY, CENTRAL PARK WEST AT 79TH STREET.

Museum Hours: Weekdays 10 AM-4:45 PM. Wednesday to 9 PM. Saturday & Sunday to 5 PM. The American Museum has a fee that you work admission policy.

In spite of its single-object focus, however, the ad was a direct forerunner of the riddle-ad that was used some three years later to promote the MOMA's "Primitivism" exhibit (see chap. 6). Is it Primitive or is it Modern?

It would be possible to argue that while the first publicist shied away from correcting the stereotype of Primitive Art, the New York ad agency boldly challenged it. Yet it is worth keeping in mind that the primary goal of ads is to sell a product, not to educate; in this context, rather than being contradicted, the stereotype was being exploited to attract the attention of readers. Like the later "Primitivism" ads (and the MOMA show they promoted), the message here was clearly not that Maroon artists are like Mondrian in being individuals who engage in deliberate, dynamic creative expression; despite the detailed documentation available in the exhibition catalog, the man's cape illustrated in the ad is described, not as being designed by a particular Maroon woman, but rather as being "designed and worn by the Suriname Maroons." The point of the comparison, then, is that Maroon art, in spite of being "a way of life" for people living in the rain forest, has nonetheless come up with some objects that bear a bizarre and rather uncanny resemblance to paintings that represent their antithesis in terms of artistic creativity, independence, innovation, and self-awareness. The ad writers hoped New Yorkers would be jolted enough by this unexpected look-alike to want to see the rest of the exhibit. But, like their colleagues who juxtaposed the Picasso painting and the African mask, they certainly did not expect the illustrated cape and the unillustrated Mondrian to be conceptualized by their audience as equivalent artistic achievements.

Another aspect of our experience with the Maroon exhibition that shed light on the Western conceptualization of Primitive Art involved reactions to our goal of presenting Maroon artistry in the context of Maroon aesthetic ideas. Descriptions of the exhibit, as well as the text of the accompanying catalog, made explicit our efforts to follow Maroon aesthetic concepts and criteria in the selection of pieces, the arrangement of displays, and the composition of interpretive label texts. That is, our intent was to eschew *both* apparently "pure," or "universal," principles of the sort that, for example, Nelson Rockefeller might have drawn on *and* the social, cultural, and technological criteria that might have structured a traditional anthropology-museum exhibit. We did our best to present Maroon art as Maroon *art* and as *Maroon* art, complete with its makers' well-articulated *aesthetic* principles and consciousness of art *history,* as these had been laid out to us during our several years' residence in the interior of Suriname.

Because the exhibition was mounted in four major museums (in Los Angeles, Dallas, Baltimore, and New York), it had excellent exposure within the United States. But we wanted to make it available also to people from the Caribbean, and especially to Surinamers. An installation in Suriname was ruled out because of the lack of climate controls and security measures adequate to meet the conditions of some of the lenders. The Netherlands, with its Suriname population of over 200,000, was the next logical choice, and we therefore tried very hard to find a Dutch museum that was interested in hosting the exhibit. All of the museums we approached (except one that was unable to raise the necessary funds) rejected the exhibit, but the reasons they gave divided into two very different kinds of discourse.

Art museums in the Netherlands responded that the material in the exhibit was too contextualized to be appropriate for their galleries. Here were objects presented in the midst of photographs, musical recordings, charts of style progressions, and commentary on native aesthetic principles. If we were willing to isolate the pieces from all the ethnographica, they suggested, they would be happy to reconsider their decision. But as the exhibit was currently envisioned, it was "anthropology," not "art."

Anthropology museums—operating in the context of a post-1968 social consciousness—also made a redefinition of the exhibit's aims a precondition for their acceptance of it. It would be necessary to add, they said, extensive information on the current political situation of this Third World republic, on the economic oppression of Maroons, and on the ecological threats to their environment. There would have to be a stronger political message.

Art museums categorized all anthropological contextualization as alien to the aesthetic character of objects; if the displays were intended to show "art," they would need to do so according to Western conventions, which kept aesthetic considerations purely implicit. Anthropology museums categorized the recognition of another society's art historical consciousness and aesthetic sophistication as being alien to the promotion of social liberalism; if the displays were intended to communicate a political message, they would need to do so according to the accepted canons. Both rejected our contention that to *recognize* Maroon objects as *art,* maintained in the context of a legitimate aesthetic system and possessing a history of its own, constituted a radical intellectual and political argument. Neither "art" nor "anthropology" according to then-current definitions, the exhibition never made it to Europe and was seen by no more than a few dozen Surinamers.[5]

The collective message of the Dutch museums is not unrelated to Joseph Alsop's stance that other people simply do not have a concept in any sense equivalent to the one that defines and vertebrates our own art world. What this implies is that objects can be presented either in terms of that concept (in which case they are "art," are best appreciated on the basis of an unmediated visual experience, and have no need of further explanation) or in terms of their place within a sociocultural context (in which case someone viewing them as art would be guilty of "ethnocentrism"). If one subscribes to this division, the question then becomes, as an *African Arts* editorial put it, whether we respond to a particular set of objects as Art or merely from a sense of "social curiosity" (see chap. 6).

It may be, however, that a merger of the "art" and the "anthropology" of non-Western cultural expression, would require little more on our part than a less proprietorial attitude toward the idea of aesthetic sensitivity.

AFTERWORD

In a discussion of Arthur Danto's concept of an "artworld," B. R. Tilghman considers the hypothetical possibility of a world in which art is isolated from all of the related activities that we expect to cluster about it.

> We can imagine a tribe that draws and paints, plays music, and recites poetry, but keeps its talk about it all to a minimum. Instruction is carried out mostly by example along with occasional comments such as "make this line thicker." "Play it like this," and so on. There are no schools of criticism, no reviews in the papers, and certainly no art history. People nevertheless take it all very seriously and are most attentive to what they see and hear; they react with gestures and facial expressions, and sometimes shift their preferences with their moods. [1984: 62–63]

In this nonartworld, not only are newspaper reviews and art schools unknown, but even evaluative language itself. In spite of their painting and music and poetry, Tilghman's hypothetical tribal beings call on gestures and facial expressions to convey their aesthetic reactions, which are, in any case, little more than the product of shifting moods. The tribal world in this example is explicitly fictional, purposefully created to advance a logical philosophical argument about the nature of art. But it has close cousins on other shelves of our libraries, where the same image sheds its philosophical function and assumes the appearance of descriptive prose. Tribal peoples *become,* in those pages, faceless producers of art who cannot appreciate or assess or review or document their work except through grunts and shrugs. Their world is imagined to be less hypothesized than "documented" as having neither history nor aesthetics, neither scholarship nor connoisseurship, neither humor nor irony.

A classical Western education offers little protection against the se-

ductive attractions of this image, which casts such flattering light on our own higher sensibilities. E. H. Gombrich's elaboration of the attributes of Tribal Society adds yet another example to those already cited in earlier chapters, authenticating for current and future generations of readers stereotypic images of the Third World as a land of ignorance, confusion, and childishness. In a chapter that makes repeated use of the word "strange," the latest edition of Gombrich's *The Story of Art* explains that

> If most works of these civilizations look weird and unnatural to us, the reason lies probably in the ideas they are meant to convey. . . . Negroes in Africa are sometimes as vague as little children about what is a picture and what is real . . . they even believe that certain animals are related to them in some fairy-tale manner . . . [they] live in a kind of dream-world. . . . It is very much as if children played at pirates or detectives till they no longer knew where play-acting ended and reality began. But with children there is always the grown-up world about them, the people who tell them, 'Don't be so noisy', or 'It is nearly bed-time'. For the savage there is no such other world to spoil the illusion. [1966: chap. 1, "Strange Beginnings"]

Gombrich illustrates his point by the reactions that "we" and "they" would experience to a scrawled doodle of a face: "To us all this is a joke, but to the native it is not." He thus corroborates William Rubin's analysis of the difference between look-alike sculptures by Alexander Calder and his counterpart from New Guinea (see chap. 3). From this perspective, the Primitive World is a sober place indeed, where doodled faces and sculpted branches are perceived as living monsters. No wonder, then, that its inhabitants have no time or inclination for such pleasurable pursuits as aesthetic discussion, intellectual history, or art-for-art's sake, preoccupied as they are with chasing spirits and demons from their midst, with no grown-ups to remind them that it is all just a game.

It is rarely necessary to mention explicitly the racial component of this other world. Like Leonard Bernstein, we can express warm pride in our Persian princes, conveying benevolence and admiration while maintaining our cultural boundary and the position of dominance that it protects.

At a time when revisionist art history is reassessing the traditional isolation of that discipline's subject matter from the fabric of social and cultural life, and at a time when anthropology is delving more and more insistently into the nature of culture in modern industrial societies, we are also at a time when our qualitative division of world art into "ours" and

"theirs" stands ready for a serious reappraisal. A part of that change is already underway, as distinguished institutions such as the Metropolitan Museum of Art and the Museum of Modern Art invite into their galleries selected Primitive Masterpieces. But their doors have been opened more willingly to the objects themselves than to the aesthetic sensibilities that gave them birth. The final, and more meaningful, step will be to recognize that the vision of Western art lovers is neither more nor less conditioned by cultural ideas—both prejudices and insights—than that of their counterparts in other societies and to follow through on our newly invigorated appreciation of "exotic" art by acknowledging the cultural diversity, intellectual vitality, and aesthetic integrity of its creators.

AFTERWORD TO THE SECOND
EDITION

First the good news. In the dozen or so years since this book was written, the discourse surrounding what, for purposes of discussion, we call "art" has opened up noticeably to perspectives outside of its traditional territory. A determinedly optimistic reading of these developments might run roughly as follows.

In the field of "fine" arts, the complex workings—social, cultural, economic, political that give structure, texture, and (contested or uncon tested) meaning to the more traditional matter of art objects and their collective history have been moving into greater prominence. Both scholarly and popular writings on art have been engaging in the scrutiny of museum ethics, curatorial strategies, auction politics, market dynamics, and collecting agendas. Even the very sensitive possibility that ethnocentrism lurks in the foundations of the edifice of connoisseurship has become more widely recognized. Artworks once viewed as visual entities set into more or less elaborate wooden borders are now being framed in a completely different sense, as contextualized productions undergoing contextualized readings. Setting art objects, artists' biographies, and the evolution of stylistic sequences more forcefully in the context of perceptions conditioned by social and cultural factors brings them closer to long-standing anthropological concerns and interests, and acts to erode the lingering temptation (stronger in some commentators than others) to view art history as the pristine, apolitical study of aesthetic forms. And sacred territories of art historical scholarship, where original works authenticated by erudite connoisseurship once held pride of place, are being quietly invaded by a growing interest in copies, fakes, appropriations, and derivative forms.

Approaches to art from beyond the Euro-cultural orbit have also undergone significant changes over the past decade or two. Especially pivotal has been a diminished focus on cultural isolates, a by-product of the ten-

127

dency for today's anthropologists to set the societies and cultures they study in broader fields of vision than did their predecessors of the mid-twentieth century. While scholars once strained to discern the stylistic essences of particular arts in particular cultures, they are now directing their gaze more frequently toward the doorways where artistic and aesthetic ideas jostle each other in their passage from one cultural setting to the next. While the site of artistic production was once located in lineages of convention within bounded communities, it now spreads into the global arena, pulling in players from every corner of the world, from every kind of society, and from every chamber of the artworld's vast honeycomb. And while the emphasis was once on abstracting back from an overlay of modernity to discover uncorrupted artistic traditions (think of Franz Boas holding up a blanket to block out the two-story houses behind the Kwakiutl natives he was filming for the anthropological record, as captured in the Odyssey series video devoted to this father of American anthropology), modernization is now seen as lying at the heart of the enterprise, providing a springboard for explorations of cultural creativity and self-affirmation.

Not surprisingly, these shifts are being accompanied by a marked, if gradual, rapprochement among the various sectors of the popular and scholarly art world. In museums, the most visible evidence has been an explosion, over the past couple of decades, of exhibitions integrating anthropological and art historical issues and scholarship, juxtaposing arts from previously segregated categories, and calling attention to the defining (and redefining) power of display context.[1] Community museums, with vigorous local participation, have sprung up in unprecedented numbers, providing active loci for grassroots cultural creativity and self-representation. Rights of interpretation are under lively discussion; cultural authority is being renegotiated; the privileged status of long established canons is under attack; and museum acquisition policies designed to maximize the preservation of data and the growth of scientific knowledge are being contested by more ethically-focused debates aimed at responsible de-accessioning and repatriation. The legal definitions of both cultural property and artistic authorship in a video-and-computer age of sampling and photoshop have begun to be recognized as a thorny bundle deeply entangled in multicultural ideologies and highly inflated economic stakes.[2]

The social/cultural atmosphere created by these changes has, among other things, brought the specific critiques made in this book more frequently into mainstream art critical discourse. Associations that have long

relegated "primitive art" to a world of irrationality, superstition, voodoo-esque rituals in flickering torchlight, and symbolic meanings linked to fertility and witchcraft still pop up in texts authored by variably informed commentators, but their frequency is diminishing significantly, giving way to a less generalizing gaze that recognizes the staggering diversity of art worlds in the non-Eurocultural universe. Exhibitions of works owned by particular collectors continue to be mounted, implicitly reinforcing the logic critiqued in chapter 7 that "pedigree" deserves to trump "signature" when aesthetic merit depends on the eye of the connoisseur rather than the sensitivities of the artist, but at the same time it is becoming increasingly common to run across arguments that, as Roslyn Adele Walker puts it, "Anonymous Has a Name" (1994), which confront head-on stereotypic notions of generic natives plodding mindlessly in the art-producing footsteps of their communal ancestors. We're also witnessing, across the board, a growing tendency for the hierarchies that assigned distinct roles (and value) to fine and folk, art and craft, primitive and modern, high and low to give way to an investigation of these categories' interpenetrations and a deconstruction of the categories themselves. Concern with the ethics of cultural ownership is also moving center-stage, thanks largely to the rising volume of voices coming from third- and fourth-world populations, cultural studies programs, and spectators of the postmodern scene from the fields of anthropology, literature, history, philosophy, economics, and political science.[3]

Although these changes are extremely multifaceted, they all operate in the direction of breaking down long-established barriers—barriers between disciplinary perspectives, between geographical focuses, between hierarchized settings, between elite and popular media, and more. While much of the initiative for the reorientation has taken place in North America (Canada at least as much as the United States), Europe has shown signs of shifting along similar lines. To cite just a few indications: Paris's global-art extravaganza, *Magiciens de la Terre,* constituted a magisterial (if flawed, according to many of its reviewers) effort to embrace the "arts of the world" as a single conceptual whole (Musée d'Art Contemporain 1989; see also Michaud 1989), and the more recent debates sparked by Jacques Chirac's agenda for establishing a museum of *"arts premiers"* have produced thoughtful reflections on the place of premier/primitive arts in the supremely civilized setting of central Paris (for example, Vaillant and Viatte 1999, Taffin 2000; see also Price 2001). In the Netherlands, an exhibition of "Art from Another World" in Rotterdam brought together "high" and "low" art from

non-Western settings in 1988; scholars have been asking hard questions about the political and ethical dimensions of collecting practices and museum displays (for example, Bouquet 1999, Corbey 2000, Lavreysen 1998, Leyten 1995, Leyten and Damen 1993), and a museum of Aboriginal Art has just opened (March 2001) in the city of Utrecht. In Austria, a special issue of the *Archiv für Völkerkunde* published an important collection of 32 essays on "Museums of Ethnology on the Eve of the Third Millennium" that covered developments throughout the world, from Greenland, Rome, St. Petersburg, and New York to Australia, South Africa, Mexico, and Kuala Lumpur. In England, Routledge has been bringing out one volume after another devoted to the same series of issues (for example, Greenberg, Ferguson, and Nairne 1996, Barringer and Flynn 1998). In Germany, a collection of essays on "ethnographic and modern" art spans commentators from Boas to Clifford (Prussat and Till 2001). And in Switzerland, a recent exhibit-cum-book focused attention on contact zones, cultural strategies behind today's art critical discourse, the international traffic in art, the classificatory transfer of objects from "ethnography" to "art," and the overlaps in categories of art such as *contemporain, appliqué, populaire, classique, pompier, pauvre, transgressif* and *convenu* (Gonseth, Hainard, and Kaehr 1999). Around the globe, the art of Australian aborigines has been providing a testing ground for every legal and ethical dilemma in the book, supplying the media with a steady stream of news items involving issues of ethnic identity, cultural property, artistic authenticity, and market concerns.[4]

All this complicates the cultural geography of art, the hierarchy of traditional art scholarship, and the division between producers and commentators. It means, for example, that while the "affinities" between the "tribal" and the "modern" could be analyzed in terms of a comfortably agreed-upon definition of a "here" (homes, galleries, museums, and studios in Europe and North America) and a "there" (remote settlements and "exotic" cultures), with objects being imported to the former on the basis of the importers' criteria, artworld traffic is now recognized as running along a much busier thoroughfare. We're forced to notice that it's not a one-way route and that it's not just the objects that are traveling. While Picasso's exploitation of African masks as inspiration for the prostitutes in *Les Demoiselles d'Avignon* may have caused European art history to turn a corner in the early years of the twentieth century, today's appropriative possibilities are being defined in more multifaceted terms. Faith Ringgold's *The Picnic at Giverny* (an acrylic-and-fabric story quilt), for example, casts Picasso as the nude model

in a gender-reversal of Manet's *Le Déjeuner sur l'Herbe,* set in the garden of Monet's *Nymphéas,* with ten (fully clothed) American women artists and writers having a picnic and discussing the role of women in art. And as bell hooks has noted, in the hands of Jean-Michel Basquiat, who took from Pollock, de Kooning, and Rauschenberg on the one end and "the guys painting on the trains" on the other, a depiction of "him and Andy Warhol duking it out in boxing attire is not as innocent and playful as it appears to be" (1995: 36, 42).[5]

As the "traffic in culture" continues to erode the distinctions once segregating first- and third- or fourth- artworlds, "high" and "low" genres, producers and critics, and even anthropologists and art historians, lanes are being opened up in many exciting directions. Anthropologists are reading art historical literature and art historians are reading anthropology, artists are increasingly demanding an interpretive role, and the influx of voices from previously underrepresented groups is gaining momentum.

And yet, if the goal is to liberate the study of art from its Eurocentric shell, much still remains to be done. My own reading of the situation suggests that the most underdeveloped aspect of artworld globalization lies less in the realm of art than in the realm of art criticism. Supplying the product is one thing, but having a say over what it represents (aesthetically, iconographically, referentially, historically) is quite another. Making the case for African American art, bell hooks cited a *Time* magazine cover story called "Black Renaissance: African American Artists Are Truly Free At Last." She lamented that the article

> assessed the development and public reception of works by black artists without engaging, in any way, the ideas and perspectives of African American scholars who write about the visual arts. The blatant absence of this critical perspective serves to highlight the extent to which black scholars who write about art, specifically about work created by African American artists, are ignored by the mainstream. Ironically, the insistence in this essay that the "freedom" of black artists can be measured solely by the degree to which the work of individual artists receives attention in the established white-dominated art world exposes the absence of such freedom. (1995: 110–11)

Carrying this observation further from home territory, and setting it in a more explicitly anthropological context, I would second Clifford Geertz's argument that "art talk" has been reported as rarely as it has for

non-Western societies, not because people in such societies don't engage in it, but because they frequently do it through forms that are different from those of Western art criticism (1983: 94–120). If we wish to tune in to the aesthetic frameworks of other cultures, we need to make a special effort to push aside our everyday understandings of how art is talked or written about and open ourselves to different modes of discourse. Often this means softening the distinction between artist and critic and paying closer attention to what art producers themselves have to say. And once we begin to listen, the commentary is abundantly available, as an eye-opening complement to European traditions of art criticism, both academic and journalistic.

The rapid globalization of recent years—from migrations of work forces and the proliferation of tourism to the border-crashing forces of the Internet or CNN's soundbite coverage of what it calls "Hotspots"—brings the absurdity of a monovocal Eurocentric criticism into full view and presents exciting new challenges for intercultural conversations about the nature and meaning of art in all its varied settings. We are profoundly enriched by being able to read the interpretive texts bordering Faith Ringgold's acrylic and strip-cloth story quilts, . . . by being able to talk to inhabitants of the Amazonian rain forest about the meaning of the dances they are performing on the Washington Mall, . . . by being able to view Maori arts from New Zealand as presented by a tribal elder formally trained in traditional Western art history, . . . by being able to visit an exhibition of Malaysian, Nigerian, Filipino, and other "Black British" art from London conceptualized by Caribbean-born curators based in New York, . . . and by being able to study Romare Bearden's analysis of compositional principles, in which paintings of the Italian Renaissance are seen through the eyes of an artist equally familiar with the one in Harlem.[6]

The need to redefine the scaffolding of art critical discourse along more multicultural lines is being argued in countless outposts of the international art world. In a consistently insightful Jamaican journal called *Small Axe*, for example, Annie Paul has cited Gerardo Mosquera's distinction between "curating cultures" and "curated cultures," and pointed the finger at a curatoriat that invests in the construction of what it passes off as "universal values" on the basis of Eurocentric and even "Manhattan-centric" criteria (1999: 66). She writes:

High modern avatars of art have gone through many transformations this century, always mirroring Europe's own response to the discovery

132

of extra-European forms of life in the Universe. One such has been the idea of art as the release of messages from the unconscious, automatic art as it were, simple and immediate no matter whether the artist comes from the most technologically sophisticated society or the most primitive. In this particular narrative, the primitive artist represents the noble savage, a superior sensibility trapped in prehistoric circumstances. In opposition to this is the figure of the modern artist, the savage noble who can psychically tap into the collective unconscious by courting the irrational and systematically flouting convention. Both are based on a concept of the artist as a "primal" creature. . . . These two groups are locked in a strategic embrace by Jamaican art history. (1999: 62)

Paul's depiction of the artist (whether primitive or modern) as a primal creature with special gifts for tapping into the unconscious is very close to the one I found in the heads of many of the French and American art collectors I interviewed in the 1980s. The effect that this pervasive conception has had on art criticism (which is, as bell hooks understands so well, where the real power lies) has been to keep artists locked up in their studios, painting or sculpting like the silent natives of the stereotype critiqued by Clifford Geertz (1983: 97), or the Baule artist ventriloquized by Susan Vogel (see chapter 2), rather than entering the discourse.

But we're clearly turning a corner, and there are promising indications that the History of Art, as a Western-authored metanarrative, is being challenged with growing success by a multiplicity of alternative frameworks. In place of the comprehensive texts familiar to anyone who's taken a course in introductory art history, where an impeccably credentialed Ph.D. narrates a unilinear evolution from cave paintings to Andy Warhol, we are now beginning to discern at least a Table of Contents for a multi-authored anthology of art histories that reflects and celebrates the variety of ways people around the world enrich their lives through artistic creativity—and, perhaps even more importantly, the variety of discourses they call on to think and talk about it.

Notes to the Afterword to the Second Edition

This essay reflects the input of Fred Myers and Chris Steiner, both of whom have generously helped me keep up with recent literature. I also wish to thank David Brent, *éditeur extraordinaire,* for the support he has given this book since Day One of its lifetime.

1. Reactions to these exhibits have often been more stimulating than the exhibits themselves. Witness the tidal wave of discussion that came on the heels of the "Primitivism" show at New York's Museum of Modern Art in 1984, "Into the Heart of Africa" at Toronto's Royal Ontario Museum in 1989 (for an overview, see Butler 1999), and "Africa: The Art of a Continent" at London's Royal Academy in 1995. K. Anthony Appiah's reflections on Asante goldweights, inspired by this last exhibit but fueled by memories of his childhood in Ghana, represent to my mind the best of this rich literature (1997).

2. Appearing the same year as the present book's original publication, Jeanette Greenfield's *The Return of Cultural Treasures* and Phyllis Messenger's edited volume, *The Ethics of Collecting Cultural Property,* heralded an attention to cultural property rights that was to develop into a pervasive wave of soul-searching on the part of anthropologists, museum personnel, and others interested in Western practices for collecting artifacts in third- and fourth-world societies.

3. For an update of the specific example presented in chapter 8, see S. and R. Price 1999.

4. The bibliography of works reflecting post-1990 perspectives on the representation of art and culture in "civilized places" is extensive enough to make any selection both partial and arbitrary, but a reasonable English-language starter list might include Clifford 1997, Coombes 1994, Coote and Shelton 1992, Dilworth 1996, Errington 1998, Henderson and Kaeppler 1996, Hilden 2000, Jonaitis 1991, Karp and Lavine 1991, Karp, Kreamer, and Lavine 1992, Kirshenblatt-Gimblett 1998, MacClancy 1997, Marcus and Myers 1995, Pearce 1993, Phillips and Steiner 1999, R. and S. Price 1992 and 1995, Root 1995, Schildkrout and Keim 1998, Sherman and Rogoff 1994, Simpson 1996, Thomas 1999, Tucker 1992, and Ziff and Rao 1997. (See also Price 1999.)

5. For more on such appropriations, see Tawadros 1996.

6. See Cameron et al. 1998, R. and S. Price 1994, Mead 1984, Beauchamp-Byrd et al. 1997, Bearden and Holty 1969; these references are but a sampling from a much larger reservoir.

References Cited in the Afterword to the Second Edition

Appiah, K. Anthony. 1997. "The Arts of Africa." *New York Review of Books,* 24 April, pp. 46–51.

Barringer, Tim, and Tom Flynn (eds.) 1998. *Colonialism and the Object: Empire, Material Culture and the Museum.* New York and London: Routledge.

Bearden, Romare, and Carl Holty. 1969. *The Painter's Mind: A Study of the Relations of Structure and Space in Painting.* New York: Crown Publishers.

Beauchamp-Byrd, Mora J., and M. Franklin Sirmans (eds.) 1998. *Transforming the*

Crown: African, Asian & Caribbean Artists in Britain 1966–1996. New York: Caribbean Cultural Center.

Bouquet, Mary (ed.) 1999. "Academic Anthropology and the Museum: Back to the Future." Special issue (#34) of *Focaal: Tijdscrift voor Antropologie* (Utrecht, Netherlands).

Butler, Shelley Ruth. 1999. *Contested Representations: Revisiting* Into the Heart of Africa. Amsterdam: Gordon and Breach.

Cameron, Dan, et al. 1998. *Dancing at the Louvre: Faith Ringgold's French Collection and Other Story Quilts.* Berkeley: University of California Press.

Clifford, James. 1997. *Routes: Travel and Translation in the Late Twentieth Century.* Cambridge: Harvard University Press.

Coombes, Annie E. 1994. *Reinventing Africa: Museums, Material Culture and Popular Imagination.* New Haven: Yale University Press.

Coote, Jeremy, and Anthony Shelton (eds.) 1992. *Anthropology, Art, and Aesthetics.* Oxford: Clarendon Press.

Corbey, Raymond. 2000. *Tribal Art Traffic: A Chronicle of Taste, Trade and Desire in Colonial and Post-Colonial Times.* Amsterdam: Royal Tropical Institute.

Dilworth, Leah. 1996. *Imagining Indians in the Southwest: Persistent Visions of a Primitive Past.* Washington, DC: Smithsonian Institution Press.

Errington, Shelly. 1998. *The Death of Authentic Primitive Art and Other Tales of Progress.* Berkeley: University of California Press.

Geertz, Clifford. 1983. *Local Knowledge: Further Essays in Interpretive Anthropology.* New York: Basic Books.

Gonseth, Marc-Olivier, Jacques Hainard, and Roland Kaehr (eds.) 1999. *L'art c'est l'art.* Neuchâtel: Musée d'Ethnographie.

Greenberg, Reesa, Bruce W. Ferguson, and Sandy Nairne (eds.) 1996. *Thinking about Exhibitions.* London: Routledge.

Greenfield, Jeanette. 1989. *The Return of Cultural Treasures.* Cambridge: Cambridge University Press.

Henderson, Amy, and Adrienne L. Kaeppler (eds.) 1997. *Exhibiting Dilemmas: Issues of Representation at the Smithsonian.* Washington, DC: Smithsonian Institution Press.

Hilden, Patricia Penn. 2000. "Race for Sale: Narratives of Possession in Two 'Ethnic' Museums." *The Drama Review* 44(3):11–36.

hooks, bell. 1995. *Art on My Mind: Visual Politics.* New York: The New Press.

Jonaitis, Aldona (ed.) 1991. *Chiefly Feasts: The Enduring Kwakiutl Potlatch.* New York: American Museum of Natural History; Seattle: University of Washington Press.

Karp, Ivan, and Steven D. Lavine (eds.) 1991. *Exhibiting Cultures: The Poetics and Politics of Museum Display.* Washington, DC: Smithsonian Institution Press.

Karp, Ivan, Christine Mullen Kreamer, and Steven D. Lavine (eds.) 1992. *Museums*

and Communities: The Politics of Public Culture. Washington, DC: Smithsonian Institution Press.

Kirshenblatt-Gimblett, Barbara. 1998. *Destination Culture: Tourism, Museums, and Heritage.* Berkeley: University of California Press.

Lavreysen, Ria. 1998. *Global encounters in the world of art: Collisions of tradition and modernity.* Amsterdam: Royal Tropical Institute.

Leyten, Harrie (ed.) 1995. *Illicit traffic in cultural property: museums against pillage.* Amsterdam: Royal Tropical Institute; Bamako: Musée National du Mali.

Leyten, Harrie, and Bibi Damen (eds.) 1993. *Art, anthropology, and the modes of representation: Museums and contemporary non-Western art.* Amsterdam: Royal Tropical Institute.

MacClancy, Jeremy (ed.) 1997. *Contesting Art: Art, Politics and Identity in the Modern World.* Oxford: Berg.

Marcus, George E., and Fred R. Myers (eds.) 1995. *The Traffic in Culture: Refiguring Art and Anthropology.* Berkeley: University of California Press.

Mead, Sidney Moko (ed.) 1984. *Te Maori: Maori Art from New Zealand Collections.* New York: Harry N. Abrams.

Messenger, Phyllis Mauch (ed.) 1989. *The Ethics of Collecting Cultural Property: Whose Culture? Whose Property?* Albuquerque: University of New Mexico Press.

Michaud, Yves (ed.) 1989. *Magiciens de la Terre.* Special issue of *Les Cahiers du Musee National d'Art Moderne* no. 28.

Musée National d'Art Moderne. 1989. *Magiciens de la Terre.* Paris: Centre Georges Pompidou.

Paul, Annie. 1999. "Uninstalling the Nation: The Dilemma of Contemporary Jamaican Art." *Small Axe* 6:57–78.

Pearce, Susan M. 1993. *Museums, Objects, and Collections: A Cultural Study.* Washington, DC: Smithsonian Institution Press.

Phillips, Ruth B., and Christopher B. Steiner (eds.) 1999. *Unpacking Culture: Art and Commodity in Colonial and Postcolonial Worlds.* Berkeley: University of California Press.

Price, Richard, and Sally Price. 1992. *Equatoria.* New York: Routledge.

———1994. *On The Mall.* Bloomington: University of Indiana Press.

———1995. *Enigma Variations.* Cambridge: Harvard University Press.

Price, Sally. 1999. Representations of Art and Arts of Representation. *American Anthropologist* 101:841–44.

———2001. Museums of the World *à la française. American Anthropologist* 103.

Price, Sally, and Richard Price. 1999. *Maroon Arts: Cultural Vitality in the African Diaspora.* Boston: Beacon Press.

Prussat, Margrit, and Wolfgang Till (eds.) 2001. *"Neger im Louvre": Texte zu Kunstethnographie und moderner Kunst.* Dresden: Verlag der Kunst.

Root, Deborah. 1995. *Cannibal Culture: Art, Appropriation, and the Commodification of Difference.* Boulder, CO: Westview Press.

Schildkrout, Enid, and Curtis A. Keim (eds.) 1998. *The Scramble for Art in Central Africa.* Cambridge: Cambridge University Press.

Sherman, Daniel J., and Irit Rogoff (eds.) 1994. *Museum Culture: Histories, Discourses, Spectacles.* Minneapolis: University of Minnesota Press.

Simpson, Moira G. 1996. *Making Representations: Museums in the Post-Colonial Era.* London: Routledge.

Taffin, Dominique (ed.) 2000. *Du musée colonial au musée des cultures du monde.* Paris: Maisonneuve et Larose.

Tawadros, Gilane. 1996. "Beyond the Boundary: The Work of Three Black Women Artists in Britain." In Houston A. Baker, Jr., Manthia Diawara, and Ruth H. Lindeborg (eds.), *Black British Cultural Studies: A Reader,* pp. 240–277. Chicago: University of Chicago Press.

Thomas, Nicholas. 1999. *Possessions: Indigenous Art / Colonial Culture.* New York: Thames and Hudson.

Tucker, Marcia (ed.) 1992. *Different Voices: A Social, Cultural, and Historical Framework for Change in the American Art Museum.* New York: Association of Art Museum Directors.

Vaillant, Émilia, and Germain Viatte (eds.) 1999. *Le musée et les cultures du monde.* Paris: École nationale du patrimoine.

Walker, Roslyn Adele. 1994. "Anonymous Has a Name: Olowe of Ise." In Rowland Abiodun, Henry J. Drewal, and John Pemberton III (eds.), *The Yoruba Artist: New Theoretical Perspectives on African Arts,* pp. 90–106. Washington, DC: Smithsonian Institution Press.

Ziff, Bruce, and Pratima V. Rao (eds.) 1997. *Borrowed Power: Essays on Cultural Appropriation.* New Brunswick, NJ: Rutgers University Press.

137

NOTES

Introduction

1. In 1965, the journal *Current Anthropology* invited twelve internationally recognized authorities to comment on the term "primitive art" (Claerhout et al. 1965). One (Phillip H. Lewis) argued that "we need not be embarrassed about [the term] primitive art. It is neither crude nor nasty." Another (Carl B. Compton) suggested a substitute, "precivilized art," merely confirming and perpetuating the evolutionary connotations of a label that had already, by most assessments, outlived its relevance. Others pointed out some basic problems—e.g., that "primitive art" is "a rubbery, shapeless, inappropriate term" (Emma Lou Davis), that "it is a catchall and its components are not visually homogeneous" (Douglas Fraser), and that these components' unifying thread is limited to "their mere foreignness [to us] in form and content" (Adrian A. Gerbrands, citing Leonard Adam). Overall, the assessment was sufficiently problematical so that the final contribution (by Adriaan G. H. Claerhout, the debate's instigator) referred, in an otherwise impeccably genteel discussion, to "primitive" as "that 'damned' word."

2. William Rubin (1984) pioneered this typographic convention as a way of writing about Western views of non-Western arts without necessarily ascribing legitimacy to them. In contrast to Rubin, however, I employ this convention to explore notions about Primitive Art that are held by the general public, rather than by twentieth-century artists. In terms of conventions, it is perhaps also worth pointing out that in this book the words "man," "he," "him," and "his" refer exclusively to persons of masculine gender, except when they appear in such capitalized terms and in passages quoted from other authors.

3. See Meyer and Schapiro 1978, in which the term is coined, the concept elaborated, and examples provided.

4. This description is written on the basis of a 1982 viewing of Ruiz's film, in a Leiden University student film series; I apologize for any inaccuracies of detail that an impressionistic memory may have introduced.

Chapter 1: The Mystique of Connoisseurship

1. *Local Knowledge: Further Essays in Interpretive Anthropology* (New York: Basic Books, 1983), p. 75.

2. In this book, my interest in connoisseurship centers on powers of aesthetic judgment more than on the ability to determine dates and authorship. The latter functions have, in any case, been reduced to a relatively crude practice in the realm of Primitive Art, as we shall see in subsequent chapters.

3. Most of the dealers and collectors who have talked to me about their life have offered an anecdote from very early childhood. One, for example, described the collection of Indian arrowheads he assembled at the age of ten. Another underscored the precocity of his obsessive passion for antiquities by recalling how, while his playmates always talked about their toys, he repeatedly held forth about the Maya. Finally one day, during a school recess, one of them blurted out the bottom-line question: "But these 'mayas' of yours—Are they things you can play with?"

4. See also the testimonials by Nelson Rockefeller, Ladislas Segy, Werner Muensterberger, and Jacques Maquet quoted in chap. 6.

5. Haskell's point has since been taken up by others as well. Keith Moxey, for example, recently made a plea for recognizing that our most cherished aesthetic judgments do not represent self-evident or value-neutral truths and for exploring the ways in which they are "colored by the historical moment in which they were made" (1988).

6. In this regard, he aligned himself with the view that Bourdieu refers to as the *discours mystique,* which he illustrates via a passage from the popular magazine, *Réalités:* "Whether ignorant or initiated, no one can fail to be disarmed before this mystery, the masterpiece. All of us—fumbling, uncertain, scrutinizing the canvas—wait eagerly for that moment of grace when the painter's message will come through to us. The silent clamor of Rembrandt, the infinite gentleness of Vermeer—no culture will make us understand it if we have not first been able to establish the calm, set up a sense of anticipation, make within ourselves the space that encourages emotion" (1960, cited in Bourdieu 1979: 74).

7. For a discussion of the popular distinction between societies with and without art history, see chap. 4.

8. Like "Play it again, Sam" (which Bogart never actually said in *Casablanca*), this "venerable Boasian principle"—enclosed in quotation marks by Marshall Sahlins (1985: 145)—seems to have first been put in (roughly) these terms by Ruth Benedict (1943: 60; see also Stocking 1968/1982: 145).

Chapter 2: The Universality Principle

1. Cited by Ruth E. Gruber, in "A Stateswoman Goes Home," *International Herald Tribune,* 19 February 1987, p. 16.

2. Clifford Geertz insists on the same point when he notes that "we are living more and more in the midst of an enormous collage" produced, for example, by

> the migration of cuisines, costumes, furnishings and decor (caftans in San Francisco, Colonel Sanders in Jogjakarta, bar stools in Kyoto); the appearance of *gamelan* themes in *avant-garde* jazz, Indio myths in Latino novels, magazine images in African painting. But most of all, it is that the person we encounter in the grocery store is as likely, or nearly, to come from Korea as from Iowa, in the post office from Algeria as from the Auvergne, in the bank from Bombay as from Liverpool. [1986: 121]

3. The philanthropic image of a little blond girl bestowing affection on a little black baby has become a sufficiently standard cliché in our society to have won inclusion (along with John F. Kennedy's funeral and Vietnam war protests) in Michael Jackson's 1988 pop-gospel video, "Man in the Mirror."

4. For more on the ironies of viewing racial equality as the product of white generosity for which non-whites owe their benefactors gratitude, see Arna Bontemps's sketch of Mrs. Eulalie Rainwater (1973: 71–87) and James Baldwin's "Journey to Atlanta" (1955: 73–84). More recently, Jesse Jackson felt called upon to point out that in expecting a Democratic party response to his strong showing in the 1988 presidential primaries, "We're not discussing generosity, we're discussing reciprocity."

5. The most recent variant of the "universality principle" would seem to be the New Age movement. Uniting not only people in all corners of the globe, but even those who have passed into the world beyond, its adherents promote pan-human understanding through such happenings as the 1987 "Harmonic Convergence," during which thousands of people assembled at "pressure points" around the world, where they "hugged, held hands, and chanted, united in the conviction that this would usher in a new era of world harmony" (Blow 1988: 24).

6. Richard Bauman has made the same point in the realm of literature, referring to

> notions, strongly colored by ethnocentric and elitist biases that privilege the classics of Western written literature over oral and vernacular literature and by nineteenth-century conceptions of "folk" society, [which] have established an image of oral literature as simple, form-less, lacking in artistic quality and complexity, the collective expression of unsophisticated peasants and primitives constrained by tradition and the weight of social norms against individual creativity of expression. [1986: 7]

7. This one-directionality also colors Western attitudes toward inter-cultural borrowing in the arts. Vincent Megaw has presented this case forcefully and sensitively, citing the MOMA "Primitivism" exhibit and pointing out the condescension implicit in such terms as "Yirrawala, the Picasso of Arnhem Land" or "Clifford Possum Tjapaltjarri, the Leonardo of the Desert" (1986: 66).

Chapter 3: The Night Side of Man

1. Trustman Senger, "Lisa Bonet Flips from Braces to Stardom," reprinted in the *International Herald Tribune*, 14–15 March 1987, p. 14.

2. A comment written in response to an ethnography having nothing to do with art might usefully be called into renewed service at this point. In a discussion of I. Hogbin's *The Island of Menstruating Men*, Remo Guidieri remarked, "The term 'monsters' constitutes part of the ethnographer's vocabulary. As for that of the 'ethnographized,' I would like to know a bit more about it" (1984: 5).

3. The tendency to project one's own fears into an image of the Other, especially in a racially tinted blurring of reality, is sensitively described in Toni Morrison's most recent novel, *Beloved:*

> Whitepeople believed that whatever the manners, under every dark skin was a jungle. Swift unnavigable waters, swinging screaming baboons, sleeping snakes, red gums ready for their sweet white blood. . . . But it wasn't the jungle blacks brought with them to this place from the other (livable) place. It was the jungle whitefolks planted in them. And it grew. It spread. In, through and after life, it spread, until it invaded the whites who had made it. Touched them every one. Changed and altered them. Made them bloody, silly, worse than even they wanted to be, so scared were they of the jungle they had made. The screaming baboon lived under their own white skin; the red gums were their own. [1987: 198]

4. Bourdieu touches tangentially on this associative opposition when he remarks: "The contrast between culture and corporeal pleasure (or, if you will, nature) is rooted in the opposition between the cultivated bourgeoisie and commoners—that illusionary locus of crude nature, of barbarity indulging in pure rapture [*jouissance*—i.e., orgasmic rapture]" (1979: 572).

5. Female sexual imagery has distinctly less success as a selling point. Several dealers commented that their remarks about objects' associations with menstrual taboos, procreative anatomy, or specifically female symbolism deterred customers consistently enough so that they found it useful to omit any such commentary from their discussions. More than one proposed that female sexuality seemed to make people uncomfortable and embarrassed, while phallic imagery inspired excitement and interest.

6. In a similar vein, Stephen Jay Gould has stressed the power of vocabulary to perpetuate obsolete received wisdom about the animal kingdom. Citing the "conventional idea that marsupials are anatomically and physiologically inferior to placentals," he argues that

> the very terms of our taxonomy reinforce this prejudice. All mammals are divided into three parts: the egglaying monotremes are called Prototheria, or premammals; placentals win the prize as Eutheria, or true mammals; the poor marsupials lie in limbo as Metatheria, or middle mammals—not quite all there.
> The argument for structural inferiority rests largely upon differing modes of reproduction in marsupials versus placentals, bolstered by the usual smug assumption that different from us is worse. [1980: 291]

7. The following year, in Paris, I heard the cannibalism account of Rockefeller's death again—this time from well-educated people who insisted that their sources were authoritative and that any other story I might have heard was a cover-up engineered by the family to protect their privacy and dignity. Increasingly intrigued by the question of whether I had been dealing with an imaginative fantasy about Primitive Life or a high-level cover-up of an unpleasant incident in the life of a politically powerful family, I pushed my investigation further by writing to a colleague who, I had reason to believe, might be as directly in touch with the facts as anyone outside the immediate family. The various pieces of information provided by him (and by others whose names he gave me) have erased all conceivable doubt in my mind, fully persuading me that Michael Rockefeller was neither mutilated, feasted upon, nor converted into a tribal trophy. He died in a drowning accident at sea. The public appetite for sensationalism, however, could not pass up this golden opportunity to link Primitive Savagery with the fate of a young blond heir. Not only do museum guards in New York and art collectors in Paris gossip privately about the gory details, but there is also a constant flow of correspondence addressed directly to M.R.'s mother. His shrunken head has been offered to her for a price; people have reported interviews with the natives who ate him; others have sent in photographs of his alleged grave; and yet others have made formal requests for funding to uncover all the gruesome facts of his final days. The volume of these communications is so great and it has continued for so long that Mrs. Rockefeller finally assigned a staff member responsibility for handling it.

8. Paul Wingert's way of communicating the same impression of integralness was to write about "the vast primitive world" (1962: 15). And Jim Mosley, an antique dealer in Key West with an interest in pre-Columbian art, UFOs, and ancient astronauts, explained the relationship as follows on a radio show transmitted from Miami on 28 March 1985: "The term pre-Columbian art is sometimes stretched to include Africa. And in that case the better term is primitive art."

Chapter 4: Anonymity and Timelessness

1. Alan Cowell, *International Herald Tribune*, 18 September 1986, p. 1.

2. Chipp is not the only commentator who has made imaginative use of the death penalty to impress upon his readers the seriousness of local taboos. Still in the realm of art, Werner Muensterberger asserted that "The Ashanti women risked capital punishment, in former times, if they tried to approach the sculptor while he was working" (1971b: 9). And on another score, the author of a book about the Saramaka Maroons of Suriname (who are of variable height, but generally shorter than Europeans or Americans) declared without reservation that "all young men who do not attain a stature of at least six feet are driven out to die" (Vandercook 1926a: 227–28).

3. An interest in the Primitive Artist's "embarrassment" creeps into a number of speculative accounts of the artistic life of exotic societies, sounding suspiciously in some cases like a projection of the Western commentator's own reaction to the art under discussion. H. W. Janson, for example, whose descriptive vocabulary for Primitive Art includes words such as "puzzling," "repellent," and "strange," cautiously concludes that the meaning of most masks "is impossible to ascertain," but shows no equivalent reticence in pinpointing the rationale behind juxtaposed linear forms in Nootka painting:

> The artist's pattern-consciousness goes so far that any overlapping of
> forms embarrasses him; where he cannot avoid it, he treats the bodies
> of the animals as transparent, so that the outline of the whale's back
> can be seen continuing right through the lower part of the bird's body.
> [1986: 51]

4. Given this view, it is not surprising that the author reads an ironic twist into modern artists' fascination with Primitive Art:

> While the artists of Europe and America are trying . . . to borrow
> instinct and vitality from the carvers of the African idols, the peoples
> of Africa are themselves awakening from their jungle sleep and would
> now like to free themselves both from the idols of their witch-doctors
> and from the influence of the White empires. [Bihalji-Merin 1972: 8]

5. The use of temporal categorizations as distancing devices, points out Fabian, lies behind one of the occupational frustrations experienced by all social anthropologists.

> I am surely not the only anthropologist who, when he identifies
> himself as such to his neighbor, barber, or physician, conjures up

visions of a distant past. When popular opinion identifies all anthropologists as handlers of bones and stones it is not in error; it grasps the essential role of anthropology as a provider of temporal distance. [1983: 30]

6. A sister notion, whose demise seems to be progressing somewhat more quickly, is the old idea that the concept of romantic love is confined to Western Civilization. Dismissing the existence of such a sentiment among Africans, for example, was justified on the grounds of cultural inappropriateness, which permitted the portrayal of their sexual involvements as carnal satisfaction on a more bestial level.

7. Thompson's actual implementation of the goal is strangely selective; in a discussion of Afro-American multistrip textiles, for example, he compares a "wool blanket [that] was fashioned around 1890 by Luiza Combs of Hazard, Kentucky," and further discussed, he notes, on page 55 of John Vlach's 1978 book, *The Afro-American Tradition in the Decorative Arts,* with an object that he identifies only as being from Suriname and representing "Djuka and Saamaka multistrip expressions of the early twentieth century"—in spite of the fact that he was aware, from both published and unpublished sources, of the latter's identity in terms of its size, raw materials, and function, and the artist's name, age, sex, tribe, and village (1983: pls. 141, 142).

Chapter 5: Power Plays

1. *Beloved* (New York: Alfred A. Knopf, 1987), p. 190.

2. The use of the word "assume" is intentional here, meaning both "to take on" and "to take for granted."

3. As the methodological handbook of the Royal Anthropological Institute of Great Britain and Ireland counseled, "It is often difficult to collect recent human skulls and bones, but every effort should be made to do so" (1874, 1951: 364).

4. Claude Lévi-Strauss has made a similar argument, but arrives at a rather different assessment of its ethical legitimacy and social value. "It is this avid and ambitious desire to take possession of the object for the benefit of the owner or even of the spectator which seems to me to constitute one of the outstandingly original features of the art of Western civilization" (Charbonnier 1969: 64).

5. In *African Art's* typically cute August 1986 editorial, the writer essentially recognized (and reveled in) this role, as repeated allusions to his own "characteristically witty and learned speech" gave way, in the final five words of the essay, to a recognition of his "characteristically silly and trivial pronouncements" (1986: 6).

6. The oppositions in this article are not difficult to tease out: the hardworking, serious North American versus the vapidly smiling African native; the clever

interviewer versus the gullible interviewee (believing he'll see copies of the end results); and the journalist's environment of ample food, drinkable water, and climate-controlled interiors (understood by readers of the newspaper and therefore not explicitly elaborated) versus the world of torrential rains, termites, vultures, food shortages, and polluted water. Ultimately, the contrast becomes that between people who are entitled to eat peanut ice cream and speak in four-syllable words and those who are not. Although this particular example leans further than some toward caricature, it is not nearly as aberrant within journalistic writing as one might imagine; together with others of its kind, produced across the United States on a daily basis (in small-town newspapers somewhat more often than in the likes of the *Washington Post*), it carries on the Western tradition of dividing the world's population into Civilized and Other, and reiterates, in sketch after sketch of the latter, the superiority of the former.

Chapter 6: Objets d'Art and Ethnographic Artifacts

1. In this light it is not surprising that gallery owners reacted with indignation when the New York City Department of Consumer Affairs decided to require that they display conspicuously the prices of paintings and sculptures; as one remarked, "It's not in keeping with the atmosphere we're trying to create" (McGill 1988).

2. I certainly do not suggest that the issue of artistic intentionality is a simple one or that all thoughtful assessments of its place in artistic creation and response are in agreement. (See, for just one taste of the debate on this question, Krauss 1988.) I *do* suggest, however, that the summary dismissal of aesthetic intentionality in non-Western artists, in contrast to serious intellectual grappling with the question for Western art, is an act of significant cultural arrogance.

3. Maquet has combined Science with Mysticism to refine the first of these options, dividing aesthetic experience neatly into two segments and advocating instant replays in which the nonverbal, contemplative mode is followed by articulate formal analysis. But authority (in the sense of both authorship and judgmental competence) rests squarely with the Western viewer, and no attempt is made to explore the analogous experiences of the non-Western artists and critics responsible for the forms in question.

Chapter 7: From Signature to Pedigree

1. The sexual analogy can even be extended to include esoteric tastes. One dealer told me that several of his customers have made known their special interest in purchasing "virgin" pieces—objects that have "never been seen" (except in private by buyer and seller); once acquired, I was told, such an object is taken home and essentially hidden, to be viewed by almost no one but its owner.

2. The only regular exception to this practice is among objects originally owned by kings and other royal personages.

3. On Joseph Brummer, see Rubin 1984: 143.

Chapter 8: A Case in Point

1. *Djuka: The Bush Negroes of Dutch Guiana* (New York: Viking, 1931), p. 4.

2. For discussion of art and exchange, see S. Price 1984; for further illustrations of Maroon art, see also Hurault 1970 and Price and Price 1980.

3. Kahn (1931) mentions in passing that "Djukas," as he calls Saramakas, also speak another language, but minimizes its importance by contrasting it with what he claims is their "ordinary tongue" and describing it as a device for the preservation of tribal lore, historical accounts of slave rebellions, and other carefully guarded secrets. His discussion of language, such as it is, also comes at the end of his book (chap. 10, Djuka Talk), long after the image of the baby-talking native has settled into the consciousness of his readers. (Given its popular reputation for simplicity, it is perhaps worth pointing out that the very real complexities of the Saramaka language have come to constitute a major focus of historical and theoretical linguistics, spawning numerous recent articles and books.)

4. Vladimir Nabokov captured the spirit of this aggressive faith in the sexual symbolism of human behavior, drawing his illustration from its child-psychology incarnation— an only lightly modified variant of its presence in Primitive Art studies.

> Victor was a problem child insofar as he refused to be one. From the Winds' [his psychiatrist-parents'] point of view, every male child had an ardent desire to castrate his father and a nostalgic urge to re-enter his mother's body. But Victor did not reveal any behavior disorder, did not pick his nose, did not suck his thumb, was not even a nail biter. Dr. Wind, with the object of eliminating what he, a radiophile, termed "the static of personal relationship," had his impregnable child tested psychometrically at the Institute by a couple of outsiders, young Dr. Stern and his smiling wife (I am Louis and this is Christina). But the results were either monstrous or nil: the seven-year-old subject scored on the so-called Godunov Drawing-of-the-Animal Test a sensational mental age of seventeen, but on being given a Fairview Adult Test promptly sank to the mentality of a two-year-old. How much care, skill, inventiveness have gone to devise those marvelous techniques! What a shame that certain patients refuse to co-operate! There is, for instance, the Kent-Rosanoff Absolutely Free Association Test, in which little Joe or Jane is asked to respond to a Stimulus Word, such as table, duck, music, sickness, thickness, low, deep, long, happiness, fruit, mother, mushroom. There is the charming

Bievre Interest-Attitude Game (a blessing on rainy afternoons), in which little Sam or Ruby is asked to put a little mark in front of the things about which he or she feels sort of fearful, such as dying, falling, dreaming, cyclones, funerals, father, night, operation, bedroom, bathroom, converge, and so forth; there is the Augusta Angst Abstract Test in which the little one (*das Kleine*) is made to express a list of terms ("groaning," "pleasure," "darkness") by means of unlifted lines. And there is, of course, the Doll Play, in which Patrick or Patricia is given two identical rubber dolls and a cute little bit of clay which Pat must fix on one of them before he or she starts playing, and oh the lovely doll house, with so many rooms and lots of quaint miniature objects, including a chamber pot no bigger than a cupule, and a medicine chest, and a poker, and a double bed, and even a pair of teeny-weeny rubber gloves in the kitchen, and you may be as mean as you like and do anything you want to Papa doll if you think he is beating Mama doll when they put out the lights in the bedroom. But bad Victor would not play with Lou and Tina, ignored the dolls, struck out all the listed words (which was against the rules), and made drawings that had no subhuman significance whatever. [1957: 90–91]

In a sense, what distinguishes Saramaka artists from little Victor is nothing more than their perceptiveness of outsiders' expectations for their psyches, plus a rather cynical willingness to play along, upon occasion, with the game.

5. The resistance to presenting art in nonestablished niches is not limited to Primitive Art. According to a journalistic account, the National Museum of Women in the Arts, which opened in Washington in 1987, was originally opposed by feminists because it did not propose to cover women's social history and by other critics because it segregated women's art from that of men. This project, too, was inspired by a wish to recognize the achievements of artists who had been subjected to more than their fair share of anonymity (Conroy 1987).

REFERENCES CITED

Note: Where relevant, I have indicated two publication dates—one for the first edition and another for the edition on which I base my discussion in this book.

Anonymous. 1931. *Instructions sommaires pour les collecteurs d'objets ethnographiques.* Paris: Musée d'ethnographie et Mission scientifique Dakar-Djibouti.

———. 1970. "First Word." *African Arts* 3(3): 1–2.

———. 1971. "First Word." *African Arts* 4(2): 1, 3, 5, 7, 73.

———. 1972. "The Vincent Price Collection." *African Arts* 5(2): 20–27.

———. 1984. *La rime et la raison: Les collections Menil.* Paris: Editions de la Réunion des Musées Nationaux.

———. 1986. "First Word." *African Arts* 19(4): 1–3, 6.

Allison, Philip. 1973. "Collecting Yoruba Art." *African Arts* 6(4): 64–68.

Alperton, Matty. 1981. "Decorating with Primitive Art." *Primitive Art Newsletter* 4(3): 1–3.

Alsop, Joseph. 1982. *The Rare Art Traditions: A History of Art Collecting and Its Linked Phenomena Wherever They Have Appeared.* Princeton: Princeton University Press.

———. 1986. "The Faker's Art." *New York Review of Books,* 23 October, pp. 25–26, 28–31.

Attenborough, David. 1976. *The Tribal Eye.* London: BBC.

Babcock, Barbara A. 1987. "Taking Liberties, Writing from the Margins, and Doing It with a Difference." *Journal of American Folklore* 100: 390–411.

Baekeland, Frederick. 1984. "The Art Collector: Clues to a Character Profile." *New York Times,* 16 September, section 2, pp. 1, 27.

Baldwin, James. 1955. *Notes of a Native Son.* Boston: Beacon Press.

Baldwin, James, et al. 1987. *Perspectives: Angles on African Art.* New York: Center for African Art.

Bauman, Richard. 1986. *Story, Performance, and Event: Contextual Studies of Oral Narrative.* Cambridge: Cambridge University Press.

Baxandall, Michael. 1985. *Patterns of Intention: On the Historical Explanation of Pictures.* New Haven and London: Yale University Press.

149

Benedict, Ruth. 1943. Obituary of Franz Boas. *Science* 97: 60–62.

Bennett, David H. 1980. "Malangi: The Man Who Was Forgotten before He Was Remembered." *Aboriginal History* 4(1): 42–47.

Berger, John. 1973. *Ways of Seeing*. New York: Viking.

Bernstein, Leonard. 1976. *The Unanswered Question: Six Talks at Harvard*. Cambridge: Harvard University Press.

Biebuyck, Daniel P. (ed.). 1969. *Tradition and Creativity in Tribal Art*. Berkeley: University of California Press.

Bihalji-Merin, Oto. 1972. "Art as a Universal Phenomenon." In Siegfried Wichmann (ed.), *World Cultures and Modern Art,* pp. 2–11. Munich: Bruckmann Publishers.

Blow, Richard. 1988. "Moronic Convergence." *New Republic,* 25 January, pp. 24–27.

Boas, Franz. 1908/1940. "Decorative Designs of Alaskan Needlecases: A Study in the History of Conventional Designs, Based on Materials in the U.S. National Museum. In *Franz Boas, Race, Language and Culture,* pp. 564–92. New York: Free Press.

Bontemps, Arna. 1973. *The Old South: "A Summer Tragedy" and Other Stories of the Thirties*. New York: Dodd, Mead & Co.

Bourdieu, Pierre. 1979. *La distinction: Critique sociale du jugement*. Paris: Les Editions de Minuit.

Bourdieu, Pierre, and Alain Darbel, with Dominique Schnapper. 1969. *L'Amour de l'art: Les musées d'art européens et leur public*. Paris: Editions de Minuit. 2d ed., revised and enlarged.

Brenson, Michael. 1984. "Discovering the Heart of Modernism." *New York Times,* 28 October, p. H33.

Brown, Laurene Krasny, and Marc Brown. 1986. *Visiting the Art Museum*. New York: E. P. Dutton.

Bunzel, Ruth, 1929/1972. *The Pueblo Potter: A Study of Creative Imagination in Primitive Art*. New York: Dover.

Carpenter, Edmund. 1973. "You Can't Unring a Bell." Talk at the Smithsonian Institution, 12 May.

———. 1976. "Collectors and Collections." *Natural History* 85(3): 56–67.

———. 1983. Introduction. In Stephen Guion Williams, *In the Middle: The Eskimo Today*. Boston: David R. Godine. Unpaginated.

Charbonnier, G. (ed.) 1969. *Conversations with Claude Lévi-Strauss*. London: Jonathan Cape. French original: *Entretiens avec Claude Lévi-Strauss*. Paris: Plon, 1961.

Chipp, Herschel B. 1971. "Formal and Symbolic Factors in the Art Styles of Primitive Cultures." In Carol F. Jopling (ed.), *Art and Aesthetics in Primitive Societies: A Critical Anthology,* pp. 146–70. New York: E. P. Dutton.

Christensen, Erwin O. 1955. *Primitive Art*. New York: Thomas Crowell; London: Thames & Hudson.

Claerhout, Adriaan G. H., et al. 1965. "The Concept of Primitive Applied to Art." *Current Anthropology* 6(4): 432–38.

Clark, Kenneth. N.d. "What Is Good Taste?" Text of 1 December 1958 program in series called "Is Art Necessary?" Associated Television.

———. 1969. *Civilisation: A Personal View.* New York: Harper & Row.

———. 1974. *Another Part of the Wood: A Self-Portrait.* London: John Murray. New York: Harper & Row, 1975.

Cohen, David William. 1977. *Womunafu's Bunafu: A Study of Authority in a Nineteenth-Century African Community.* Princeton: Princeton University Press.

Cole, Douglas. 1985. *Captured Heritage: The Scramble for Northwest Coast Artifacts.* Seattle: University of Washington Press.

Cole, Herbert M., and Chike C. Aniakor. 1984. *Igbo Arts: Community and Cosmos.* Los Angeles: Museum of Cultural History.

Conroy, Sarah Booth. 1987. "Building a New Portrait of Women in Art." *International Herald Tribune,* 20 February, p. 18.

Counter, S. Allen, Jr., and David L. Evans. N.d. "The Bush Afro-Americans of Surinam and French Guiana: The Connecting Link." Pamphlet.

———. 1981. *I Sought My Brother: An Afro-American Reunion.* Cambridge, Mass.: MIT Press.

Dark, Philip, J. C. 1954. *Bush Negro Art: An African Art in the Americas.* London: Tiranti.

Darriulat, Jacques. 1973. "African Art and Its Impact on the Western World." *Réalités* (English edition) no. 273: 41–50.

Dening, Greg. 1980. *Islands and Beaches: Discourse on a Silent Land, Marquesas, 1774–1880.* Honolulu: University Press of Hawaii.

Duerden, Dennis. 1968. *African Art.* Feltham, Middlesex: Paul Hamlyn.

Epstein, Jacob. 1963. *Epstein: An Autobiography.* New York: E. P. Dutton. (Expansion of his 1940 book, *Let There Be Sculpture*)

Fabian, Johannes. 1983. *Time and the Other: How Anthropology Makes Its Object.* New York: Columbia University Press.

Fagg, William. 1979. Introduction. In Werner Gillon, *Collecting African Art,* pp. viii–x. London, Sydney, Auckland, and Johannesburg: Studio Vista/ Christie's.

Firth, Raymond. 1936/1979. *Art and Life in New Guinea.* New York: AMS Press.

Forge, Anthony. 1971. "Art and Environment in the Sepik." In Carol F. Jopling (ed.), *Art and Aesthetics in Primitive Societies: A Critical Anthology,* pp. 290–314. New York: E. P. Dutton.

Freedman, Samuel G. 1985. "How Inner Torment Feeds the Spirit of Creativity." *International Herald Tribune,* 22 November, pp. 9, 11.

Fried, Michael. 1985. "Realism, Writing, and Disfiguration in Thomas Eakins's *Gross Clinic,* with a Postscript on Stephen Crane's Upturned Faces." *Representations* 9: 33–104.

Geertz, Clifford. 1986. "The Uses of Diversity." *Michigan Quarterly Review* 25(1): 105–23.

Glueck, Grace. 1984. "Show from France Opens New Center for African Art." *New York Times*, 21 September, pp. C1, C28.

Gombrich, E. H. 1966. *The Story of Art.* 11th ed., revised and enlarged. London: Phaidon Press.

Gould, Stephen Jay. 1980. *The Panda's Thumb: More Reflections in Natural History.* New York: Norton.

Graburn, Nelson H. H. (ed.) 1976. *Ethnic and Tourist Arts: Cultural Expressions from the Fourth World.* Berkeley: University of California Press.

Guiart, Jean. 1985. "The Musée de l'homme, the Arts, and Africa." In Susan Vogel and Francine N'Diaye, *African Masterpieces from the Musée de l'homme*, pp. 13–17. New York: Center for African Art and H. N. Abrams.

Guidieri, Remo. 1984. *L'abondance des pauvres: Six aperçus critiques sur l'anthropologie.* Paris: Seuil.

Harden, Blaine. 1986. "In Sudan, Time Refuses to Heed the Reporter's Calendar." *International Herald Tribune*, 26 September, p. 7.

Haskell, Francis. 1976. *Rediscoveries in Art: Some Aspects of Taste, Fashion, and Collecting in England and France.* Ithaca: Cornell University Press; London: Phaidon.

Herskovits, Melville J. 1930. "Bush Negro Art." *Arts* 17(51): 25–37, 48–49.

Herskovits, Melville J., and Frances S. Herskovits. 1934. *Rebel Destiny: Among the Bush Negroes of Dutch Guiana.* New York: McGraw-Hill.

Hess, Thomas B. 1968. Editorial. *Art News* 66(9): 27.

Higbee, Arthur. 1987. "American Topics." *International Herald Tribune*, 7 January, p. 3.

Hobsbawm, Eric, and Terence Ranger (eds.) 1983. *The Invention of Tradition.* Cambridge: Cambridge University Press.

Holm, Bill. 1974. "The Art of Willie Seaweed: A Kwakiutl Master." In Miles Richardson (ed.), *The Human Mirror*, pp. 59–90. Baton Rouge: Louisiana State University Press.

Hooper, J. T., and C. A. Burland. 1953. *The Art of Primitive Peoples.* London: Fountain Press.

Honan, William H. 1988. "Artists of All Disciplines, Newly Militant, Are Fighting for Their Rights." *New York Times*, 3 March, p. 20.

Hoving, Thomas. 1982. *King of the Confessors.* New York: Ballantine Books.

Hurault, Jean. 1970. *Africains de Guyane: La vie matérielle et l'art des Noirs Réfugiés de Guyane.* Paris and The Hague: Mouton.

Huyghe, René. 1973. "African and Oceanic Art: How It Looks from the West." *Réalités* (English edition) no. 273: 66–67.

Janson, H. W. 1986. *History of Art.* New York and Englewood Cliffs, N.J.: Harry Abrams and Prentice-Hall. 3d ed., revised and expanded by Anthony F. Janson.

Kahn, Morton C. 1931. *Djuka: The Bush Negroes of Dutch Guiana.* New York: Viking Press.

————. 1939. "Africa's Lost Tribes in South America: An On-the-Spot Account of Blood-Chilling African Rites of 200 Years Ago Preserved Intact in the Jungles of South America by a Tribe of Runaway Slaves." *Natural History* 43: 209–15, 232.

————. 1954. "Little Africa in America: The Bush Negroes." *Americas* 6(10): 6–8, 41–43.

Kamer, Henri. 1974. "De l'authenticité des sculptures africaines / The Authenticity of African Sculptures." *Arts d'Afrique Noire* 12: 17–40.

Kisselgoff, Anna. 1984. "Pagan Rituals Live on in British Folk Dance." *New York Times,* 23 December, pp. H12, 14.

Kramer, Hilton. 1982. "The High Art of Primitivism." *New York Times Magazine,* 24 January, pp. 18–19, 62.

Krauss, Rosalind. 1984. "Giacometti." In William Rubin (ed.), *"Primitivism" in Modern Art: Affinity of the Tribal and the Modern,* pp. 502–33. New York: Museum of Modern Art.

————. 1988. Review of Richard Wollheim's *Painting as an Art. New Republic,* 12–19 September, pp. 33–38.

Leach, Edmund R. 1971. "A Trobriand Medusa?" In Carol F. Jopling (ed.), *Art and Aesthetics in Primitive Societies: A Critical Anthology,* pp. 45–54. New York: E.P. Dutton.

Lee, Sherman E. 1986. Reply to Alsop 1986. *New York Review of Books,* 18 December, p. 76.

Leiris, Michel, 1934/1981. *L'Afrique fantôme.* Paris: Editions Gallimard.

————. 1950/1969. "L'ethnographe devant le colonialisme." *Les Temps Modernes* 58: 357–74. Reprinted in Michel Leiris, *Cinq études d'ethnologie,* pp. 83–112. Paris: Gonthier, 1969.

Lévi-Strauss, Claude. 1958/1974. *Anthropologie structurale.* Paris: Librairie Plon. Translated as *Structural Anthropology.* New York: Basic Books.

Lippard, Lucy R. 1973. *Six Years: The Dematerialization of the Art Object.* New York: Praeger.

Lynes, Russell. 1954. *The Tastemakers.* New York: Harper & Bros.

Manning, Patrick. 1985. "Primitive Art and Modern Times." *Radical History Review* 33: 165–81.

Maquet, Jacques. 1986. *The Aesthetic Experience: An Anthropologist Looks at the Visual Arts.* New Haven: Yale University Press.

Marrie, Adrian. 1985. "Killing Me Softly: Aboriginal Art and Western Critics." *Art Network* 14: 17–21.

McEvilley, Thomas. 1984. "Doctor Lawyer Indian Chief: '"Primitivism" in twentieth-century art,' at the Museum of Modern Art in 1984." *Artforum* 23(3): 54–61.

McGill, Douglas C. 1984a. "An Autumn of Tribal Art." *New York Times*, 14 September, p. C26.

―――. 1984b. "Center Devoted to African Art Opens." *New York Times*, 18 September, p. C17.

―――. 1985. "Art World Subtly Shifts to Corporate Patronage." *New York Times*, 5 February, p. C14.

―――. 1988. "Art Galleries Are Told to Post Prices." *New York Times*, 10 February, p. 22.

Megaw, Vincent. 1986. "Something, but for Whom? Ethics and Transitional Art." *Cultural Survival Quarterly* 10(3): 64–69.

De Menil, Dominique. 1962. Introduction, *The John and Dominique de Menil Collection*. New York: Museum of Primitive Art. Unpaginated.

Meyer, Melissa, and Miriam Schapiro. 1978. "Waste Not, Want Not: An Inquiry into What Women Saved and Assembled." *Heresies* 4: 66–69.

Mintz, Sidney W. 1985. *Sweetness and Power: The Place of Sugar in Modern History*. New York: Viking.

Moberg, David. 1984/85. "Primitive Inspiration." *In These Times*, 19 December–8 January, pp. 24, 23.

Morrison, Toni. 1987. *Beloved*. New York: Alfred A. Knopf.

Moxey, Keith. 1988. "High Art/Low Art." Paper presented at the 76th Annual College Art Association meeting, 11–13 February, Houston.

Muensterberger, Werner. 1971a. "Roots of Primitive Art." In Charlotte M. Otten (ed.), *Anthropology and Art: Readings in Cross-Cultural Aesthetics*, pp. 106–28. New York: Natural History Press.

―――. 1971b. "Some Elements of Artistic Creativity among Primitive Peoples." In Carol F. Jopling (ed.), *Art and Aesthetics in Primitive Societies: A Critical Anthology*, pp. 3–10. New York: E. P. Dutton.

―――. 1979. *Universality of Tribal Art / Universalité de l'art tribal*. Geneva: Barbier-Muller Collection.

Mumford, Lewis. 1979. *My Works and Days: A Personal Chronicle*. New York and London: Harcourt Brace Jovanovich.

Muntslag, F. H. J. 1966. *Tembe: Surinaamse Houtsnijkunst*. Amsterdam: Prins Bernhard Fonds.

―――. 1979. *Paw a Paw Dindoe: Surinaamse Houtsnijkunst*. Paramaribo: VACO.

Myers, Bernard S. 1967. *Art and Civilization*. New York and Toronto: McGraw-Hill.

Nabokov, Vladimir. 1957. *Pnin*. London: Heinemann.

Newton, Douglas. 1978. *Masterpieces of Primitive Art*. New York: Alfred A. Knopf.

―――. 1981. *The Art of Africa, the Pacific Islands, and the Americas*. New York: Metropolitan Museum of Art.

Novack, Cynthia. 1982. "Reactions to Art: The Rockefeller Wing, Metropolitan Museum." Manuscript.

Ortega y Gasset, José. 1925/1972. "The Dehumanization of Art." *Velazquez, Goya, and the Dehumanization of Art,* pp. 65–83. London: Studio Vista.

Ottenberg, Simon. 1984. "Books on Primitive Art: Coming of Age." *Bookman's Weekly,* 30 July 1984, pp. 587–602.

Van Panhuys, L. C. 1928. "Quelques ornements des nègres des bois de la Guyane Néerlandaise." *Proceedings of the International Congress of Americanists* 22: 231–74.

———. 1930. "Ornaments of the Bush-Negroes in Dutch Guiana: A Further Contribution to Research in Bush-Negro Art." *Proceedings of the International Congress of Americanists* 23: 723–35.

———. 1934. "African Customs and Beliefs Preserved for Two Centuries in the Interior of Dutch Guiana." *Proceedings of the International Congress of Anthropological and Ethnological Sciences* 1: 247–48.

Paudrat, Jean-Louis. 1972. "The Negative Reception of the Art of the Traditional Societies of Africa." In Siegfried Wichmann (ed.), *World Cultures and Modern Art,* pp. 252–54. Munich: Bruckmann Publishers.

Price, Richard. 1970. "Saramaka Woodcarving: The Development of an Afroamerican Art. *Man* 5: 363–78.

———. 1976. *The Guiana Maroons: A Historical and Bibliographical Introduction.* Baltimore: Johns Hopkins University Press.

———. 1983. *First-Time: The Historical Vision of an Afro-American People.* Baltimore: Johns Hopkins University Press.

———. 1990. *Alabi's World: Conversion, Colonialism, and Resistance on an Afro-American Frontier.* Baltimore: Johns Hopkins University Press.

Price, Sally. 1982/1988. "Sexism and the Construction of Reality: An Afro-American Example." *American Ethnologist* 10: 460–76. Reprinted in Johnnetta B. Cole (ed.), *Anthropology for the Nineties,* pp. 126–48. New York: Free Press.

———. 1984. *Co-wives and Calabashes.* Ann Arbor: University of Michigan Press.

———. 1986. "L'esthétique et le temps: commentaire sur l'histoire orale de l'art." *L'Ethnographie* 82(98–99): 215–25.

Price, Sally, and Richard Price. 1980. *Afro-American Arts of the Suriname Rain Forest.* Berkeley: University of California Press.

Reischek, Andreas. 1930/1952. *Yesterdays in Maoriland.* New Zealand and Australia: Whitcombe & Tombs.

Richard, Paul. 1984a. "Magical Affinities: Linking Tribal and Western at the Museum of Modern Art." *Washington Post,* 30 September, pp. H1, H6–8.

———. 1984b. "Tribal Masterpieces: The Esthetic Dilemma." *Washington Post,* 11 November, pp. K1–2.

Rodrigues, Georges. 1981. "Evolution et psychologie des collectionneurs d'art africain." *Antologia di Bella Arte* 17/18: 18–24.

Rosaldo, Renato. 1980. *Ilongot Headhunting, 1883–1974*. Stanford: Stanford University Press.

Roy, Claude. 1957. *Arts sauvages*. Paris: R. Delpire. Translated as *The Art of Savages*. Sheldon, N.Y.: Golden Griffen Books, 1958.

Royal Anthropological Institute of Great Britain and Ireland. 1874/1951. *Notes and Queries on Anthropology*. London: Routledge & Kegan Paul Ltd. 1st ed. 1874; 6th ed. 1951.

Rubin, William (ed.). 1984. *"Primitivism" in Twentieth-Century Art: Affinity of the Tribal and the Modern*. New York: Museum of Modern Art.

Russell, John. 1984. "Primitive Spirits Invade the Modern." *New York Times*, 28 September, pp. C1, C28.

Sahlins, Marshall. 1985. *Islands of History*. Chicago: University of Chicago Press.

Sandburg, Carl. 1955. Prologue. *The Family of Man*, pp. 2–3. New York: Museum of Modern Art.

Schwartz, Gary. 1985. *Rembrandt: His Life, His Paintings*. New York: Viking.

———. 1987. "Art in History, History in Art." Paper presented at the Getty Center Workshop, 2 May 1987.

Segy, Ladislas. 1975. *African Sculpture Speaks*. 4th ed. New York: Da Capo Press.

Seligman, Germain. 1961. *Merchants of Art, 1880–1960: Eighty Years of Professional Collecting*. New York: Appleton-Century-Crofts.

Sieber, Roy. 1971. "The Aesthetics of Traditional African Art." In Carol F. Jopling (ed.), *Art and aesthetics in primitive societies: A critical anthology*, pp. 127–31. New York: E. P. Dutton.

Sigel, Linda. 1971. "A Private Collection at the Art Institute of Chicago." *African Arts* 5(1): 50–53.

Silverman, Raymond A. 1987. Review of James Baldwin, et al., *Perspectives: Angles on African Art*. *African Arts* 21(1): 19–24.

Stephen, Ann. 1980. "Margaret Preston's Second Coming." *Art Network* 2: 14–15.

Stocking, George W., Jr. 1968/1982. *Race, Culture, and Evolution: Essays in the History of Anthropology*. Chicago: University of Chicago Press.

Stocking, George W., Jr. (ed.) 1985. *Objects and Others: Essays on Museums and Material Culture*. Madison: University of Wisconsin Press.

Strathern, Marilyn. 1987. "Out of Context: The Persuasive Fictions of Anthropology." *Current Anthropology* 28(3): 251–81.

Thompson, Robert Farris. 1968. "Aesthetics in Traditional Africa." *Art News* 66(9): 44–45, 63–66.

———. 1983. *Flash of the Spirit: African and Afro-American Art and Philosophy*. New York: Random House.

Tilghman, B. R. 1984. *But Is It Art? The Value of Art and the Temptation of Theory*. Oxford: Basil Blackwell.

Tregaskis, Moana. 1986. "Trading in the Rich Art of Nepal." *International Herald Tribune*, 19 September, p. 7.

Vandercook, John Womack. 1926a. *Tom-Tom.* New York and London: Harper & Bros.

———. 1926b. "We Find an African Tribe in the South American Jungle." *Mentor* 14(3): 19–22.

Vogel, Susan M. 1982. "Bringing African Art to the Metropolitan Museum." *African Arts* 15(2): 38–45.

Vogel, Susan, and Francine N'Diaye. 1985. *African Masterpieces from the Musée de l'homme.* New York: Center for African Art and Harry N. Abrams.

Volders, J. L. 1966. *Bouwkunst in Suriname: Driehonderd Jaren Nationale Architectuur.* Hilversum: G. van Saanen.

De Vries-Hamburger, L. 1959. "Over Volkskunst in het Algemeen en die van Suriname in het Bijzonder." *Kultuurpatronen* 1: 106–10.

Wade, Edwin L. (ed.). 1986. *The Arts of the North American Indian: Native Traditions in Evolution.* New York: Hudson Hills.

Warner, John Anson. 1986. "The Individual in Native American Art: A Sociological View." In Edwin L. Wade (ed.), *The Arts of the North American Indian: Native Traditions in Evolution,* pp. 171–202. New York: Hudson Hills.

Wingert, Paul. 1962. *Primitive Art: Its Traditions and Styles.* New York: Oxford University Press.

Wright, Robin K. 1983. "Anonymous Attributions: A Tribute to a Mid-Nineteenth Century Haida Argillite Pipe Carver, the Master of the Long Fingers." In Bill Holm, *The Box of Daylight,* pp. 139–42. Seattle: Seattle Art Museum and University of Washington Press.

Zilczer, Judith K. 1977. "Primitivism and New York Dada." *Arts Magazine* 51 (May): 140–42.

ILLUSTRATION CREDITS

Frontispiece: Maori warrior at the Metropolitan Museum of Art, on the occasion of the Te Maori exhibition, 1984. Photo by Fred R. Conrad, NYT Pictures.

P. 9: Joseph and Stewart Alsop, from *International Herald Tribune,* 13 September 1985, p. 7. Photo by Henri Cartier-Bresson, Magnum.

P. 14: British Caledonian Airways ad, from *Liberation* (Paris), 30 April–1 May, p. 11.

P. 24: Poster published by Comite français contre la faim, Paris, 1986.

P. 30: G. B. Trudeau, *Doonesbury,* from *International Herald Tribune,* 1986.

P. 41: Sculptures from Europe and Africa, from Kenneth Clark, *Civilisation: A Personal View* (New York: Harper & Row, 1969).

P. 42: Sculptures from New Guinea and Europe, from William Rubin, ed., *"Primitivism" in Twentieth Century Art: Affinity of the Tribal and the Modern* (New York: Museum of Modern Art, 1984): Imunu figure, Namau Gulf Province, Papua New Guinea (left), courtesy of the Friede Collection, New York, and Apple Monster, by Alexander Calder (right), courtesy of Mary Calder Rower.

P. 45: Coty Wild Musk cologne ad, from an in-flight airline magazine.

P. 49: Headline for dance review by Anna Kisselgoff, *New York Times,* 23 December 1984, p. H12. Copyright © 1984, by The New York Times Company. Reprinted by permission.

P. 82: Clipping from the *International Herald Tribune,* 1986.

P. 94: Clothing ad, from the *New York Times,* 1984. Courtesy of Antique Boutique, Inc.

P. 95: Ad for Museum of Modern Art exhibit "Primitivism" in Twentieth Century Art, from *New York Times,* 9 September 1984, p. H41.

P. 120: Ad for American Museum of Natural History exhibit Afro-American Arts from the Suriname Rain Forest, *New York Times,* 6 November 1981, p. C30. Courtesy, American Museum of Natural History.